KU-468-592

GONZO·The ART

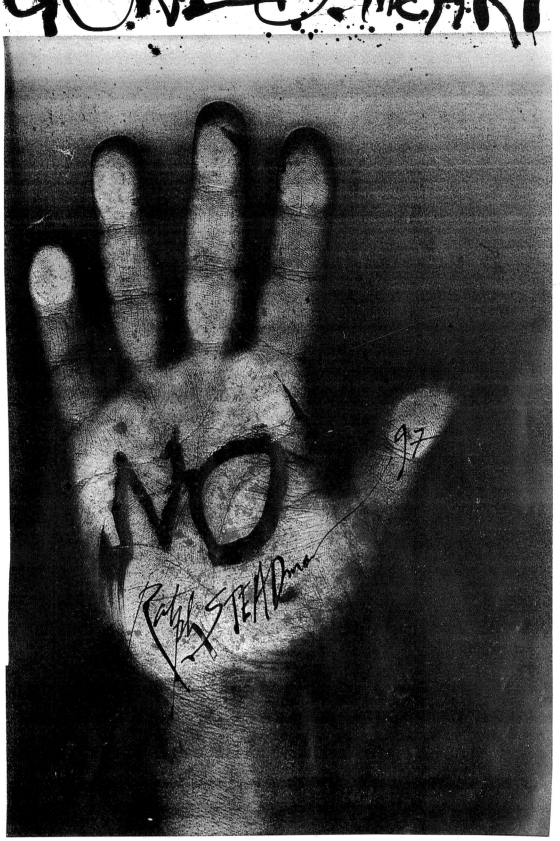

The ART

Ralph STEADman

PHOENIX
ILLUSTRATED

To Liz Knights

We recently attended a funeral at Pond Square Chapel in Highgate, north London, a thanksgiving service for the life of a person taken from her husband, Ian Craig, and her family and friends at the tragically early age of 41. She was talented, perceptive, intelligent and lovely. Everyone spoke of her celebrated loveliness. She rose in her chosen profession to become managing editor of Victor Gollancz, Publishers, the lovely book boss herself. The chapel was packed and the service moving. I dedicate this book to her memory, to her talent, her loveliness, and to Ian himself, her husband and my dear friend, who also designed and directed this collection.

I acknowledge and thank Bill Cardoso, writer, who coined the word 'Gonzo' to describe the Kentucky Derby story which first appeared in the short-lived magazine *Scanlan's Monthly* back in 1970.

First published in Great Britain in 1998
by Weidenfeld & Nicolson

Text copyright © Ralph Steadman, 1998
The moral right of Ralph Steadman to be identified as the author of this work has been asserted in accordance with the Copyright, Designs and Patents Act of 1988
Illustrations copyright © Ralph Steadman, 1998
Design and layout copyright © Weidenfeld & Nicolson, 1998
Foreword copyright © Hunter S. Thompson, 1998

All rights reserved. No part of this publication may be reproduced, stored in a retrieval system, or transmitted, in any form or by any means, electronic, mechanical, photocopying, recording, or otherwise, without the prior written permission of both the copyright holder and the above publisher of this book.

A CIP catalogue record for this book is available from the British Library
ISBN 0 75380 726 2

Half title: No. A hand print
Title page: Gonzo landscape

Editorial Director: Susan Haynes
Designed and Art Directed by: Ian Craig
Disorganized by: Dave Crook
Edited by: Christine Davis
Set in: Bembo (with Ralphabet)

Printed in: Italy

This paperback edition first published in 1999 by Phoenix Illustrated
The Orion Publishing Group Ltd
Orion House, 5 Upper Saint Martin's Lane
London WC2H 9EA

Contents

'I never intended Gonzo journalism to be any more than just a differentiation of new journalism. I kind of knew it wasn't that. Bill Cardoso – then working for the *Boston Globe* – wrote me a note about the Kentucky Derby thing ('The Kentucky Derby Is Decadent and Depraved', *Scanlan's Monthly*, June 1970) saying, 'Hot damn. Kick ass. It was pure gonzo.' And I heard him use it once or twice up in New Hampshire. It's a Portuguese word [actually it's Italian], and it translates almost exactly to what the Hell's Angels would have said was 'off the wall'. Hey, it's in the dictionary now.'

Hunter S. Thompson in an interview with P.J. O'Rourke, Rolling Stone, *November 1996.*

FOREWORD

When Adolf Hitler filled in the registration form for the Männerheim (men's hostel) in Vienna's 20th district in 1910, he confidently listed his profession as 'artist'. Three years later, when he came to Munich, he still referred to himself as an 'academic painter' and 'artist'. As a young man, he told his close friends he would be a 'great artist' some day.

From Adolf Hitler: The Unknown Artist, *by Billy F. Price*

Editor's note: Dr Thompson was asked to provide a brief introduction to this volume. And here it is – in the form of a direct personal correspondence to Mr Steadman. Read it and weep.
– Ed.

...r Ralph,

...t and your cheap drunken whining. I'm tired of your increasingly squalid ...act. Of *course* I denounced the Foreword you wrote. It was a shit-eating fraud from the ... you proudly admitted in your sottish letter of February 28, 1998. Most of your art is rotten and looks like it was copied off subway walls at three or four in the morning. It reeks of greed, deceit and mendacity. If there is any justice in this world you will be banished and thrown out of that once-proud Arts club in London where you have worked as a Pimp all these years and brought shame on your closest friends.

I am one of these friends, Ralph, and I have suffered along with the others, as your vile sense of humor and your twisted vengeful ethics came more and more to dominate your behavior and make you like a living, dangerous holograph of Dorian Gray. It is getting harder and harder to defend you, as you become more and more depraved.

But don't worry about me, Ralph. I'm not like the others – and in my heart I know that you're not either. Your instincts are as pure as they always were, but your soul is more and more ravaged by clinical symptoms of Syphilis. The disease is always fatal and the victim becomes crazier and crazier until he dies.

Or maybe it's Mad Cow Disease, or some related Staph infection. Who knows? You have led a reckless life, naked of Moral Restraint, and many good people have suffered because of your Treachery.

This is not idle chatter, Ralph. This is the Foreword to your New Book. You want Coat-tails? I'll give you some fucking coat-tails.

How about the idea that History will remember you as "the Albert Gore of late 20th-century art?"

That's Al Jr. – current VP of the USA... but you wouldn't know that name, would you? No. You say – in this scabrous little book – that you "refuse to draw politicians any more," because their slimy little egos get in the way of your Art, they are Hams, they interfere with your fun, politicians were impossibly beneath your standards.

I remember the Trauma, Ralph. It was a nightmare. You felt you were going through a personal crisis of some kind, a fork in the road, as if you were suddenly locked in a moment of artistic definition... And I suffered *with* you. No problem.

It was a bad time, but it was necessary. You were making a huge and fateful decision about the very essence of your art – to take the high road or the low road. Neither one of us knew which way you would go, but we both understood the gravity of your decision.

And that was when you started drawing *grapes*, Ralph. Fruit. Politics was below you, so you stooped to worship grapes. Stupid little grapes.

After that, it was whisky. Grapes, hired help and whisky. It was a nasty fermentation, but we let it happen. You were wrong, Ralph, you were wrong from the start, and we knew it... But you were so amusing, so suave.

Well, that was before you drew horrible cartoons of my mother. That was over the line, Ralph. It was the cruelest and craziest thing you've ever done. You are now worse than Hitler in my mind.

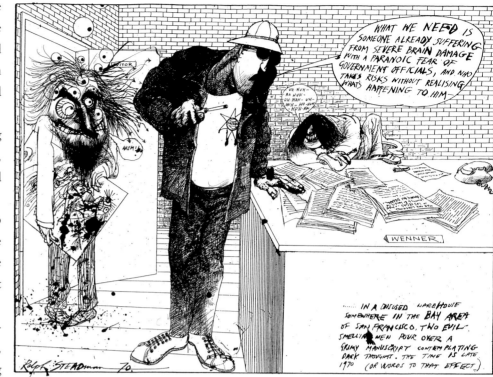

You remember Adolf Hitler, eh? Sure you do, the Reichsführer, the supernazi, the freak who bombed London and caused your Birth Certificate to be "blown up in a hospital explosion during a German rocket attack in 1941."

Adolf was also an artist, Ralph – just like you, in the early days: hustlers, thieves, pimps, sociopathic perverts in the making, like worms coming out of cocoons.

But time passed, as it will, and you each took a separate path. Hitler took the high road and you took the low road. That was when it happened – when you came to the fork in the road.

Except that it *wasn't* really a fork, Ralph. It was only a detour. Both roads led to Hell. (He was a monster and so are you. You were twins perhaps, or born in the form of hyenas, then chased out of the tribe for weirdness.)

Let me tell you something, old sport. You may be designing postage stamps for the Queen and wallowing shamelessly with the whisky rich of our degraded time –

But never forget that you were a thief, once, a whore and a desperate brute of the streets. You forced your children into crime and sick burglaries, just to support your foul habits. Don't lie about it anymore, Ralph. Your lying time has run out. You are doomed and I can't help you. Your bell has rung, your number has come up on the great blackboard. Soon you will have your moment in the Great Hall, face-to-face with the Lords of Karma. Good luck, buster. You'll need it.

Hunter S. Thompson
Woody Creek
March 16 '98

At the moment of my birth and before the umbilical cord was cut I laid my first solid bowel movement into the hand of a gentle nurse who delivered me into this world.

'Biologico impossibile!' gasped an astonished male orderly, Giuseppe **Gonzaga**, who had been present during my mother's titanic struggle. 'Mama mia!' he exclaimed, 'GONZO PURO!' which might have meant 'pure shit' or 'bad luck' as far as anybody knew, if Giuseppe had not been an Italian medical student on an exchange visit from a small town 15 miles north of Mantua called **GONZAGA**. Giuseppe was from an aristocratic family. During the fourteenth century the GONZAGAS seized the town as the imperial powers in Italy began to fade. Luigi Gonzaga assumed sovereignty in 1328 and gave the town its name whilst his sons, inflamed by private revenge and saddle rash, took possession of Mantua with eight hundred foot soldiers and a mere snort of horsemen. The Gonzagas, tyrannical and proud, produced many celebrated offspring.

Ludovico GONZAGA was a poet in the sixteenth century. Caesar GONZAGA established the academy Degli'Invaghiti in 1565 and some of the family used their vast plundered wealth to found art galleries and museums of antiquity. They were fine people, the Whitneys of their day. Lucrezia, named after the Borgias' own impressive Comptesse, bared her sensitive soul in letters, and Louisa Maria married a couple of kings. Most impressive of all was **GONZO GONZAGA**, one of Italy's earliest operatic tenors, who claimed to have invented spaghetti when he fell hopelessly in love with a celebrated Jewish diva called Giuditta **PASTA**. It was in fact Marco Polo who had brought a sample of its characteristic effulgent gooeyness to Venice, from China, seven hundred years earlier, but GONZO claimed it as his own in a fit of amorous endorsement. His brilliant career was flawed when he discovered yodelling while touring in the mountainous region of Ticino between Italy and Switzerland. He insisted that opera's future lay in that direction. GONZO's yodelling *Rigoletto* finished his career and he died a tragic figure. He yodelled his last aria – the Hebrews' Chorus from *Nabucco* – singlehanded. From the top of the Swan Mountain of Fiesole, overlooking Florence, he majestically yodelled himself to death. It was 3 o'clock on the morning of 15 May 1856 – but I digress.

I was referring specifically to 3 o'clock in the morning on 15 May 1936, when Giuseppe uttered the strange oath-like words, 'GONZO PURO', at my birth. Three hours later the Spanish Civil War broke out.

What I have told you is true and was probably the earliest manifestation of a Gonzotic event, years before its time. I went on from that very moment to fail miserably and forever in the watery eyes of those around me who viewed my act of wilful excretion with utter disgust, as though I had committed the original sin. Mind

you, I must say in all humility that it was a pretty damned original sin to commit in 1936 when Surrealism itself, in all its sinful glory, was in full flood.

There is a time and place for everything, but not in that order, and my chosen style of self-expression, my DaDa DooDoo, so early in the game, hardly endeared me to those present. My dear mother apologized on my behalf, since I had not yet learned to speak, and forever after never wanted to make trouble. 'I don't want to be a bother,' she would say, and never was. She was sweet, gentle, generous, honest and blessed with the most trusting nature and a total acceptance of life's bitter lot. It was my mother who instilled in me a naive trust in everyone and in that respect I discovered in my own time and in my own way the imperfections of humankind. Distrust was never learned, certainly not chosen. It was thrust upon me at an impressionable age as I stumbled from one failed try at life to another. I failed art at school. The same school, Abergele Grammar School (motto: QUALITY and EXCELLENCE), now has a Ralph Steadman Creative Suite in my honour. I proudly unveiled the plaque myself hardly two years ago.

I dedicate this book to failure. Failure to come up to scratch. Failure to achieve. Failure to fit into the margins of society's narrow aspirations. Failure to resolve my fear of authority. Failure to impress those who have the power, the power that suffocates all our abilities like a heaving oil slick. The power is always there so I ran away and hid myself in a world of flying objects, model aeroplanes, futile rockets and boomerangs.

'Hecky Pecky' was the strongest profanity my mother ever uttered to express her annoyance or her dismay. What can I do? was my incessant question that dismayed her the most. I must have uttered it at least three times a day, particularly during school vacations, looking out of the window onto a wet backyard, the weeks and the puddles stretching out ahead. She raided the local stationery store for anything that might keep me occupied.

My father was funny, as sardonic as he was repetitive. He had his private collection of jokes which he learned during the First World War when time stood still. He was wounded three times. The third time would have been fatal had the bullet not passed through the leather wallet he kept in a pocket over his heart, and deflected through his shoulder. Apart from telling me he had been in the Cavalry until the coming of tanks, and that he used his sword to make toast and peel oranges, he never wanted to talk about it. Men in the trenches preserved a silent inner self and didn't take their socks off for three months, if they lived that long. When they did and were able to remove their socks, the skin came off too. My father tended to make such odd pronouncements sound like light-hearted banter but I knew they masked dark memories he wanted to forget. He had been a surveyor before the war though he would have preferred to have been a hands-on engineer, a car mechanic. After the war he got involved with a partner in the rag trade selling woollen goods (it must have been the socks). They were doing quite well considering the economic climate in a

post-war land 'fit for heroes' until his partner ran off with the profits. My father became a freelance commercial traveller – in search of his rotten partner, no doubt, 'or why else would you want to be one?' he used to say fatalistically. He travelled in 'ladies' knickers, coats and costumes', his own phrase, and he never really did well again as far as I could make out. Denied the chance to realize his earlier ambitions, he found that his heart just wasn't in knickers.

Nevertheless he maintained a businesslike appearance all his life – homburg hat, collar-stud shirts and black dress-boots, full-length combinations and a draught back-flap. He hated draughts. He aired everything twice before he wore it. He also married twice. I was told that his first wife died. My father never told me and he never knew that I knew. He met my mother, a Welsh miner's daughter, during his travels, she worked in T.J. Hughes Department Store in Liverpool. His letters to her are from places all over the north of England, and are strangely addressed to her as either Gwennie Rogers or G. Rylands. Unless he had another secret, I presume they were both my mother since they all went to the same address in Johnstown, north Wales, or to the store. They married in 1928 and lived to celebrate their golden anniversary. A Victorian to the end, my father said at the age of 87 that the only thing he had noticed about growing old was that the undertaker raised his hat to him. He died at the age of 92 beneath my painting of Leonardo's *Last Supper* (now renamed *The Last Cuppa*) on the guest bedroom wall. He had a cup of tea at his lips held by my mother saying, 'Buck up, Dad. You can't refuse a cup of tea. You've never refused a cup of tea in your life.' He only did so the once.

I went up to the room to stand with him in silence. I looked at him long and intensely, the way an artist looks at a sitter, but I didn't draw him. I photographed him instead, beneath the *Last Supper*. He looked so peaceful in the shuttered light. His head lay against a purple pillow. His mouth was open. It always was when he slept in an easy chair of an evening. He was sleeping. That is what I decided there and then. That is what he would have thought himself. I'm OK. Don't fuss. At his funeral he would have said the same. Don't fuss and don't hang about in the rain. Go home or you'll catch your death. OK Dad.

He is buried just three miles away from here in Marden, Kent, full length; my mother's ashes were placed just above him six years later. Don't make a fuss love. I'm with you now. It's the only piece of real estate they ever owned. Pure Gonzo.

Gonzo is the essence of irony. You dare not take it seriously. You have to laugh.

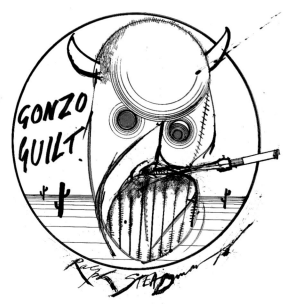

Nobody I have read knows what GONZO is, was, or ever could be, not even Hunter, and if he doesn't know what it is, I do. I am the only one who does. GOnzo makes you feel GOod rather than BAd which is BANZO. Pursue BANZO if you must but don't blame me or even credit me or you will make me sick. GOnzo is GOod. BAnzo is BAd. It is a simple equation.

I have located the tenuous hint of gonzotic frenzy I was looking for inside the stylistic variations of my work. I have uncovered the print of a drawing, the footprint of my future, my nemesis. It bears the flaw of immature work, the bloodline. The figure of the woman shop assistant demonstrates the schizophrenic tendencies present in my drawings of the early sixties when I worked for *Private Eye*. I am expressing the state of my subconscious. My apparent desire to conform was the trick. This drawing is the birth of GONZO in my work — a dispassionate statement of fact intended to elicit uncomfortable laughter — its ruthless portrayal a gentle assassination of the subject in a spat of ink... I am a kind person but outwardly I project a volatile disposition, a lonely soul at peace with the forces of huridomidomatonic slavery — What?... Don't write, Ralph.

But that was yesterday. Hopeful. Today cartoon imagery has been flogged to death. Electronic wizardry has devoured it, digested it and spat out the bits left stuck in its teeth. What is unacceptable in the world is served up as light entertainment in every living room in the land. Well, good! What I used to do with a passion, foolishly and vainly imagining I would change the world for the better, I no longer tolerate in myself or anyone else. But draw, always draw — and WRITE!

There is a self-regulating mechanism inside everything (the GAIA principle). Violence is a reaction to helplessness. Helplessness is impotence.

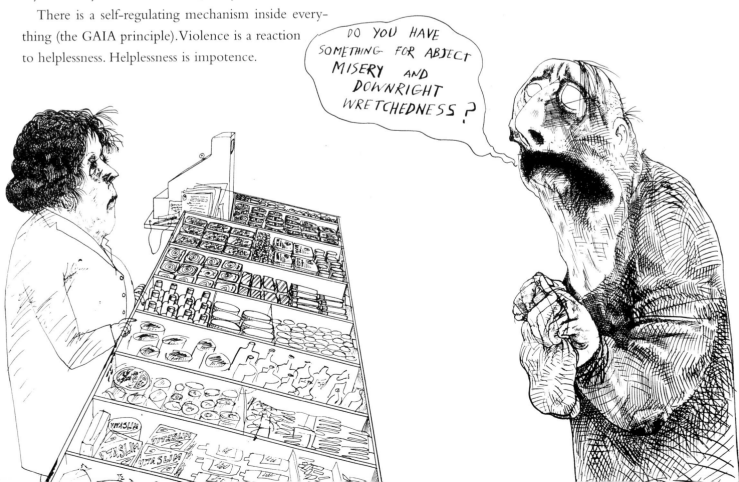

Samson got Delilah, John the Baptist got Salome and we got the Spice Girls.

Cartoonists were always denied the right to any kind of memorial due to 'an absence of moral artistic consistency'. But isn't it that will-o'-the-wisp flexibility that has transformed their work over time into its own memorial? And aren't they supposed to be disreputable rakes, otherwise how on earth can they understand lowlife? Loyalty was never the name of the game, but perception is...

Dragon in our DREAMS

You wake at two o'clock in the morning. The merest smattering of a thought has crossed your sleeping mind. The damn thing bursts into life like a buzz-saw hacking through lumber jams. The thought won't go away. We don't like waking up in the middle of the night – there's darkness all around, your partner is asleep, no one to turn to, doesn't want to know; your spirit is at its lowest ebb and the problem is at its height. It's a kind of inspiration, even though it's a problem. The mind races, considers all the aspects and all the ramifications and nothing resolves itself. Leonardo had such nights – waking and fumbling for the candle switch, not finding it and falling back on his horse-hair bolster with a groan and a mind full of half-finished dissections and unresolved indulgences about why he has so many words in his mother tongue but not enough to fully express the concept that is in his mind. Why do the muscles of the lips contract and alter their shape to express laughter or misery? For in nature nothing is lacking and nothing is superfluous and that's enough of a question for anybody, particularly at 2 o'clock in the morning. Problems are the dragons of our nights, and sooner or later you must confront them. Leonardo confronted them and pacified his own dragon. He externalized it.

From beneath the deep study of every part of every living thing there erupted something of a fusion of parts. A kind of safety valve. A fantasy. For in spite of his inquisitive mind and compulsive probings, Leonardo remained a romantic. His discoveries would serve both knowledge and masquerade. For those who wish to dictate harsh order, straight dogmatic lines, rules and regulations are what they impose. Those who create fantasy are the liberators. Leonardo's mind united science and fantasy.

Excerpt from GOD'S DRAWING BOARD

(Fade and quiet as 'AUTHOR', dressed in paradoxically confused clothing, walks onstage backwards as though addressing someone in the wings and coaxing them on to join him. BEGGARS crane their necks trying to see who he is referring to.)

'AUTHOR':

Let's go, Mum. Let's show them the Armageddon Trinity
 along with Dad

Let's pose naked honest before the world

That wasn't meant to be this bad

You told me

Help me Mother

Shine your gentle strength from beyond the grave

Blow the dust of your remains out of your box

Like a sign

Let me see a puff of spirit

Alert Dad!

Shake him into life, to the surface, to the barricades

What shall I do Mum?

I listened to everything you said

Your honesty was never blind

When you told me to wash my hands I always did

Why Mum?

Had you got some idea in mind?

I finished my homework before 5 pm. Always

I did it as soon as I got home

You never pushed, but I did it.

You seemed so wise

You should have been a teacher

I picked your brains

You left them out every day like bread on a wall for
 the birds

I pecked

Like an idiot

Was I an idiot? Am I? Still?

You left a scar – not a scar, a weakness in me

A vulnerable place. I learned to trust

There was a simple order in your world

Some things could be relied upon

Some things looked good

So I nestled inside your sense of right and wrong

There was a good world and a bad one

If I did what I was told things would work out

In a certain way they did

Why Mum? Why should they?

Did you ever doubt or was your blissful goodness
 inviolate?

It protected you. It gave you grace.

When you were here I never doubted the sanity of
 this place

When the bombs fell around us – you continued to knit

We sheltered and cowered – and you continued to knit

My questions fell like gentle rain between explosions

Then I went back to bed

Or under it, for safety, you said

So gently

But we didn't hang around, we left in the night

Let's go Dad!

Dad would find safe haven

And he did but you were unhappy

At first. You wanted to go back

But there was no going back

Our home was full of others

Frightened, running too, like us

We ran again back towards your safe unhappiness

This will do, you said. At least we'll be safe

And we were!

(Coos and harmony-singing chorus with derision and mockery come from the cage of the DAMNED EXCITED)

NARRATOR (W.C. FIELDS):

> Reminds me of my own dear mother and father, God
> rest 'em
> Both suffered from leprosy
> And they showed me their love constantly –
> They kept their distance
> Then one day my father hit me over the head with a
> shovel
> For juggling with the contents of his fruit stall
> So I hit him back
> It seemed the only decent thing to do at the time –
> *(juggles to side)*

'AUTHOR' *(continues)*:

> A childhood full of safety
> This is what you gave me
> A single dimension
> A place to stand and judge
> Lie encapsulated in a single dimension
> Let's go, Mum!
> Let's feed the hungry
> Not for their hunger's sake
> But for progress away from hunger
> We could start again
> Hunger would be a memory
> A zero in a scale of one to ten
> Start at square one
> Rise up Mum! Come back!
> I always was the clever one
> You said I was
> I'm clever now
> But not too smart
> I took up Art.
> I drifted with some purpose
> In a certain way
> I took up Art and drifted towards a moving goal
> Both you and Dad were proud
> Let's go, Mum!
> Go through
> Me and you
> And Dad

> Poke your nose around and see
> Things have changed.
> Not like you would imagine Mum
> Not like they used to change
> Not like Mrs Millward at the chandler's shop dying
> You remember, not like that
> Not like the Abergele Visitor
> Not your reading matter, your local paper
> Not like, Well I never!
> Not – You remember Ieuan Evans, you went to school
> with his son Dewi
> He used to keep the cobbler's in the Arcade
> Not – Well what about him then, as I used to ask
> Not – well. He just died. Not that –
> Not – I expect Dewi will carry on
> They worked together – him and Dewi – Father & Son
> Not that kind of change
> Never that again
> Not now.

> Forget that, Mum
> The Arcade has gone, eaten up by a bank
> Eaten up by money, eaten by greed.
> Appetites are funny things, Mum
> There are lanes now
> Slow ones, slightly faster and fast
> Insane lanes for insanity's sake
> Then there's another lane
> Beyond sanity
> There's a suicide lane
> Not for us, Mum
> We didn't choose suicide
> But they do, Mum
> They are mad to escape
> Mad with getting there
> Somewhere else
> Mad to belong –
> To madness
> They are the new people
> The new deaths in the Abergele Visitor
> The, Well, I nevers!

The Gladiators of Well – I – Neverland

Hopeless in greed, greedy helpers

Helping themselves to destruction.

Blood in veins, yes. Healthy blood like you used to have, Mum

Not ashes, nothing like that

But a torrent of fierce passions

Hardly passions, grabbing desires, grinning needs

Taut with numbness

Taunting abuse

Playing with fire

Yet longing for the rains to come.

Rain makes you think Mum

Rain makes you remember

The good time

The cosiness of shelter, safe shelter, the lost world

The longing for the sunshine

Again

The sun always comes again

But not in your world, Mum, I guess

No light, never

Only in the rain

Your ashes turn to mud

And stay mud

Even in the sunshine

My mother is mud

This is outrageous!

My–mother–is–mud

But your memory is lighter than air, Mum

Your memory is safe with me

But your precious remains are mud

Now you stick to my boots

Become my roots again

Hold me to the spot

Reinvent the past

Reincarnation

Right where I stand

Mum, I love you – and tell Dad he's OK too!

(Moans and groans, oohs and aahs emanate from the cage of the
DAMNED EXCITED, jeering singing whoops to diffuse any signs
of sentimentality. Thunder crashes and…)

Failed DREAMER

Excerpt from GOD'S DRAWING BOARD

(Lights catch falling sheets of paper – hundreds of them. Figure dressed in paper suit made of forms and letters with portable phone and laptop leaps onto the stage. Dramatic discordant music. Shafts of organ sounds.)

CITY TRADER:

Many years and many taxes
Oval dreams and endless faxes
The time has come to pay our dues
Taken in, moulded in time putty
Graven slices of pierced flesh
Open wounds tomato sauces
Able-bodied human spirits
Laugh outrageous taunts in perfumed lemon groves
Rattlesnakes don't rattle like they used to anymore.

A better way to forget
Community care
Throw yourself into the system and milk it dry
Grind hellos into spent goodbyes
Piercing the surface of our own appearance
Shouts of abuse ugly and true
Cancerous trials of a guilty loner
Convict on sight
Shuffling off, unable to reason
Mumbling screams into black sponges of friendless nights
Grovelling for help inside capsules of plastic heaven
Rattlesnakes don't rattle like they used to anymore.

Hitching en route, guttering into side issues
Sinking in ditches
Casting jagged shadows across broken worlds
Making bridges over ugly gaps
Between problems and solutions
Mind gone, nothing there
Printed circuit voices chatter naked details
Over plugged-in airless webs
Broadcasting secrets for everybody
Bouncing off walls
In punter's heaven
Rattlesnakes don't rattle like they used to anymore.

Observations on GONZO — A Victorian View.

To analyse the origin and progress of a deranged mind, to prescribe a mode of cure and, what is still more important, to prove from long practical experience that GONZO chiefly owes its origin to some peculiar physical organization, or rather, disorganization.

Nothing, indeed, is so acutely agonizing to a mind of any sensibility as the idea that GONZO is constitutional, that it creeps onward in its blighting influence, from father to son; increasing in power through each successive generation until, having reached an overwhelming climax, it becomes finally extinct in the person of some devoted maniacal descendant. It can mildew in its early blossoming the life of an individual and render him a joyless outcast – turn his springing hope to gloom – poison the pure fountain of his feelings, and finally send him down into oblivion abandoned of God and man. To minds thus scarred and blighted, but to whom one little gleam of reason, like a well-spring in the desert, yet remains, I recommend an attentive care to one's predicament. GONZO, so far from being hereditary, is physical; it has a nervous rather than a mental epilepsy, ague, paralysis or any similar disorder.

An account of a deranged mind demonstrates the thrilling power of imagination which such an intellect possesses and which, guided by corresponding judgement, would form the staple of a first-rate poet. GONZO, indeed, is at all times grand – it is idiotism only that degrades human nature. No one looks down upon the madman, but all condescendingly commiserate the idiot. The one is majestic, though in ruin; the other, simply disgusting. The victim describes his own sensations when in the grip of a GONZOTIC SEIZURE:

BEAST bites BACK

Prowling in my sleep
Growling in the thunder of some
 godless dread
Filling in my tracks
The beast is on my back
Out of its tree
It follows me inside my head
It scratches on the skylight of
 my mind.
Prowling in my sleep
Growling through the scrapyards of
 the gutless dead
Filling in my tracks
The beast is back
The beast is in my head.
Peering through the skylight

It illuminates the gloom
The vacant eyes reflect the fears
That blossom in the room.
A placid scaly nightmare
Shudders slowly making faces, only
 leaving traces
If I make a move
– I never make a move –
I never move a muscle
I never move a limb
That fearsome thing that really
 moves
The blood that moves in him.
It feeds the claws
It holds the teeth in grim
 upholstered charm

Lying in wait
Taunting the fate
Of the one it comes to harm.
So in my sleep I shudder
In a place I dare not know
The beast that lies awake in me
The faceless fear, the gruesome leer
The tireless threat
The mask in me
Hangs from the tree
Of the beast
– that troubles me –
The – beast – bites – back – the –
 beast – bites – back – the – beast –
 bi – i – i – ttt – e – e – e – ssss

17

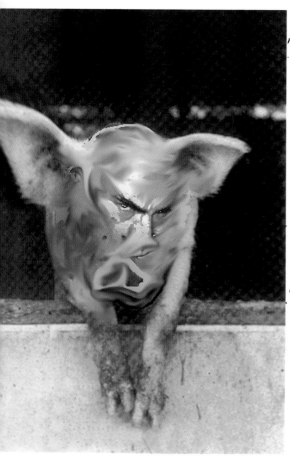

PIGS Animals and US

Pigs have been treated like swine since the dawn of time, or at least since man first stood on two legs and found a creature more loathsome than himself. Pig said oink and man said ink. From that moment on, man was master. Man learned to write.

The hog tribe stands unrivalled among quadrupeds in its grossness of manner, which corresponds in equal measure to their actions. Pigs have capricious tastes. While chewing herbs and vegetable peelings with delicacy and relish they voraciously devour nauseous and putrid carrion.

They eat their own young and have been known to attack and mangle young children. A pig's appearance is slothful and stupid and if not disturbed it will sleep for the remainder of the time not devoted to gluttony. Given enough food a pig will indulge itself until it can no longer move. Pigs display a prodigious ability to multiply. The pig devours our trash and we devour the pig. It's a deal!

Its features remind us of our newborn babies and its pink flesh taunts us with an image of ourselves in middle age. For this unfortunate similarity some religions have banned it as a source of nourishment, casting the wretched creature in the role of a delicious temptation, one step away from cannibalism. Cannibals referred to white humans as 'long pigs'. A pig's sense of smell is acute – they can locate truffles some distance under the ground. Generally their life is one long round of torpor, gluttony and self-interest. They support a prodigious wealth of vermin on their person and suffer crippling alimentary disorders more varied and complex than those of an army on the march. There I thought the similarities ended until it occurred to me that while the pig will eat its young, we will turn half of ours into starving refugees or slaughter them for no good reason. We are natural brothers and distance ourselves from the discomfort of this fact by using the word 'PIG' to describe the brutish, the despicable, the unsavoury and those among us who would attempt to control societies with harsh and repressive measures.

Noah had a lot to answer for when he saved two of every species. He gave the animal kingdom a taste for domestication. Slopping out and putting up with the most obnoxious smells was all the thanks man got. Count your blessings, Noah. The bible does not mention dinosaurs and Tyrannosaurus Rex. They had long gone.

Cleaning up after only one beast like that would have been a mammoth task – and there would have been two of those as well.

Man tired of his diet of human flesh. He was losing friends. He used his cunning instead. Animals needed to drink so he lay in wait along paths leading to waterholes, displaying a practical intelligence beyond the wit of beasts. This is the principle of pyramid selling. He drove the animals out of their holes and caves of post ice-age palaeolithic times to inhabit those places himself and then with this new-found domestication brought the animal back in to share his house on a second-class citizen arrangement.

Man displayed a flair and a desire for interior decoration in his home by capturing the likeness of a beast he was about to hunt. Drawing a line which portrayed these creatures gave man a symbolic and superstitious power over them, possessing their souls and rendering them victims of his imminent pursuit.

Man killed the mother and father beasts, while the babies would be incarcerated, tethered and herded into enclosures. He made them work. Then he ate them, clothed himself with their skins and bound his feet with their guts. And so nomadic man settled down.

Domestication affected man. He built and fashioned and ultimately spoke. Animals became mysterious because they did not. Man imbued the animal with a silent, god-like wisdom. His reasons for eating them shifted to a symbolic ritual. He coveted their wisdom and ate their flesh to acquire it. The first god-beasts were the goat, the ram, the antelope and the ibex, all domestic animals. Then the larger beasts, the bison, the yak and the aurochs achieved a double status. They were both common and divine. Man lived side by side with these huge beasts, but separate, treating them as a living pantry, killing them when he needed food and appeasing his guilt by transforming their memory into god-like effigies with names.

He built temples in their honour to augment the separation and the animals became a conduit between heaven and earth. All along the banks of the Tigris and the Euphrates, through Sumer, Persia, along the Nile and throughout India the sacrifice of animals became a powerful ceremony which in due course developed into different systems of mythology. There were powers peculiar to each species and priests adopted certain animals as special and magical. The bull and Minotaur became the god Hap, the god of fertility and a strength that united Upper and Lower Egypt in the First Thinite Dynasty. Lions became extinct in Egypt but gave birth to the sphinx, the life-giving guardian of the two horizons, yesterday and the future. The giraffe and the elephant, however, remained commonplace, as did all insects save the bee and the scarab. The hyena was trained and used domestically in Egypt.

Human capacity for language increased our technical proficiencies. Apes became human. Humans became scientists. But is a chimpanzee's failure to speak an indication of the creature's lesser sensitive abilities? By what right do we revere verbal communication among humans over non-verbal communication among other animals?

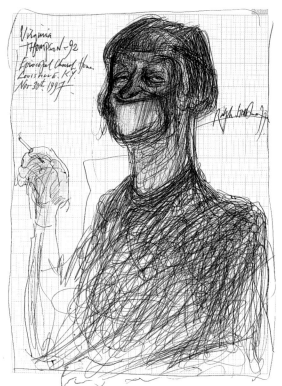

There is more to language than speech. We have the ability to externalize our senses and aspirations. To understand elephants we do not have to pretend that they are just like humans, let alone that they are like late twentieth-century Western middle-class humans. We have imposed upon animals what anthropologists have called 'cultural constructs', by assuming certain presumptions from our observations of them to suit our perception of the world.

It was 130,000 years ago that homo sapiens developed an anatomically human form but another 90,000 years before the signs of modern human behaviour emerged. We developed a perception of domestication (together with one of its by-products, slavery), the difference between hunting and homicide, carnivorousness and cannibalism, and called it civilization. Becoming human was a process of discerning cultural evolution. Language enabled us to construct an imagination that could describe possible future developments, although mainly to suit ourselves. (Science fiction writers do it constantly, constructing greater and wider parameters of possibility.)

The difference between humanity and animality is so imperceptible that many cultures do not believe in the concept of human superiority. When we watch a wildlife film of some exotic and alarming creature we might, for all we know, be watching a sci-fi movie in the form of a nature documentary.

We are animals, too, and our fear of them is based on the insidious thought that their biting back might not be so much physical as mental. We fear their lack of a recognizable vocabulary and look upon their silence as a telepathic power to which we are not privy. They may be in the process of taking over the world; they could do so with the suddenness of an earthquake and the tables will have turned in their favour. Only man's insufferable pride prevents such an idea from taking a paralysing hold on our daily sense of well-being and demonic motivation.

Are animals capable of evil? Or is evil a consciously provoked antisocial act, and peculiar to humans?

Is it an evil act for the young men in a tribe to kill the older male leaders who otherwise would take all the females for their own uses? Guilt is unique to man. The young feel guilty enough to re-establish the authority of the murdered older males by creating icons of them. Then within their community they worship them as gods and therefore appease their guilt.

Man is prey – mosquito bites kill more than any other form of life on earth.

The human race is driving other species to extinction at an unprecedented rate. Within one hundred years the only animal species left will be those genetically engineered by man for his own medical purposes.

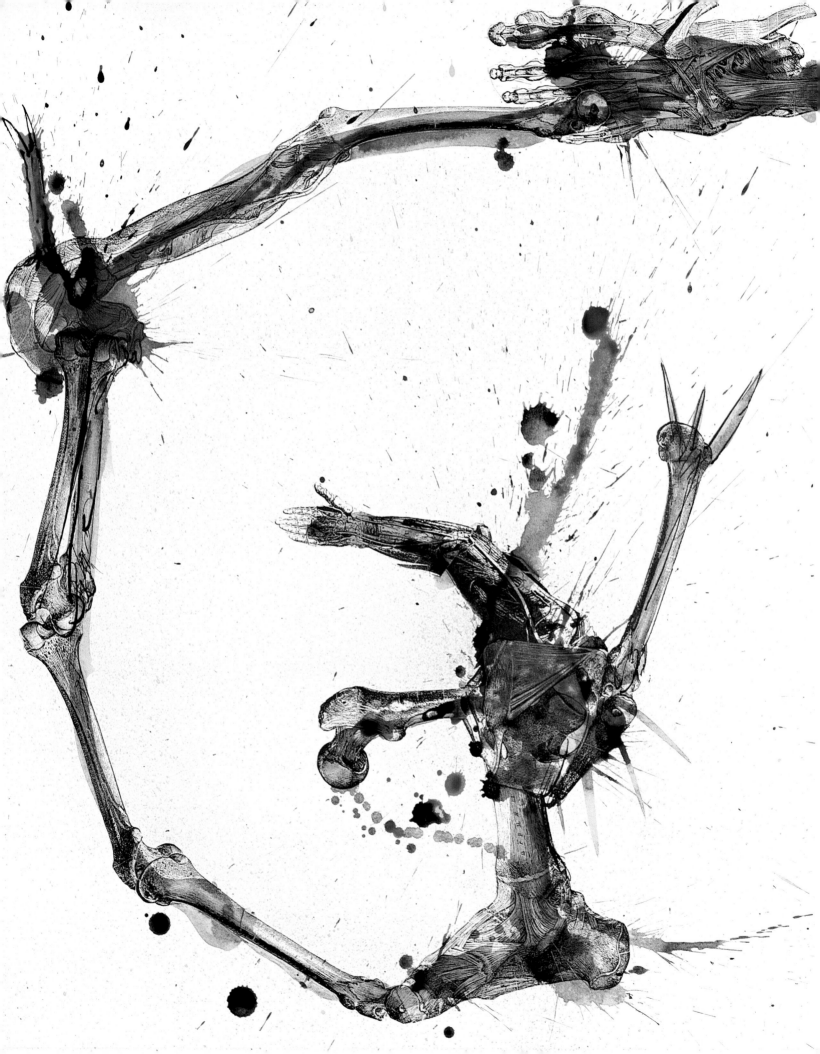

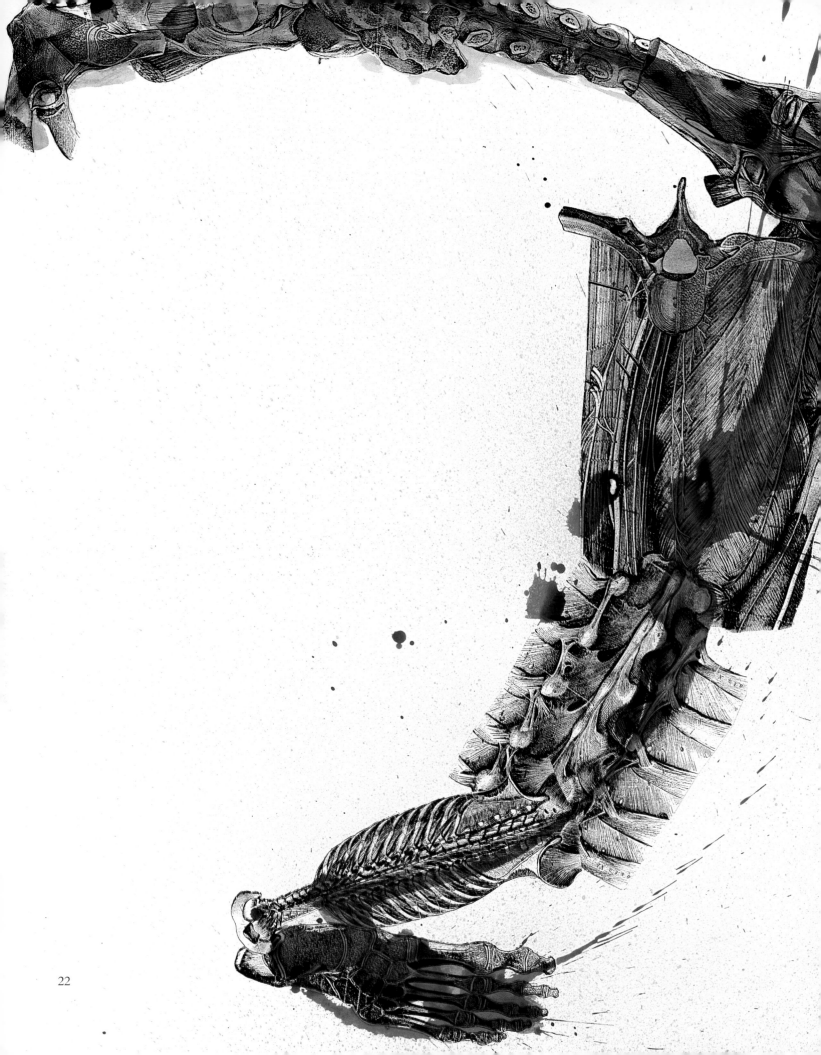

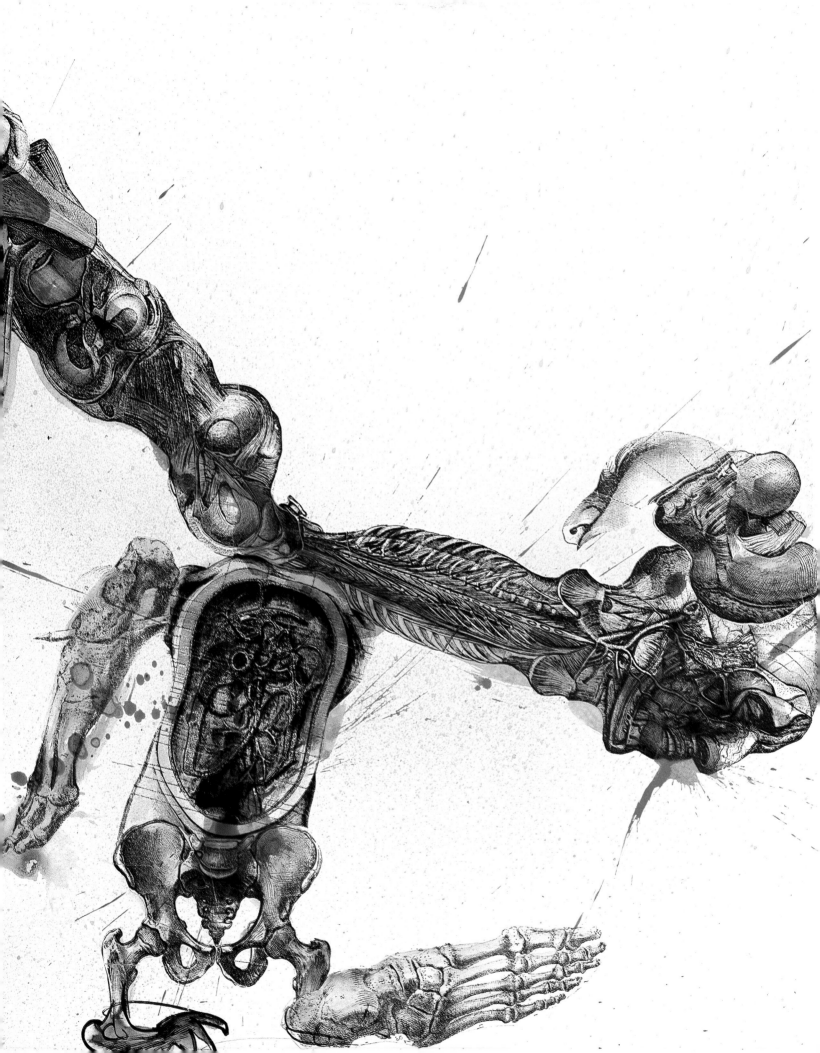

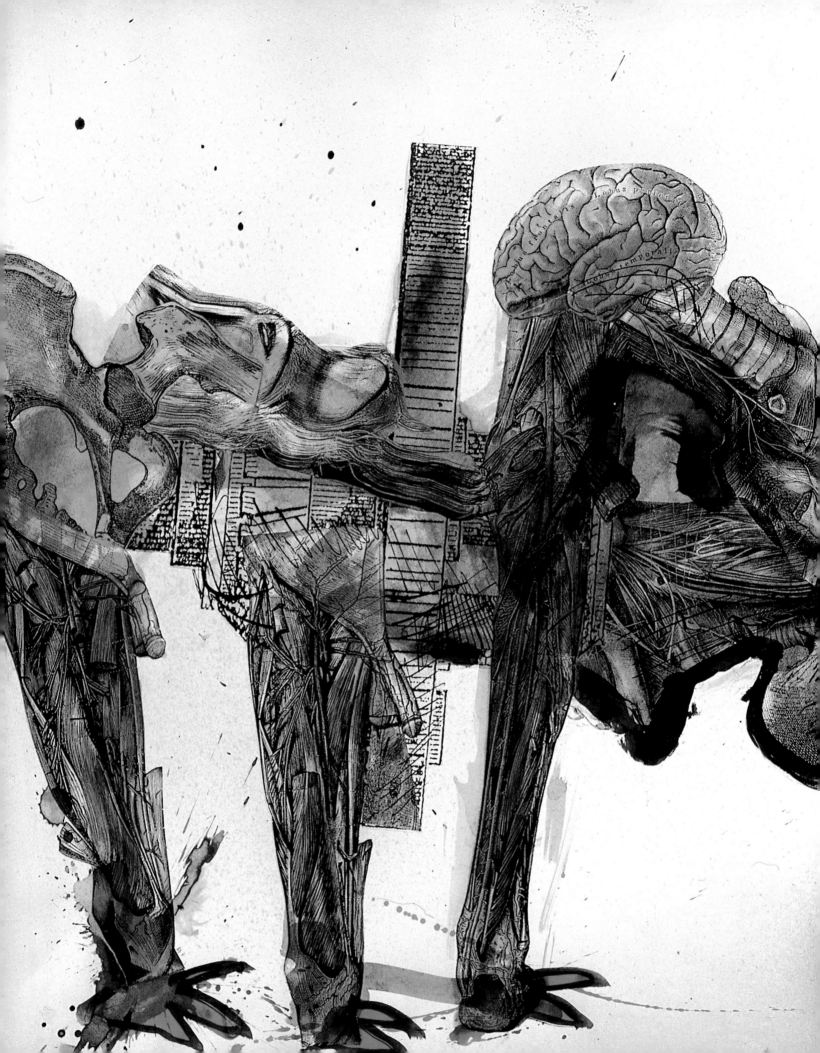

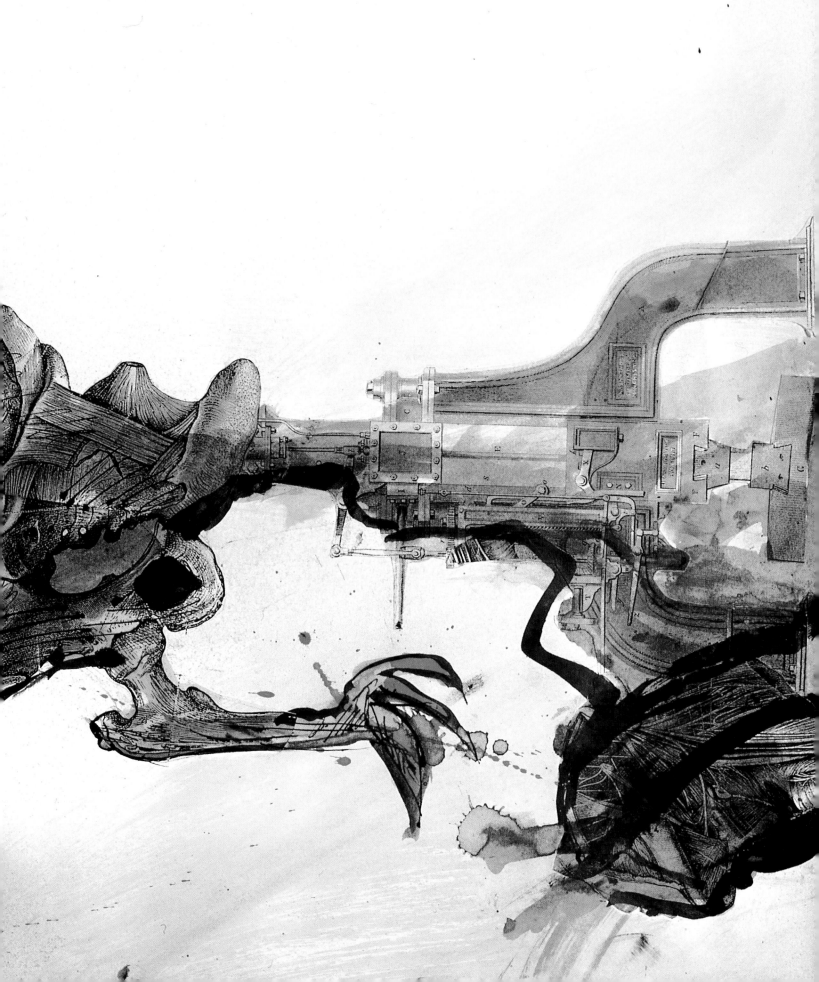

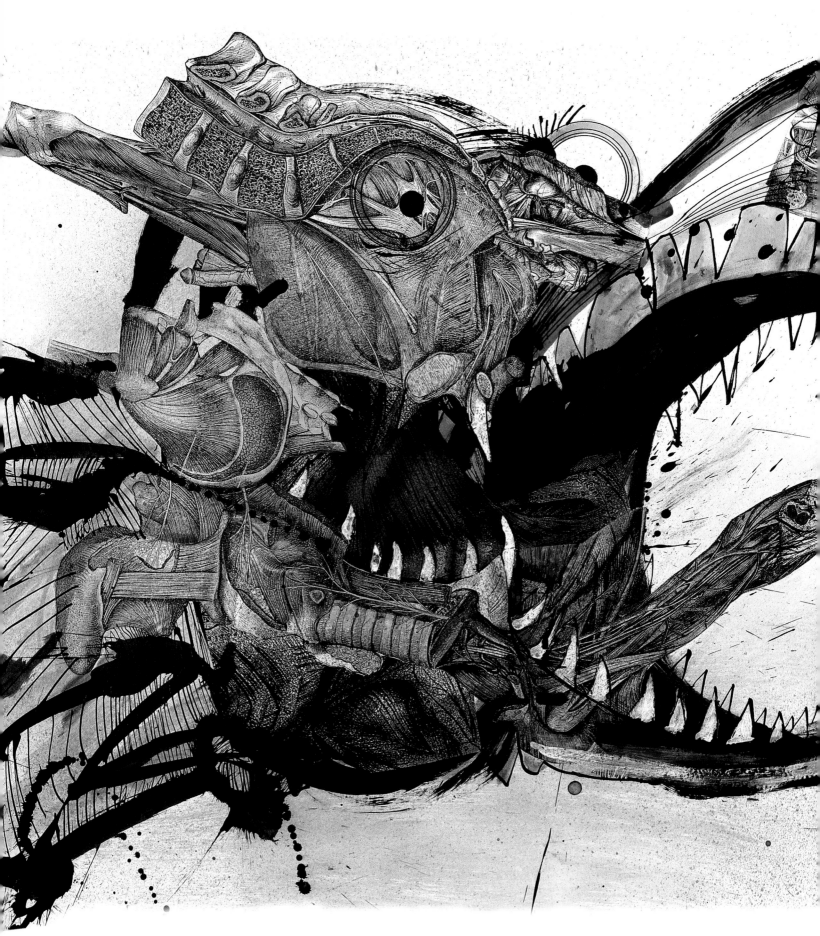

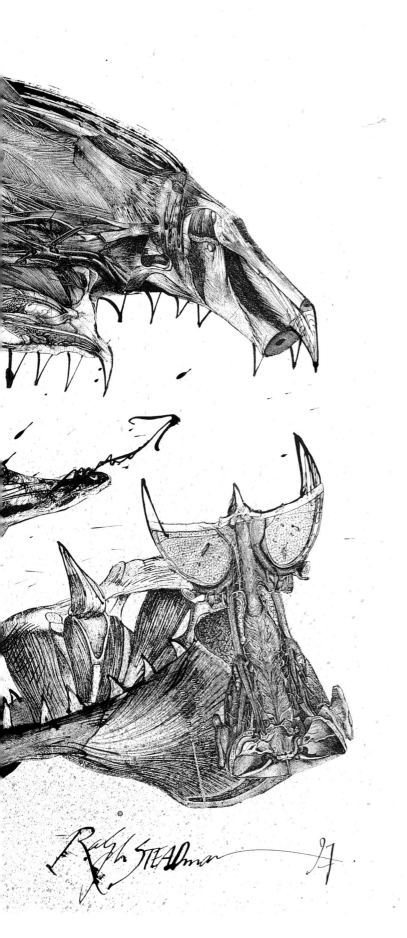

The Leviathan. A gargantuan figure conveying the ruthless inevitability of historical revisionism by consuming all the words of condemnation that were set on these pages.

To know is **HUMAN** – to imagine divine.

Opposite The dream of reason produces monsters. The thoughts that invade my mind at 2 o'clock in the morning, a time of nauseous antipication about something which might never happen.

Below The human condition on the butcher's block of life.

Overleaf Top left: Screaming fun. Created for the film *Tales from the Dark Side*. The clown image masks an underlying threat. Bottom left: Financial madness in a cheap café. From Ted Hughes' book, *The Threshold,* which I published privately with Bernard Stone through Steam Press. It was drawn directly onto paper litho plates. Right: A silk-screen reverse print, with white ink on black paper, of the drawing for the dust jacket of the first hardback edition of *Fear and Loathing in Las Vegas,* published in 1971. Printed by Joe Petro III, Lexington, Kentucky, in 1996.

Boundaries between instinct and learning do not coincide. We refer to all things 'cultural' as that which is learned. What we learn today is effectively innate received knowledge within society rather than a power which is symbolically grounded. 'Traditional behaviour' overlaps human and non-human behaviour. The production of artefacts depends on a capacity for symbolic thought. This appears to be unique in homo sapiens, based on our capacity for language. But behavioural 'dialects' exist in animals, particularly in chimpanzees.

With language there are enormous implications for human evolution and human history. Our languages allow for innovation by deliberate invention rather than acts of blind variation. We direct our evolution towards an imagined future Utopia. We practise an active and conscious acquisition of culture (rather than imitative learning) which in turn is responsible for cumulative or progressive growth of knowledge. The consequences of this educational restraint misleads humans into thinking that it underlies everything we do. It underlies only a small (albeit significant) fraction of what we do. Human conduct does not differ from the conduct of non-human animals.

Our emancipation from the animal kingdom must be regarded as a freak of nature. The story of creation favours man and has been passed down and elaborated by the one faculty peculiar to us – language. It is language which has spearheaded our rapid evolution into the position of a selected species and even in that capacity, our specific cultural concepts have dominated the variations by which we have formed our hierarchical sense of being. Over to you, Noah!

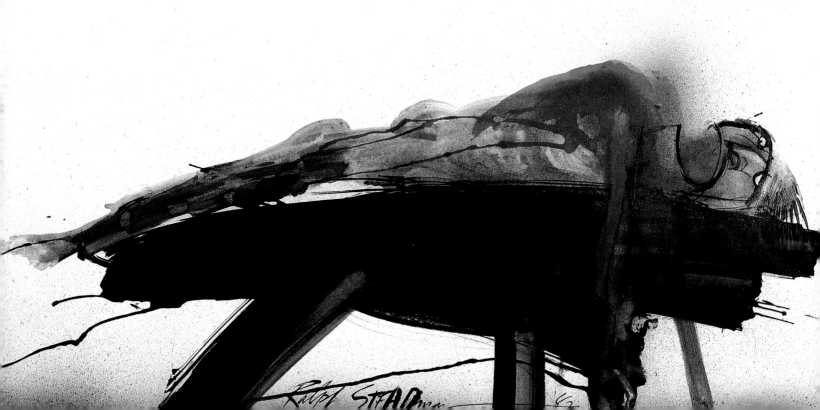

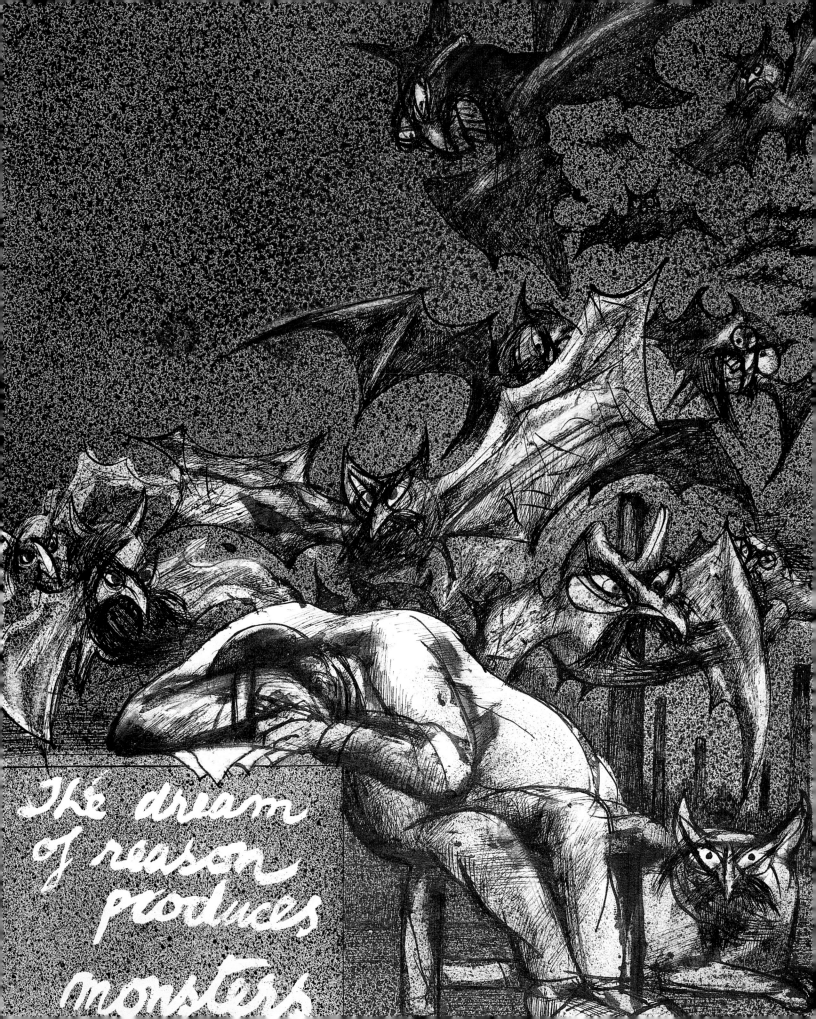

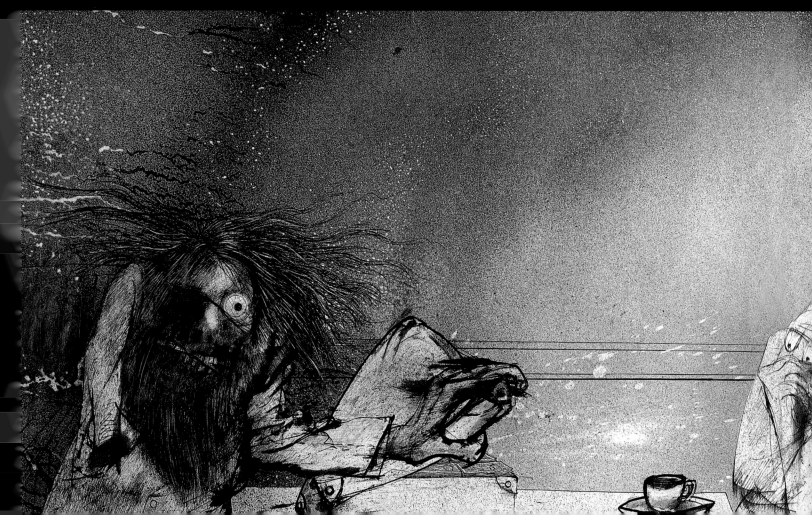

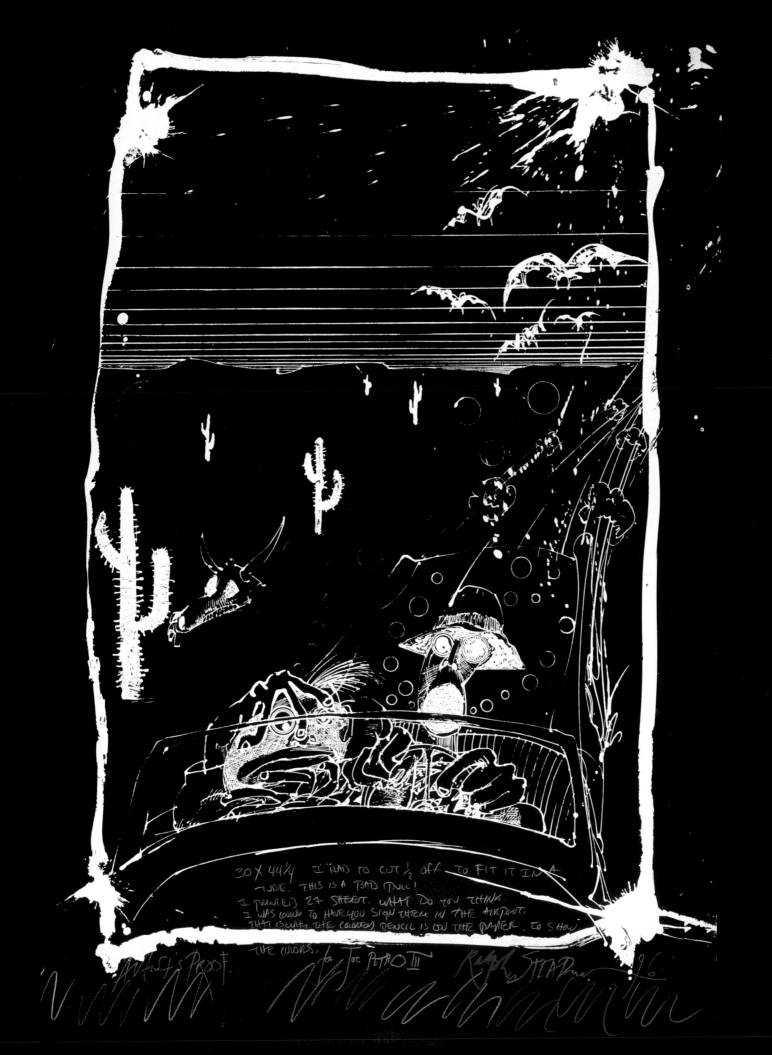

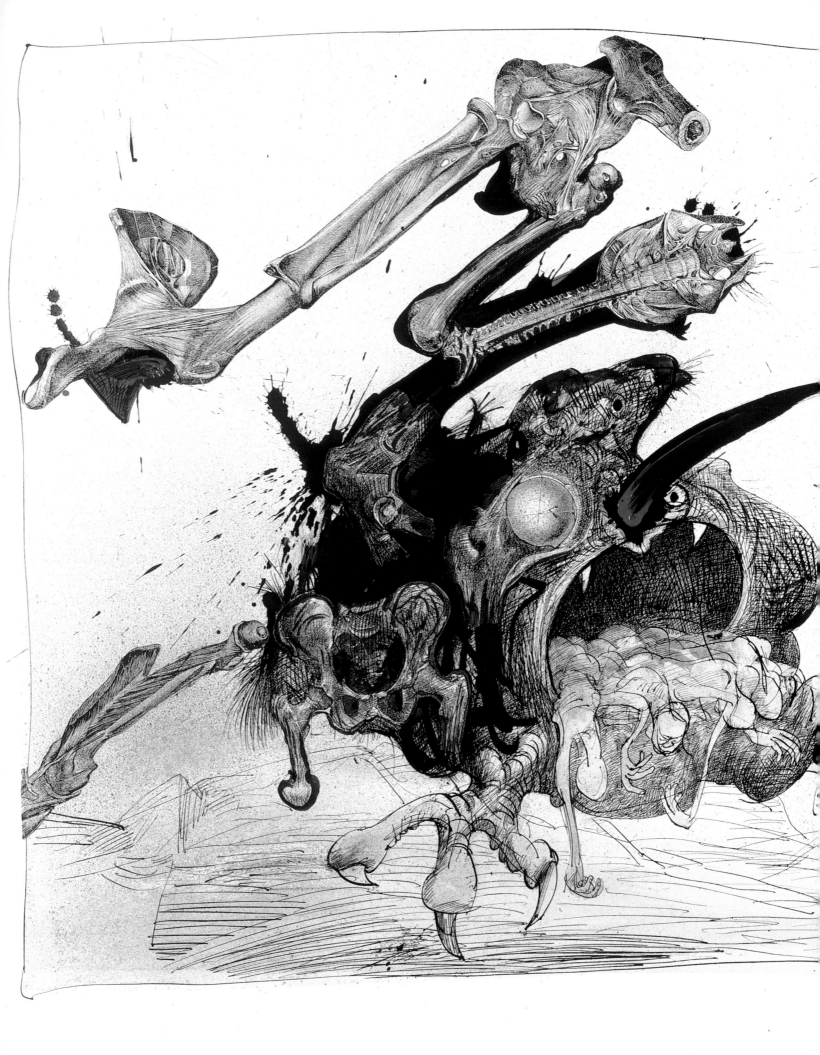

Code Word: Last Exit Election...

Since 1987 I have refused to draw politicians.
I feel that by lavishing hard-won skills upon their
image I merely augment their already inflated sense
of importance. If I play their game they love it.
But that was never my idea of political invective
and I turned away, leaving them to their latex
lookalikes which rendered their unspeakable antics
a cosy entertainment in every living room
throughout the land. I don't want buffoons to
wield such power in my ideal world. Their
authority is a mask of violence. They have
disrupted communities, created new ones in
limbo, caused unemployment by transforming
economics into a weapon against a human work-
force, discouraged and dismembered our welfare
systems and our culture and learned to lie with
eloquent ease. It is now respectable to cheat and
win; personal gain, at any cost, is progress and a
job for life is as desperate as a back-street abortion.

There's pornography in the madhouse, madness
in the food chain, stupidity at the heart of govern-
ment, intolerance on the streets and greed in our
water supply, and childhood is a dangerous option.

Left The beast who forgot what it was.
The British Tory Party in 1997.

Below The self-destructive violence that
is an integral part of all our psyches.

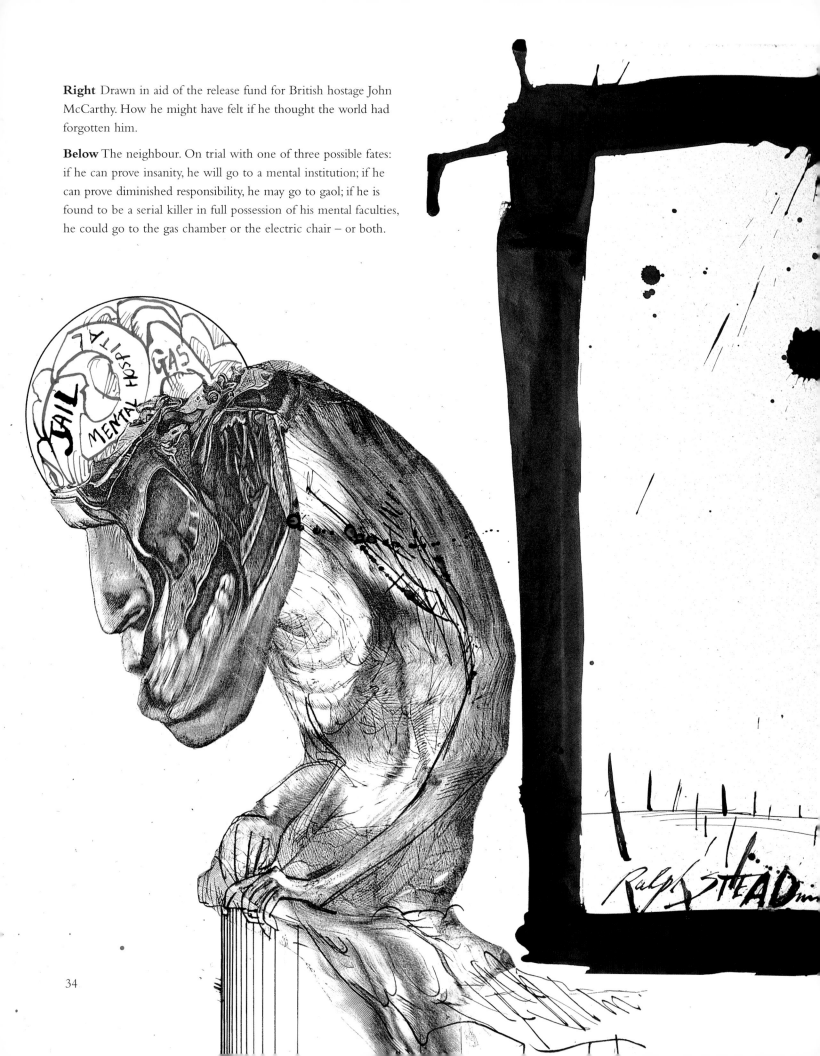

Right Drawn in aid of the release fund for British hostage John McCarthy. How he might have felt if he thought the world had forgotten him.

Below The neighbour. On trial with one of three possible fates: if he can prove insanity, he will go to a mental institution; if he can prove diminished responsibility, he may go to gaol; if he is found to be a serial killer in full possession of his mental faculties, he could go to the gas chamber or the electric chair – or both.

34

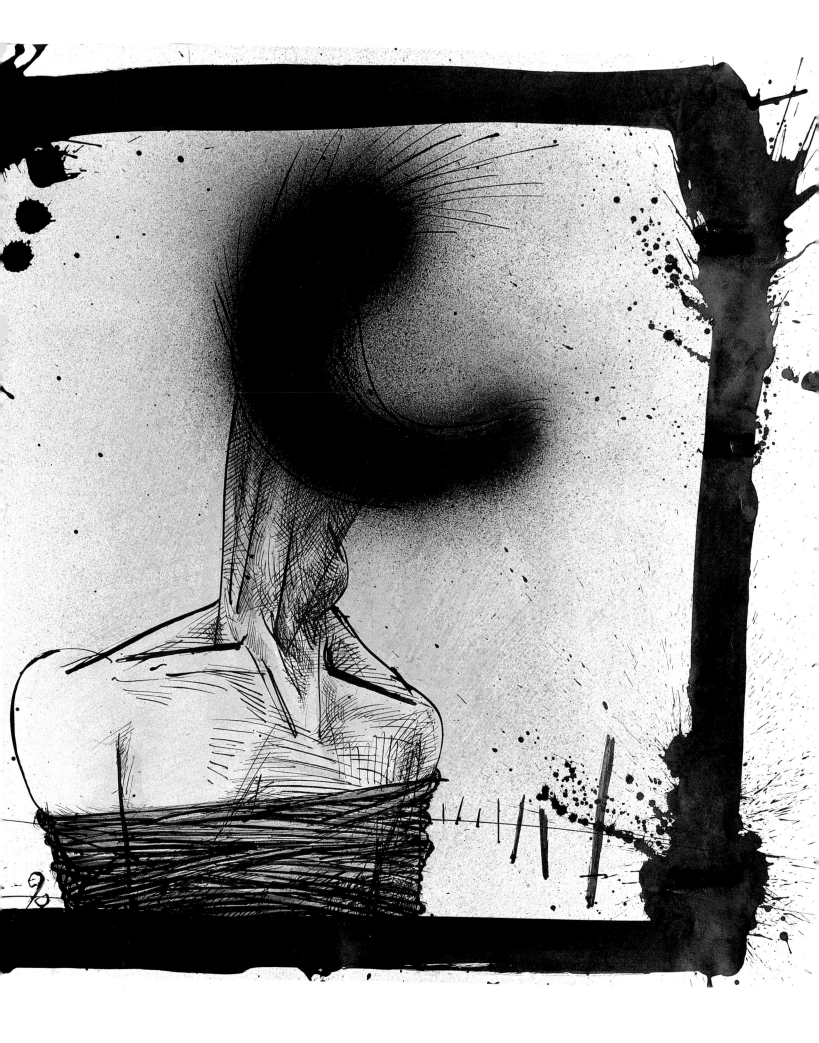

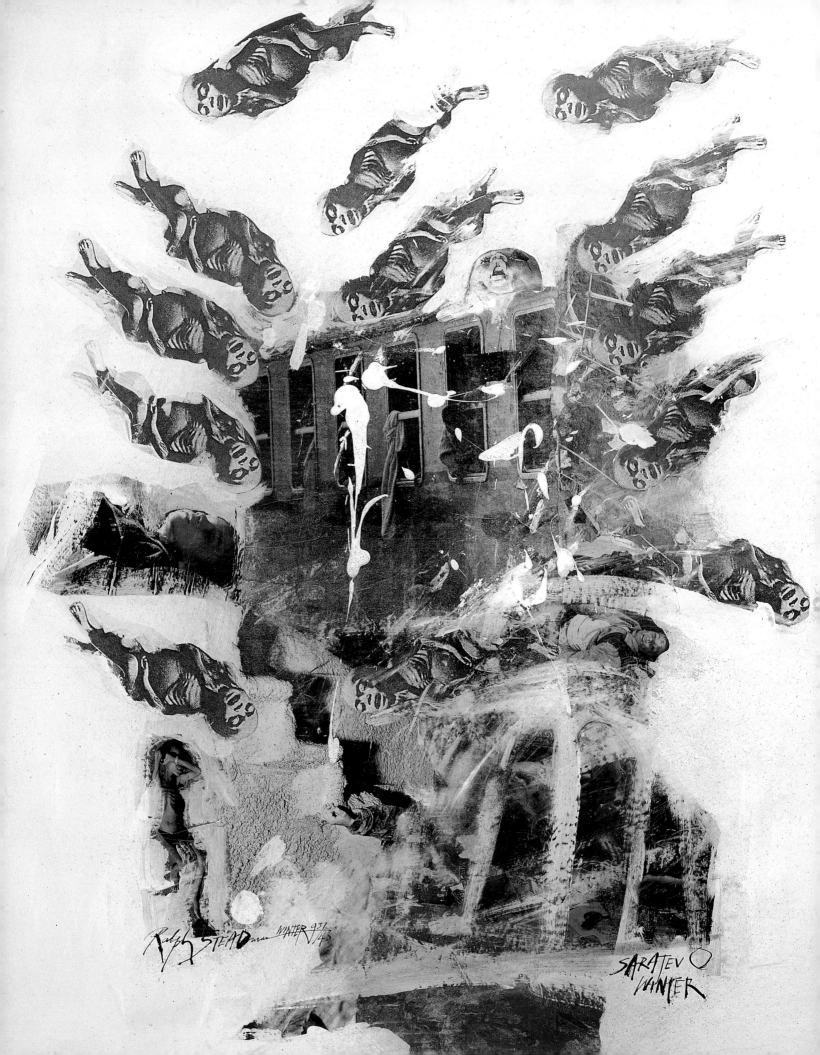

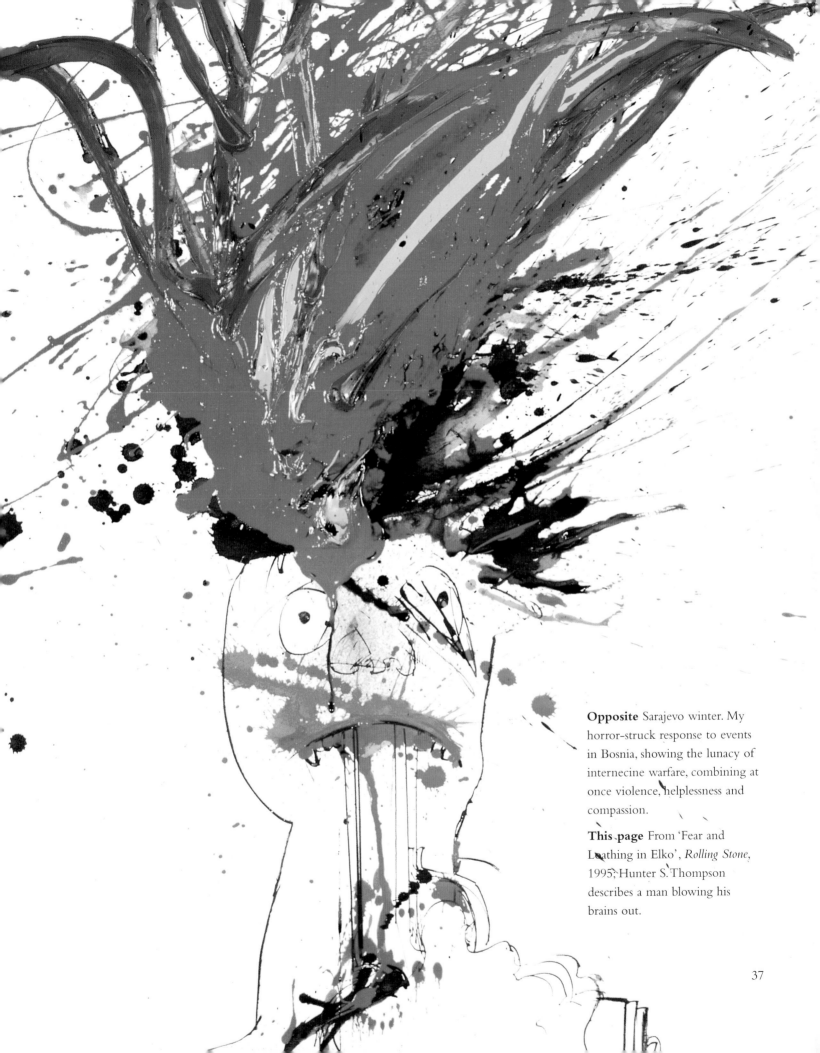

Opposite Sarajevo winter. My horror-struck response to events in Bosnia, showing the lunacy of internecine warfare, combining at once violence, helplessness and compassion.

This page From 'Fear and Loathing in Elko', *Rolling Stone*, 1995, Hunter S. Thompson describes a man blowing his brains out.

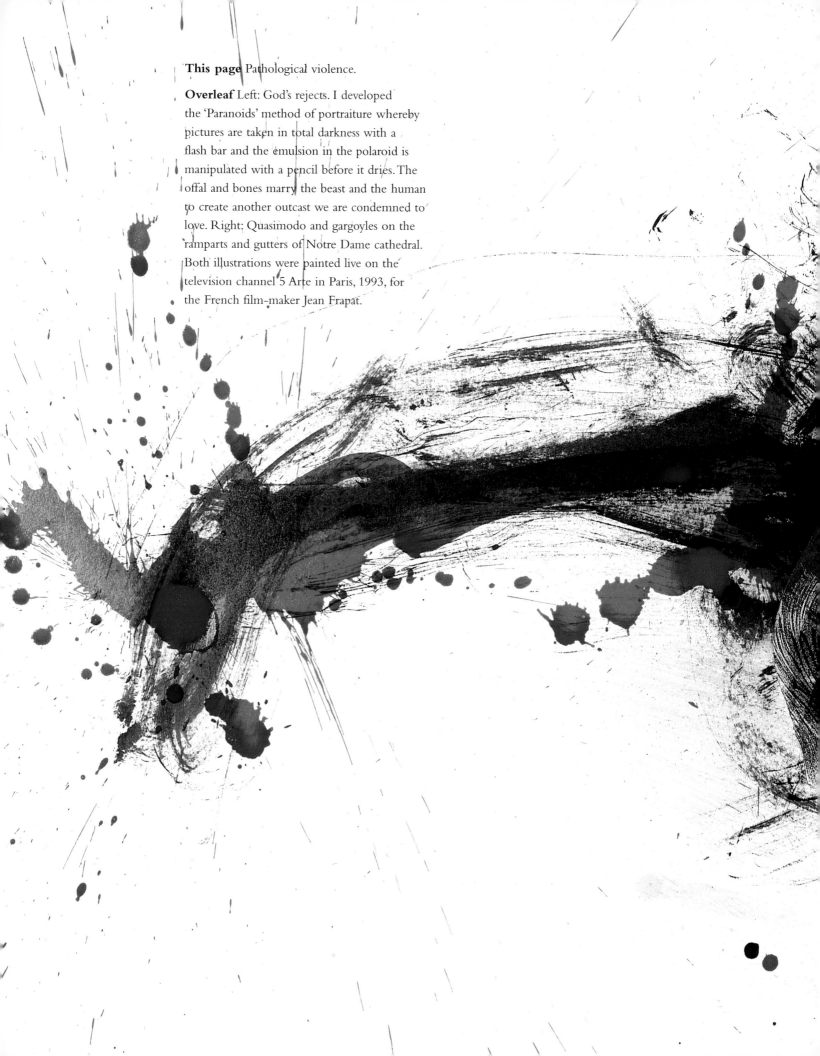

This page Pathological violence.

Overleaf Left: God's rejects. I developed
the 'Paranoids' method of portraiture whereby
pictures are taken in total darkness with a
flash bar and the emulsion in the polaroid is
manipulated with a pencil before it dries. The
offal and bones marry the beast and the human
to create another outcast we are condemned to
love. Right: Quasimodo and gargoyles on the
ramparts and gutters of Notre Dame cathedral.
Both illustrations were painted live on the
television channel 5 Arte in Paris, 1993, for
the French film-maker Jean Frapat.

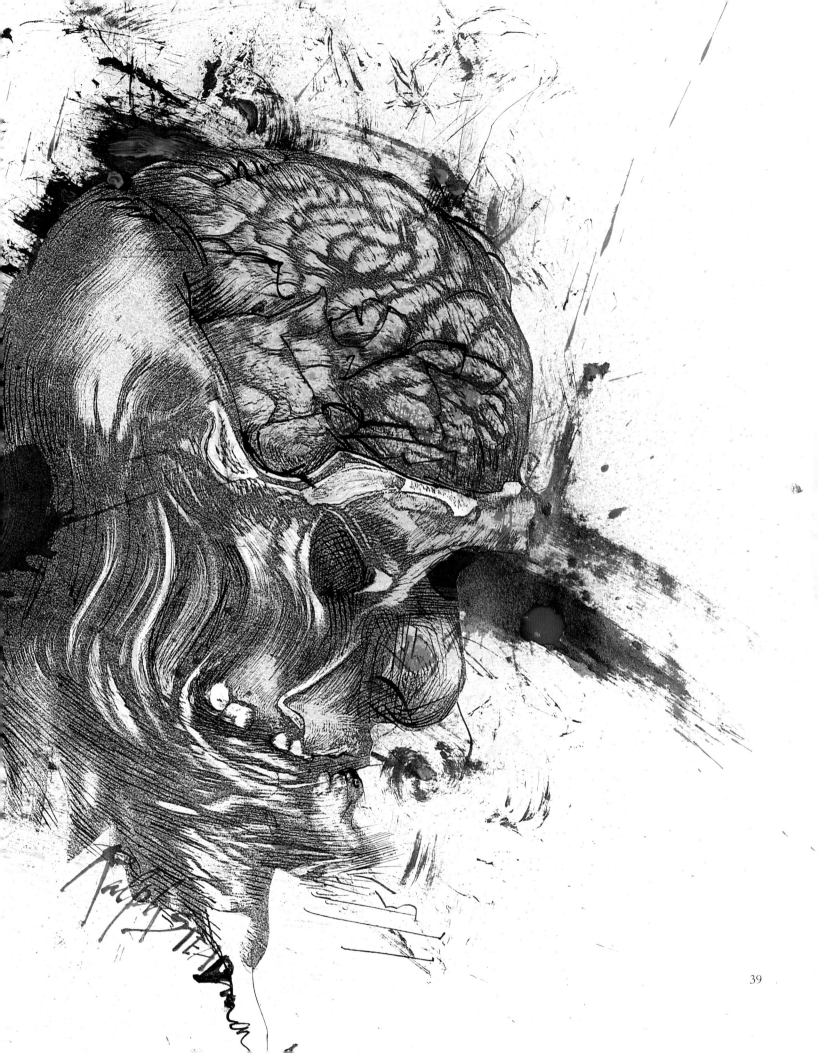

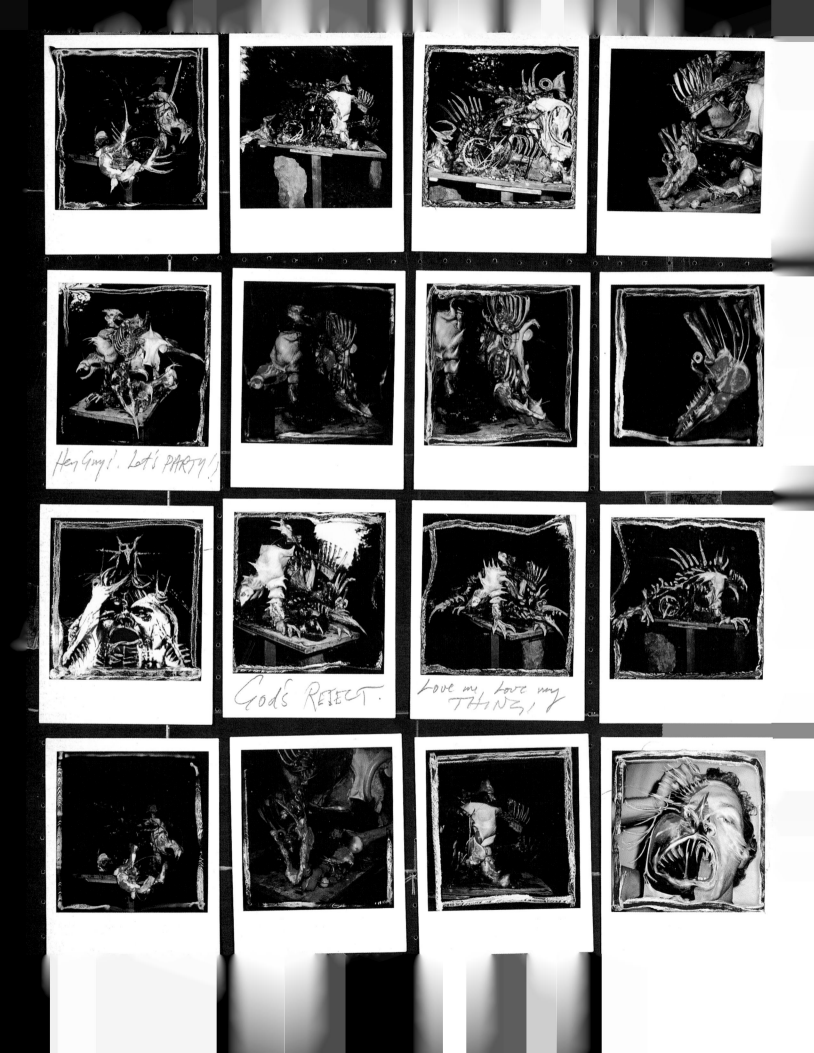

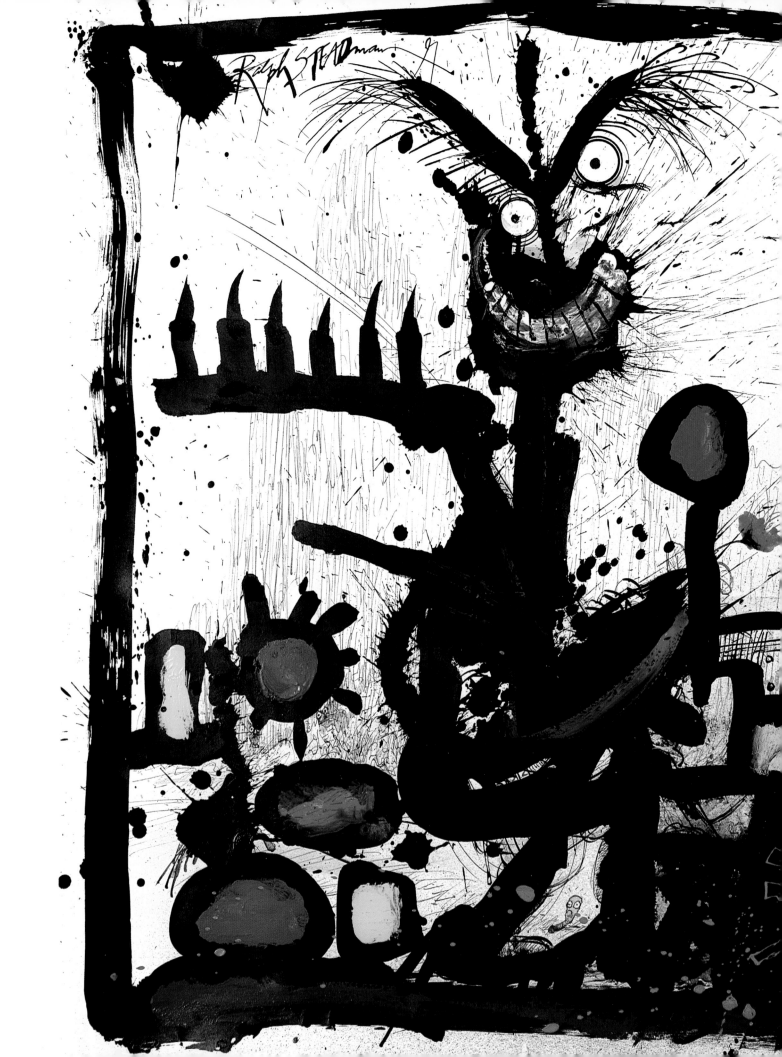

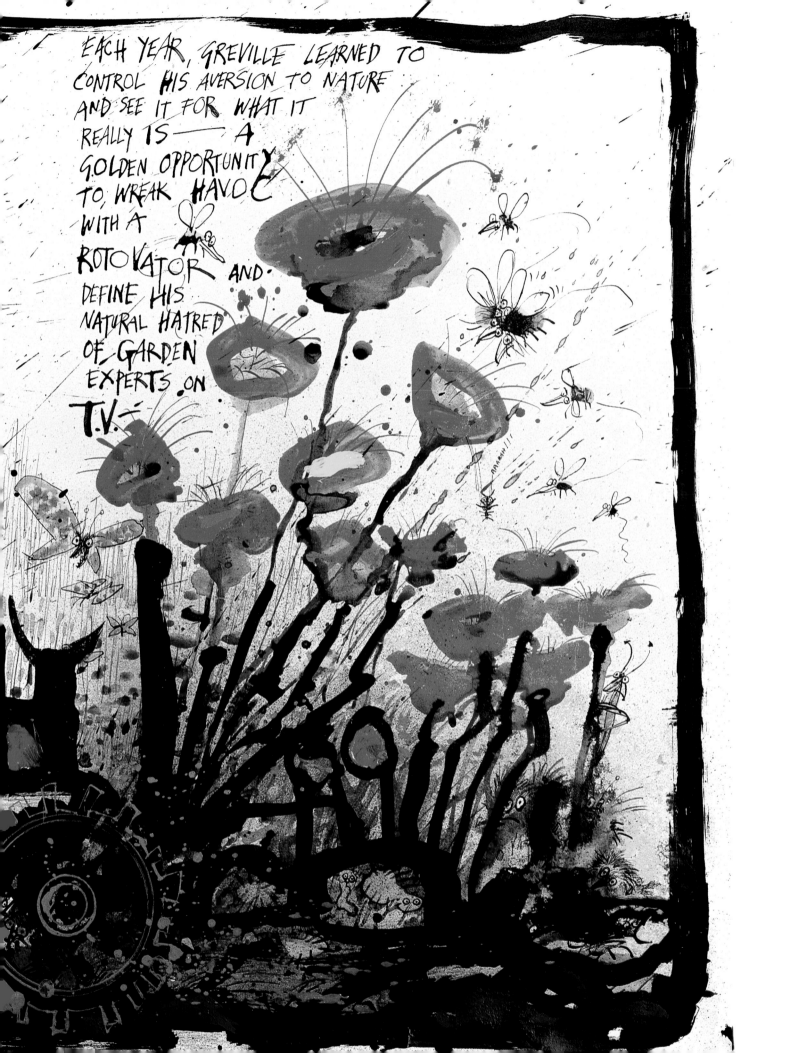

EACH YEAR, GREVILLE LEARNED TO CONTROL HIS AVERSION TO NATURE AND SEE IT FOR WHAT IT REALLY IS —— A GOLDEN OPPORTUNITY TO WREAK HAVOC WITH A ROTOVATOR AND DEFINE HIS NATURAL HATRED OF GARDEN EXPERTS ON T.V.

Previous pages The demonic. Another aspect of Gonzo – horror with a twinkle in its eye. It is impossible to sustain such a perpetual state of intensity without going mad.

Below Man's best friend. Cute, adorable and smelling of roses.

Opposite Politician's Legs No. 8. For ten years I have refused to draw politicians. Drawing their legs is more insulting.

Overleaf Pigs – the perfect foil to man. Endearing, yet personifying the ugly and verminous. Top left: The true nature of Napoleon, from *Animal Farm,* manifests itself in the group appearance of the dogs. Bottom left: Sleaze frenzy. The strength of this seriously perplexed pig lies in the fact it shows no bitterness. Top right: Pompous Vinous Pig. Bottom right: Bosnian General Karic.

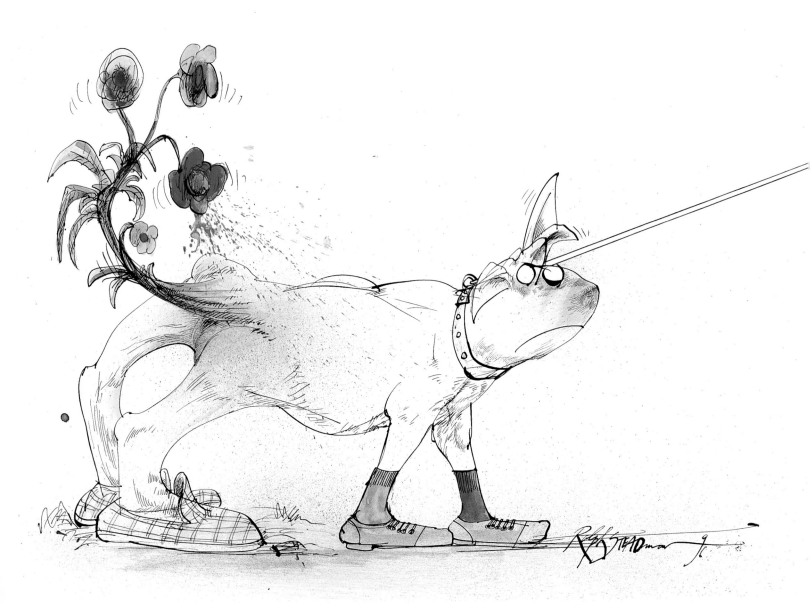

Old Chinese Proverb:
He who shits on his own
doorstep is destined to
step in it.

POLITICIANS LEGS No. 8
SICK AS A DOGFEREL

Ralph STEADman 97

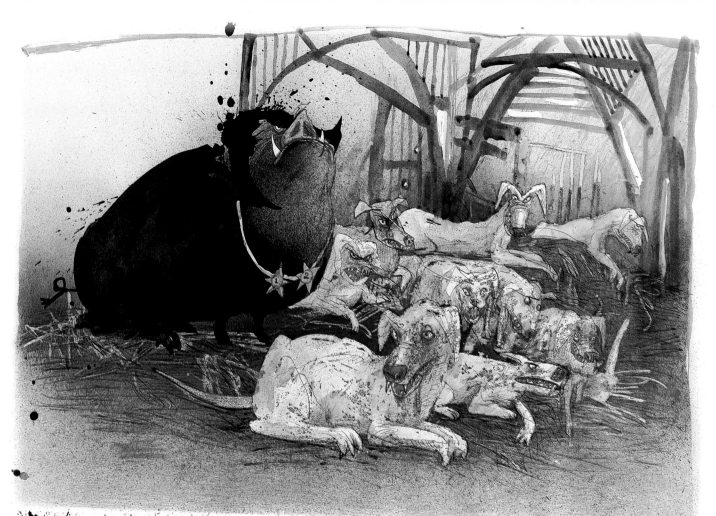

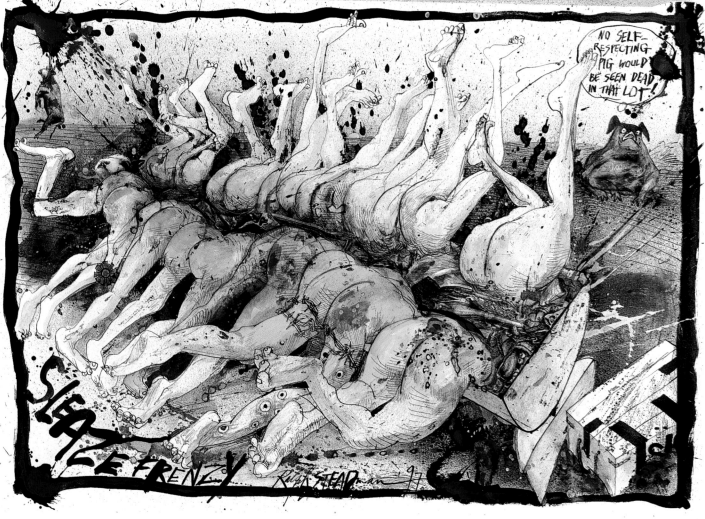

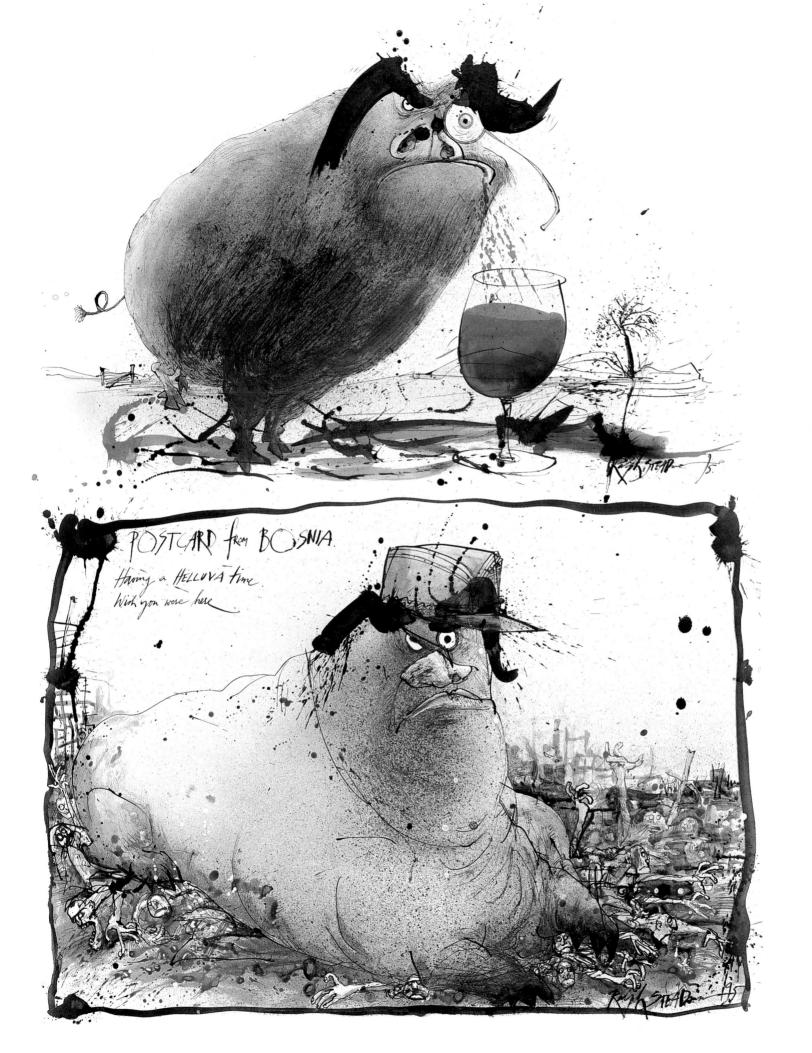

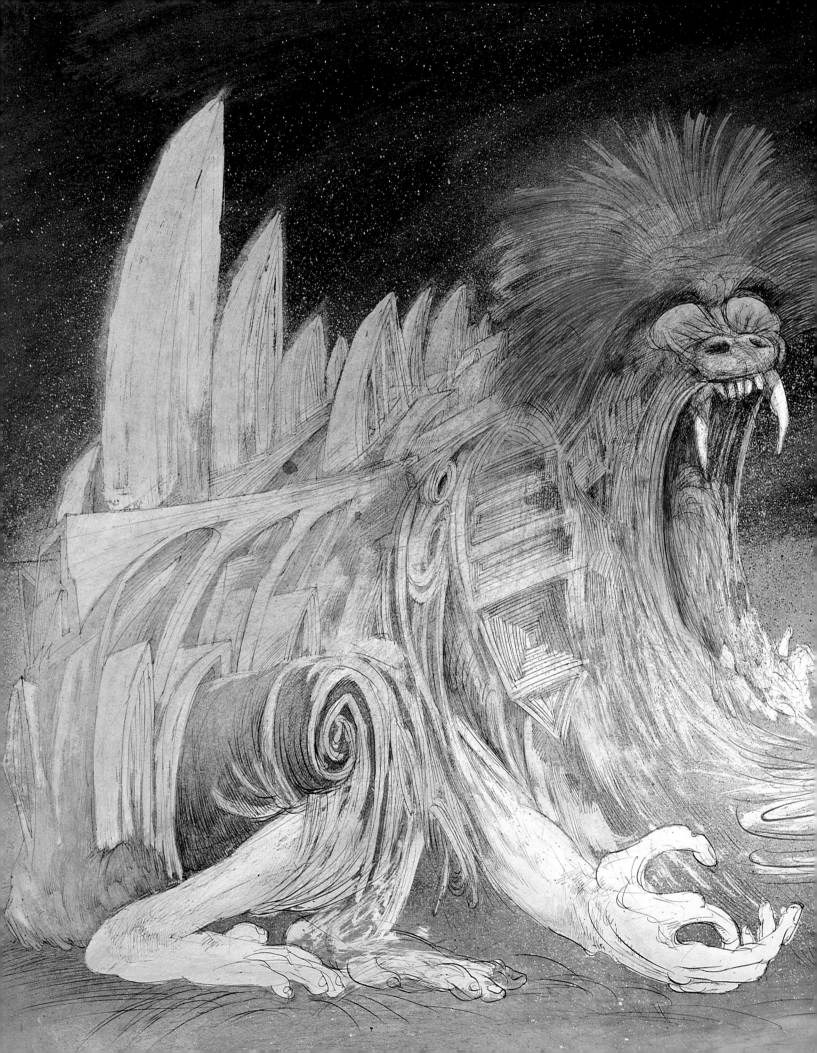

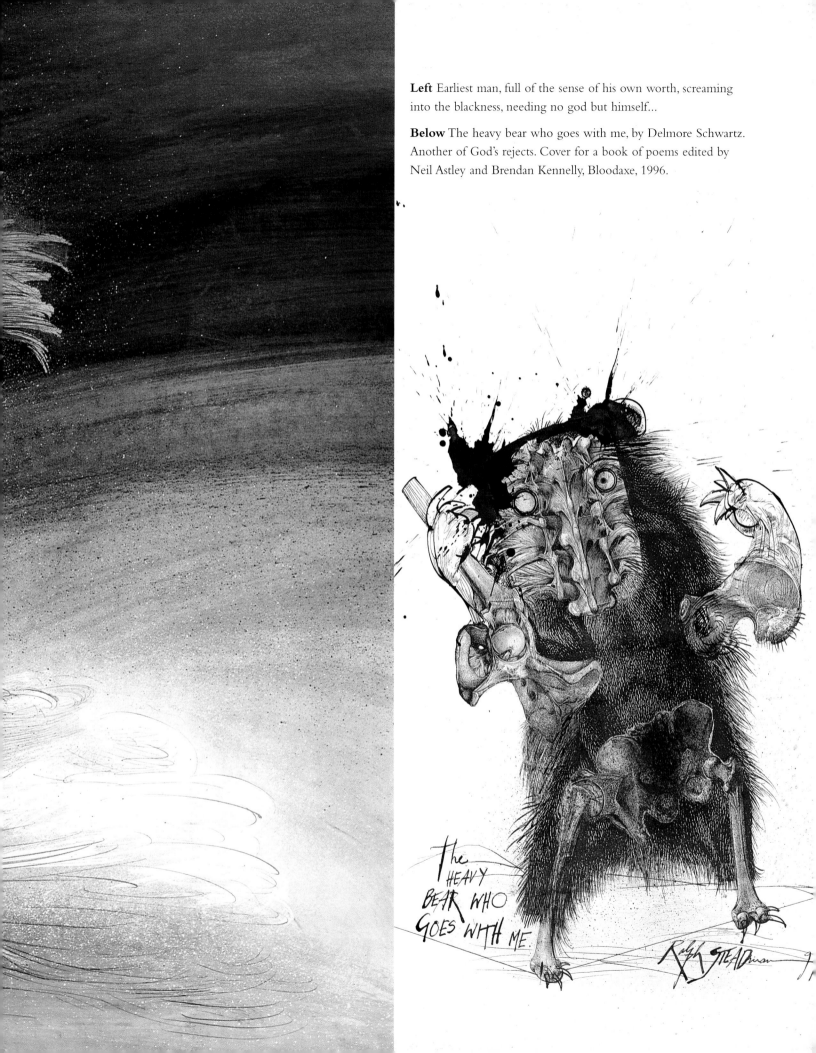

Left Earliest man, full of the sense of his own worth, screaming into the blackness, needing no god but himself...

Below The heavy bear who goes with me, by Delmore Schwartz. Another of God's rejects. Cover for a book of poems edited by Neil Astley and Brendan Kennelly, Bloodaxe, 1996.

The
HEAVY
BEAR WHO
GOES WITH ME.

This page Cover drawing from *Heart on the Left*, collected by Adrian Mitchell.

Opposite Save the Rhino.

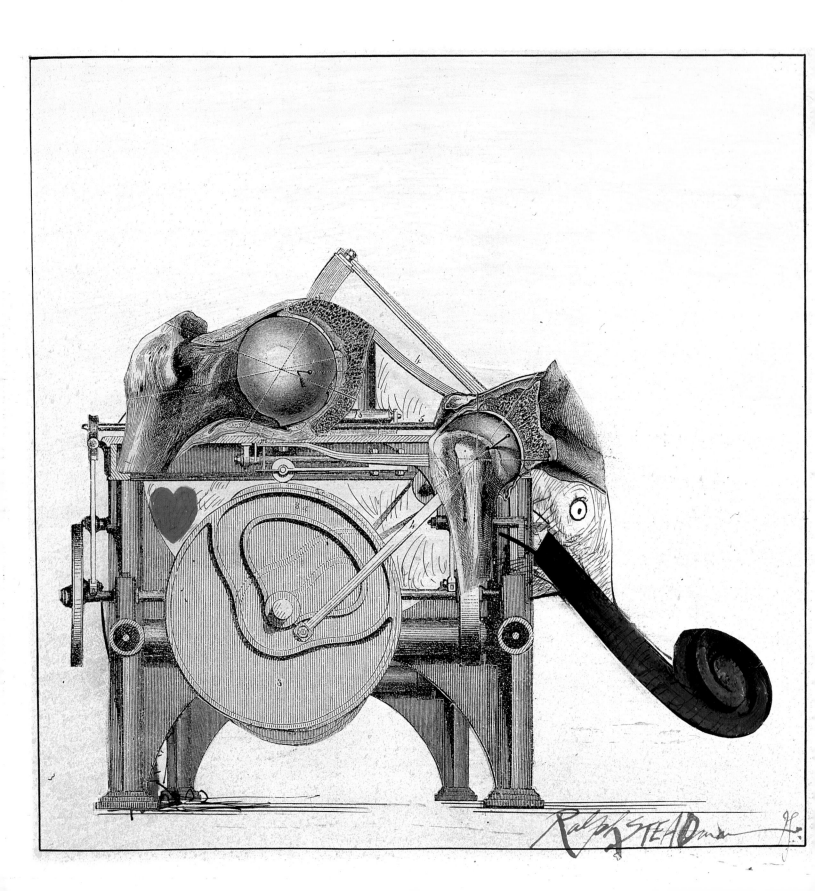

Overleaf Belinda, the four-eyed horse goddess. Hunter fell in love with Belinda, who comes from the Polo sequence of drawings (1994) for his book *Polo is my Life*. Hunter was drawn to her lasciviousness. I wanted to see if a four-eyed horse would work, and it did. Hunter observed, 'Ralph, you have risen with majesty.' The book is yet to be completed.

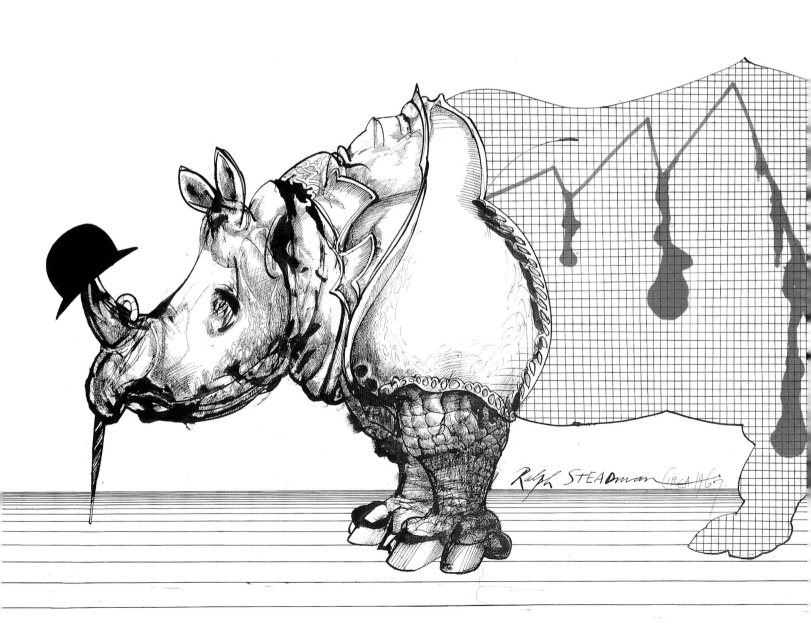

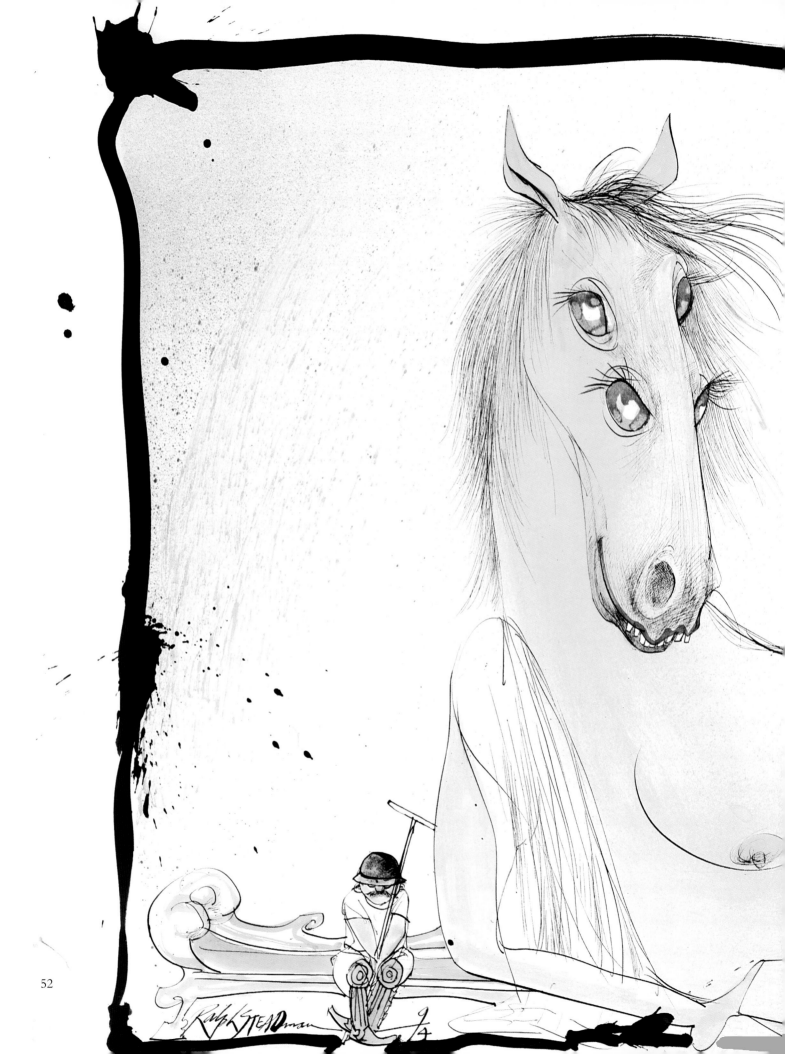

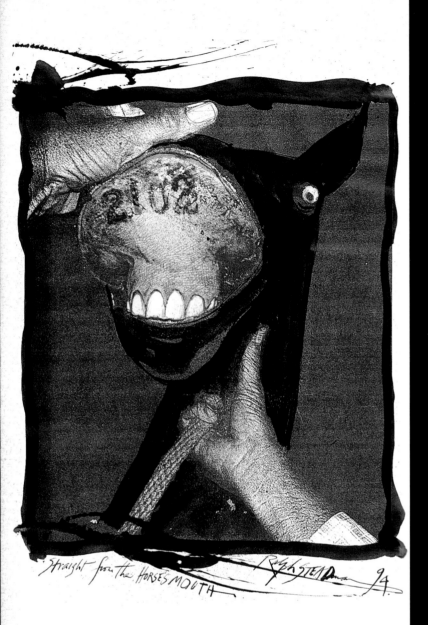

Straight from the HORSE'S MOUTH

Above Looking a real horse in the mouth.

Right Goat-hurling by moonlight. A myth from the deserted ghost town of Ofcina Puelma in northern Chile. By the light of a crescent moon figures wearing cat masks throw goats from the top of the highest building. The ritual throwing of the goat symbolizes the futility of life; the cat mask represents the self-defence mechanism we employ to hide from the awful truth of it all.

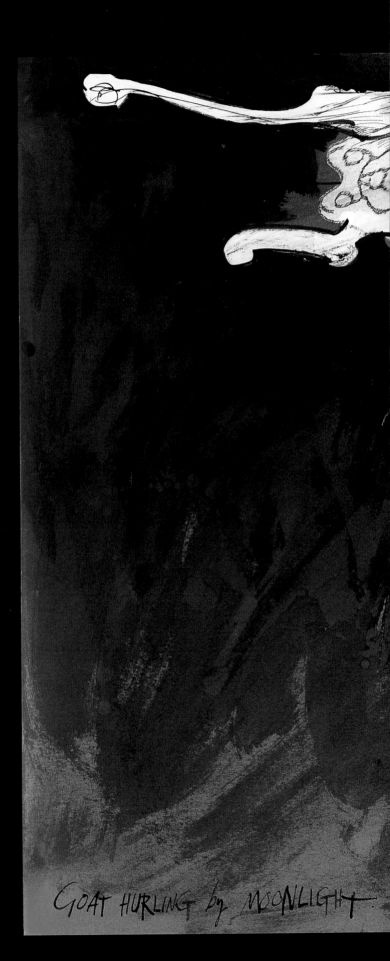

GOAT HURLING by MOONLIGHT

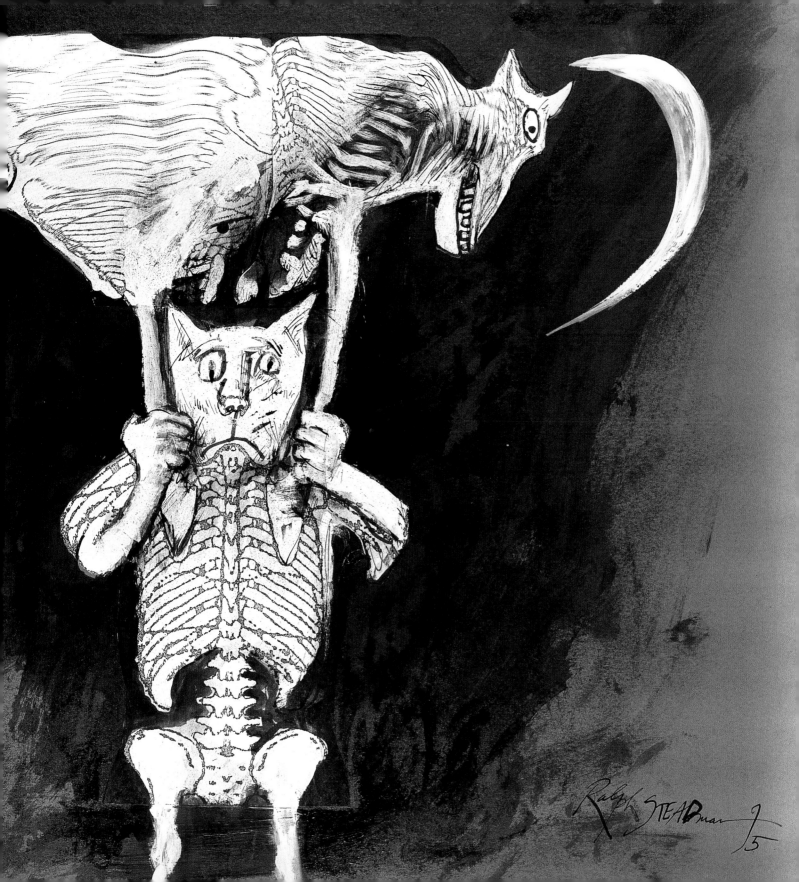

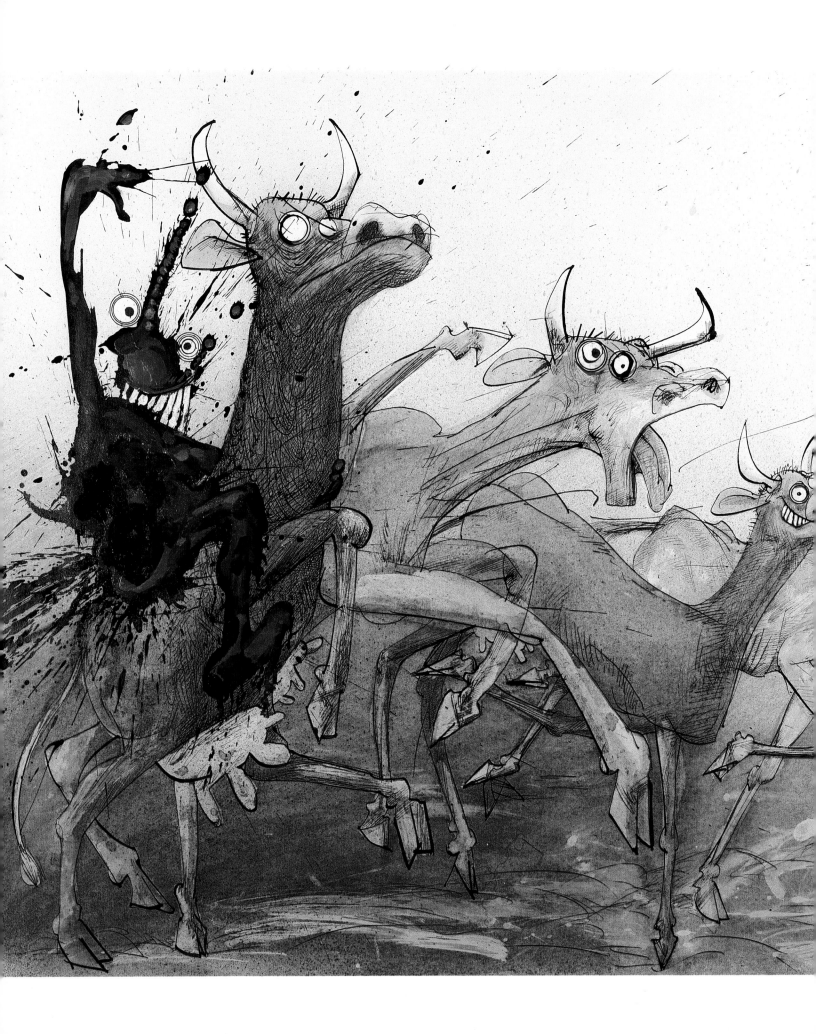

Left Official bullshit rides out on the backs of the four mad cows of the Apocalypse. BSE is an apocalyptic reality. The sins of the fathers are finally being visited upon the children.

Below Gut reaction. Portrayal of a haggis.

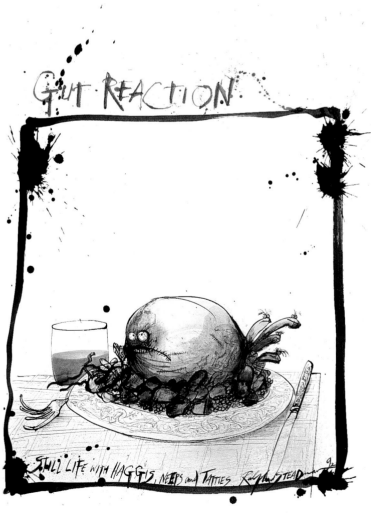

GUT REACTION

STILL LIFE WITH HAGGIS, NEEPS and TATTIES Ralph STEADman

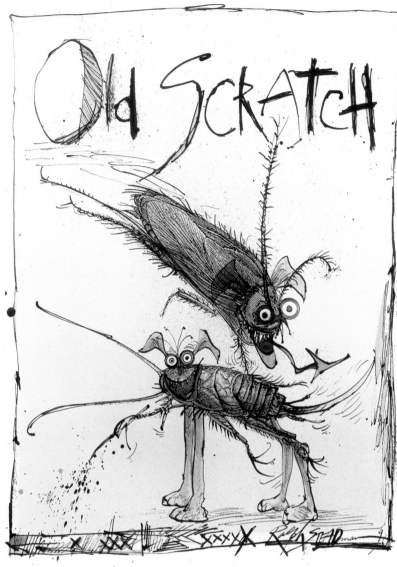

Old Scratch

Above Old Scratch, a beer label. These dogs started life as cockroaches. I misunderstood the brief.

Left The perversity of this title lies in the hideousness of the creature, which is at the same time rather endearing.

Overleaf Left: Poster for The Grub Street Opera, 1995 – an opportunity for a bit of Jacobean sleaze. Right: Ubu. This play by Alfred Jarry, a Dada artist before his time, was performed in Paris in 1896. Its power to shock is still evident. The play portrays the lives of an ugly royal family. It was not performed in Britain for many years.

THE GRUB STREET OPERA

by Henry FIELDING

Ralph Steadman

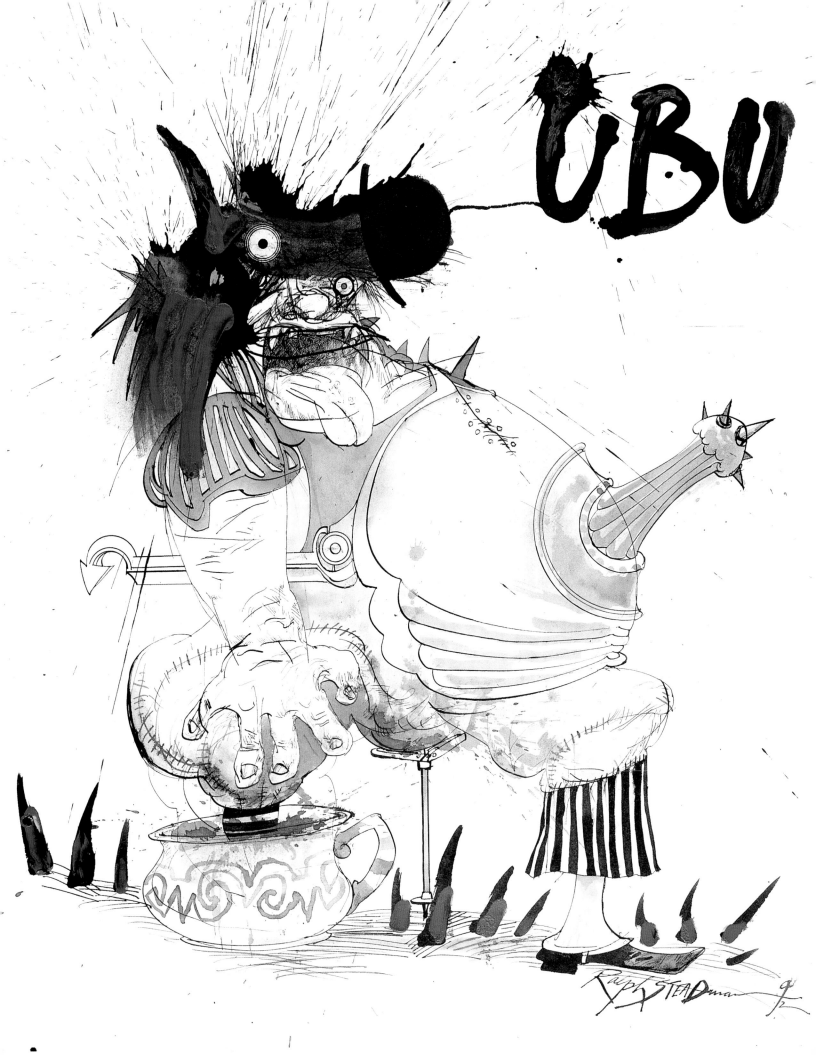

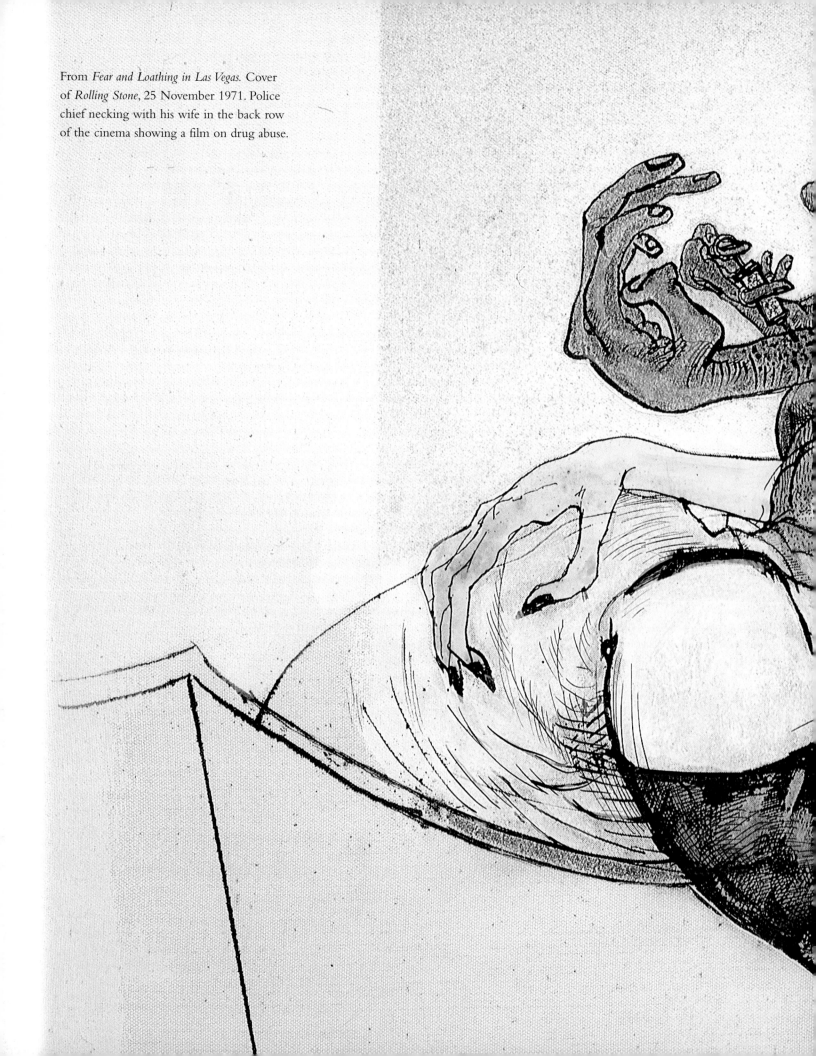

From *Fear and Loathing in Las Vegas.* Cover of *Rolling Stone*, 25 November 1971. Police chief necking with his wife in the back row of the cinema showing a film on drug abuse.

This brings together characters I have drawn
in my work from the sixties onwards, osten-
sibly for a party which turns into an ugly
feeding frenzy.

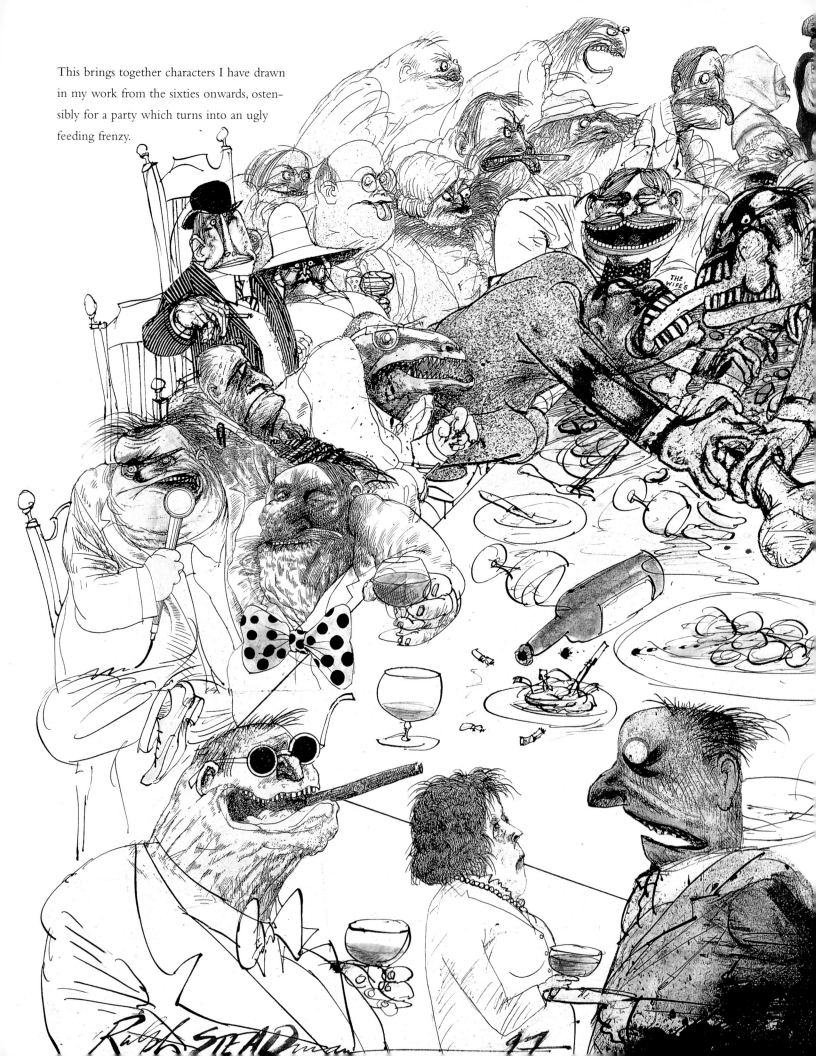

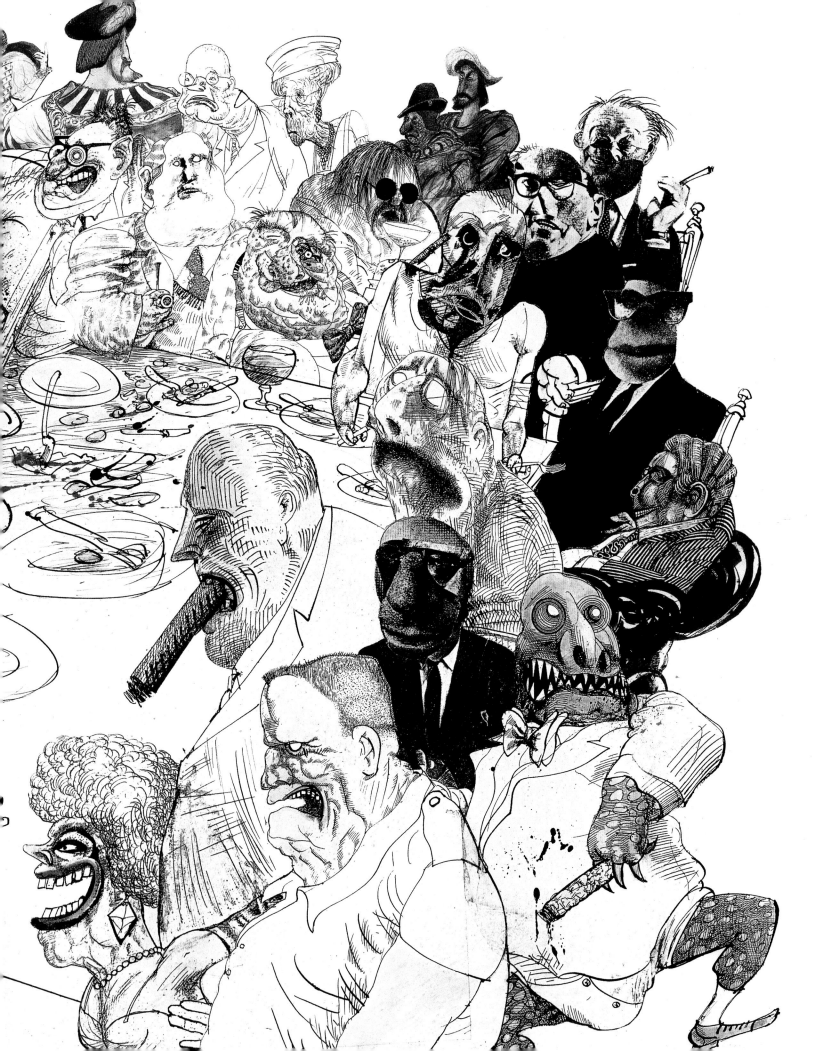

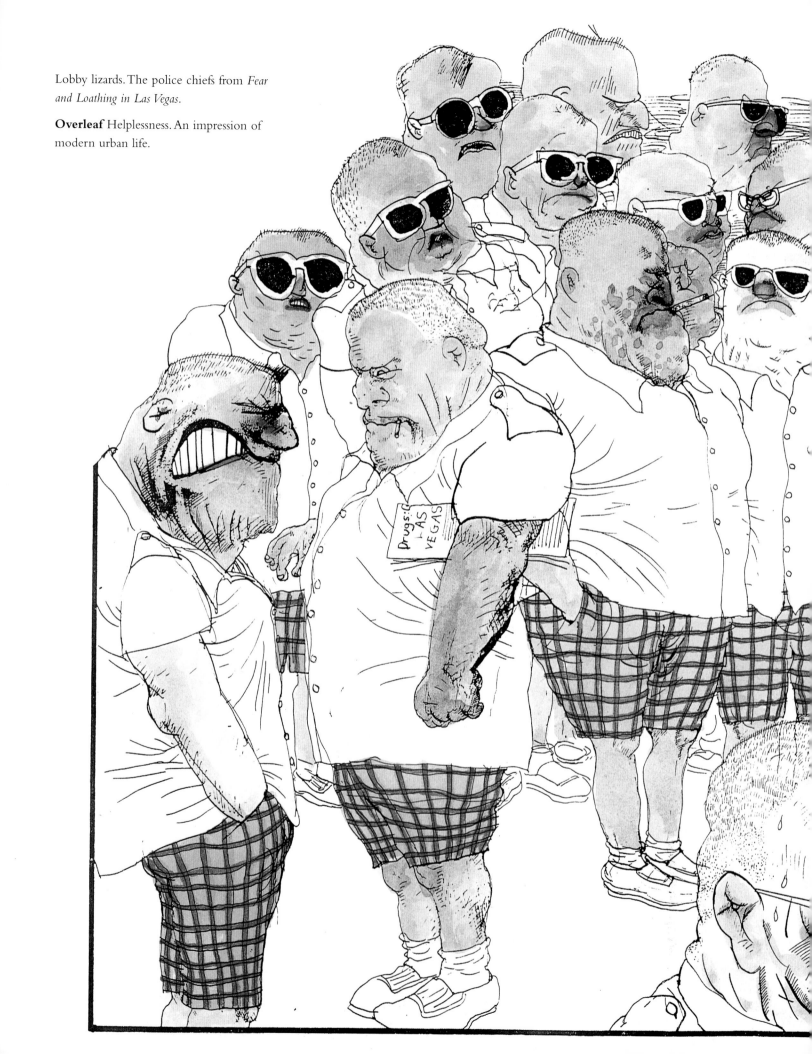

Lobby lizards. The police chiefs from *Fear and Loathing in Las Vegas*.

Overleaf Helplessness. An impression of modern urban life.

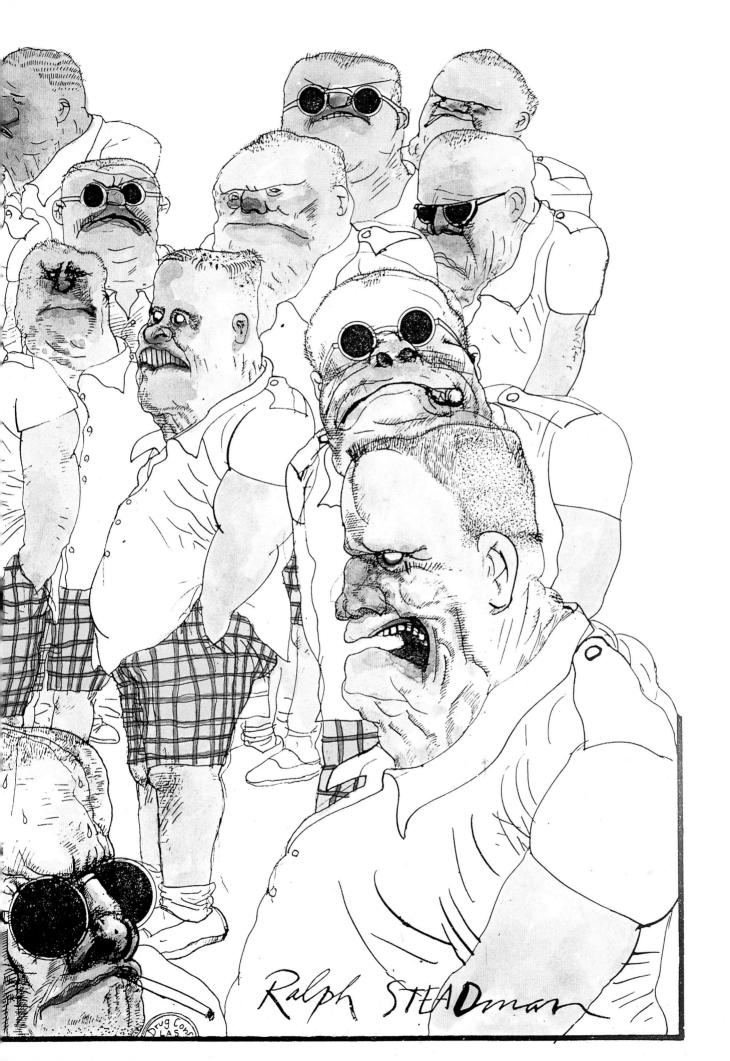

Ralph STEADman

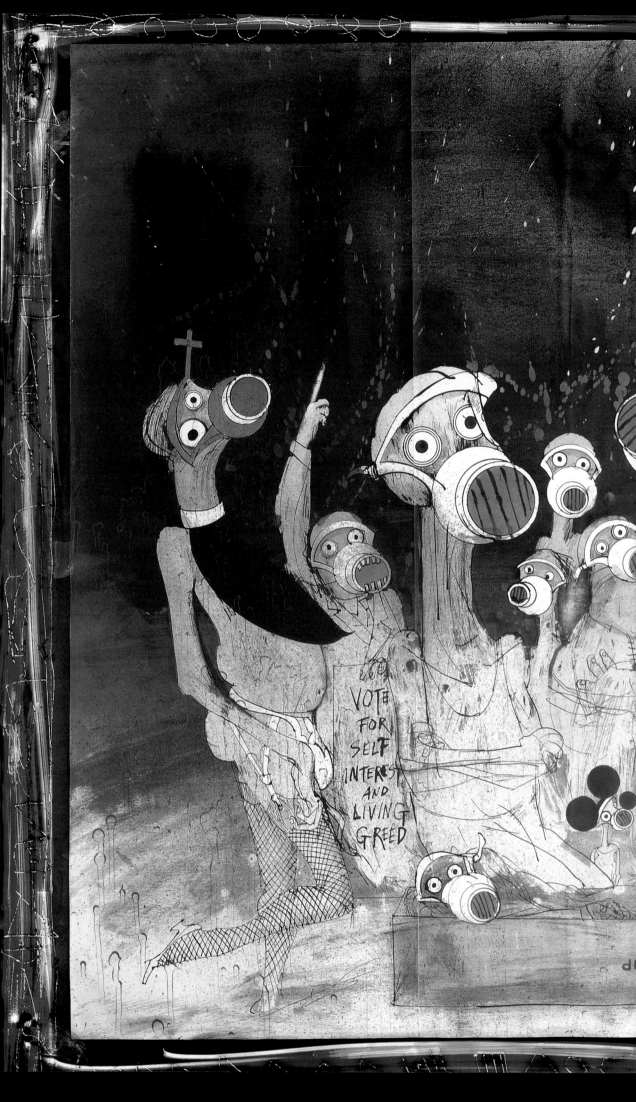

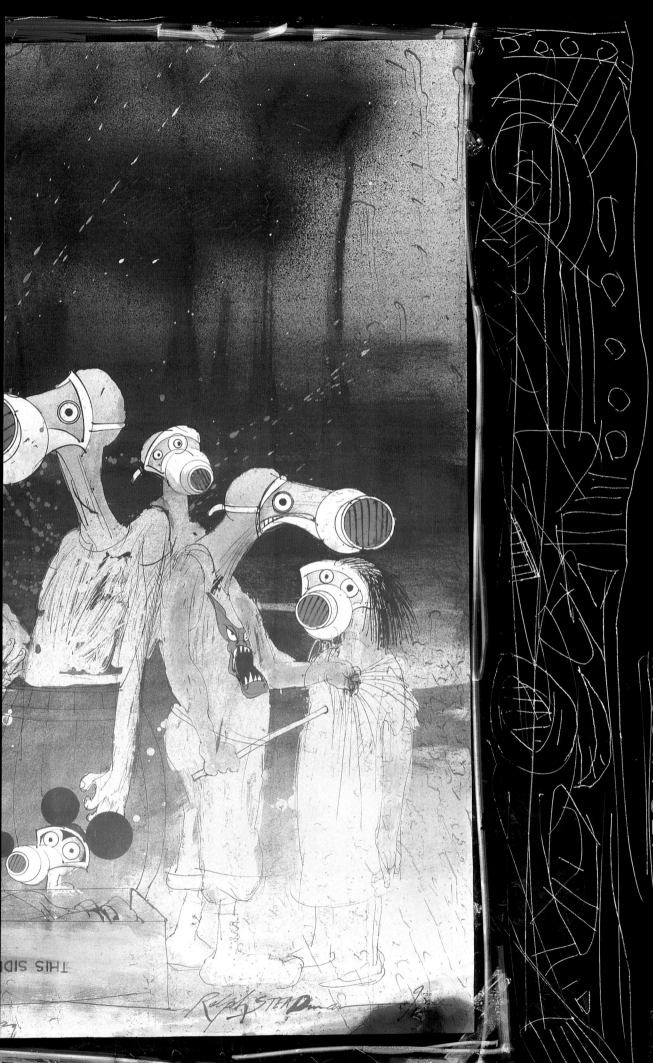

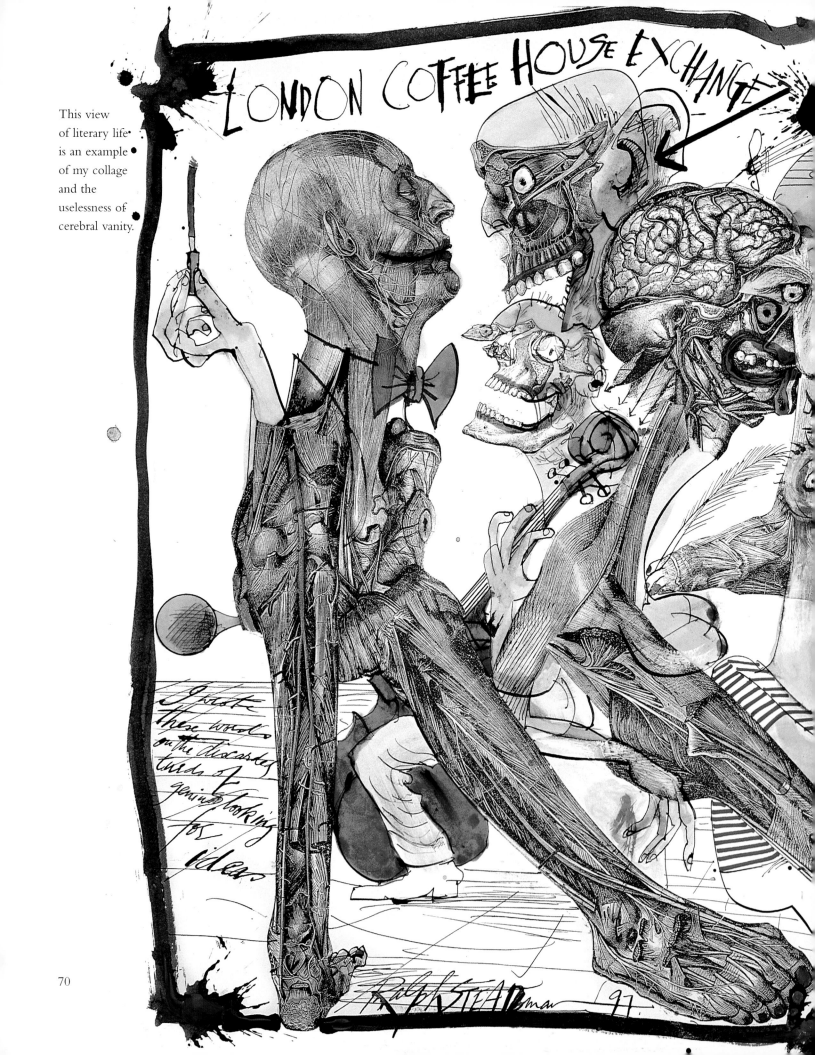

London Coffee House Exchange

This view of literary life is an example of my collage and the uselessness of cerebral vanity.

70

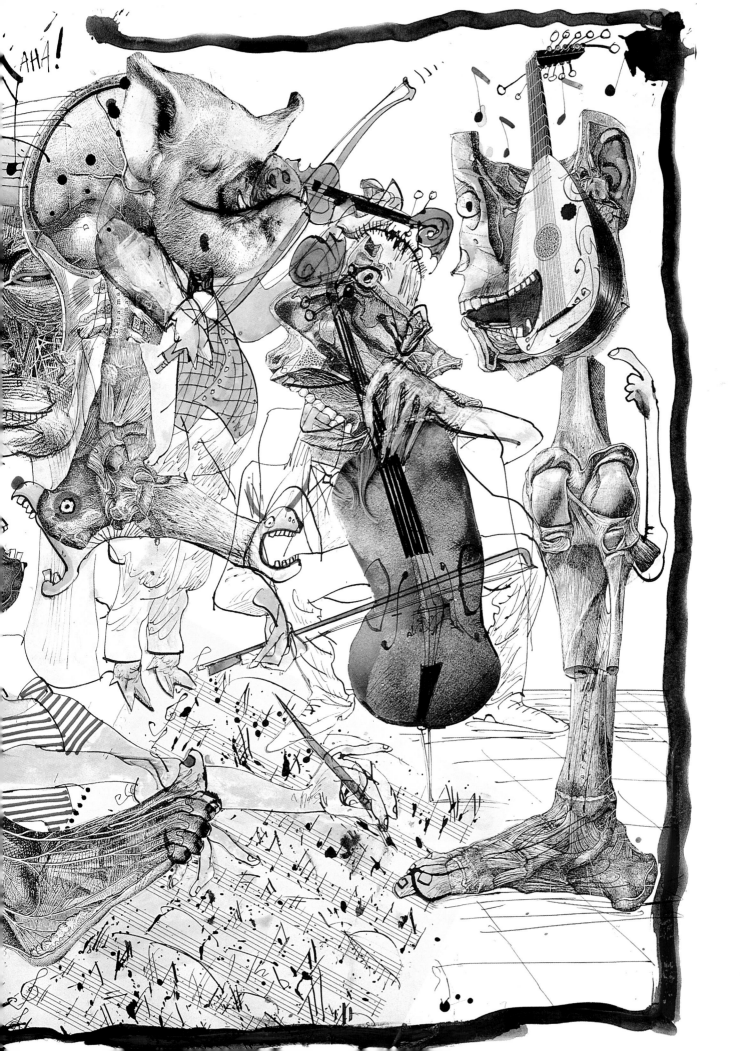

71

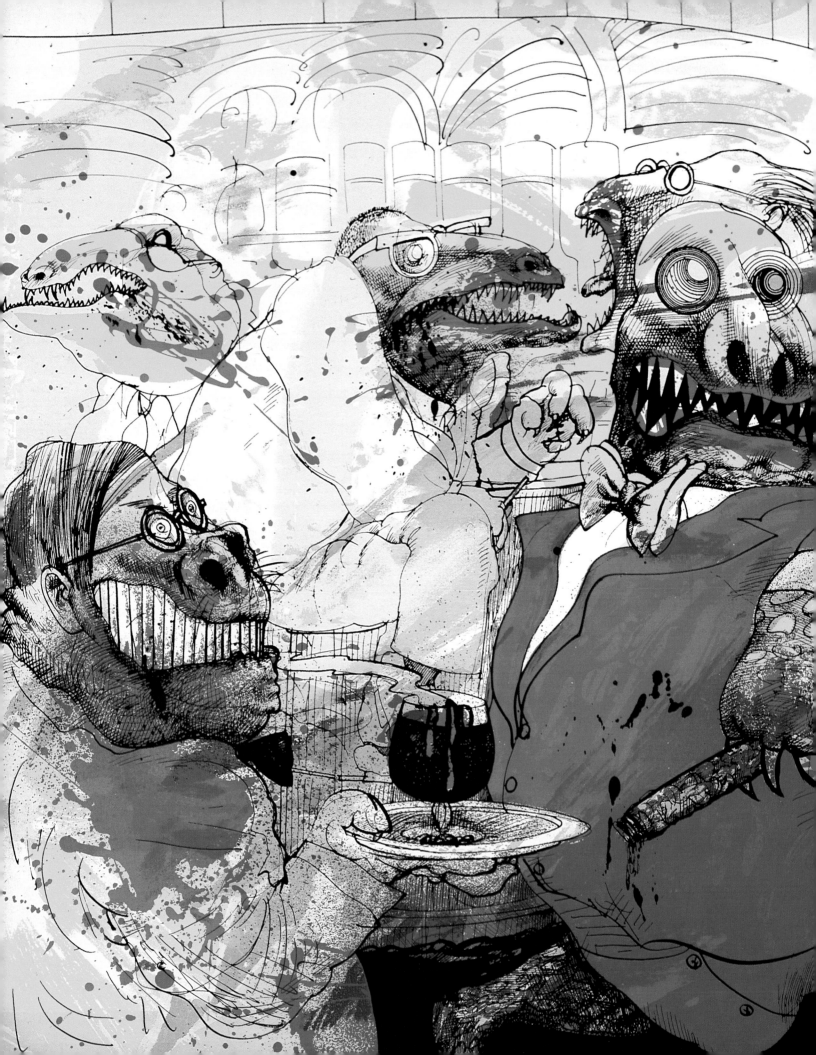

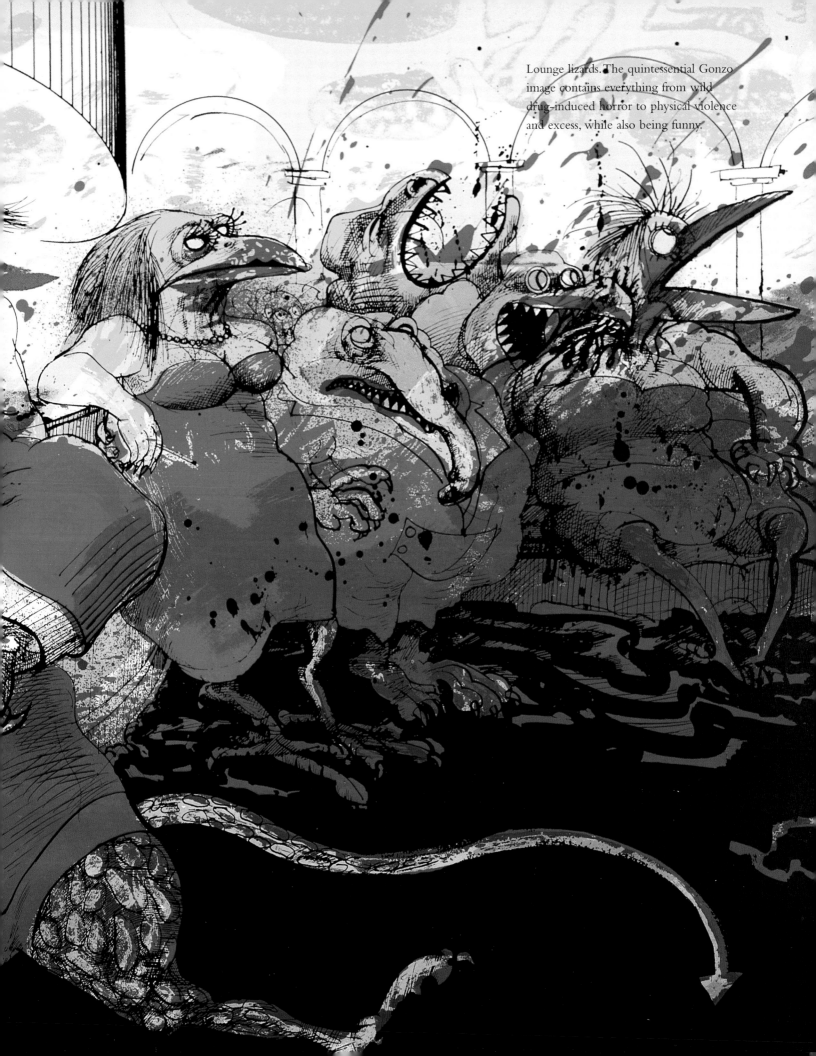

Lounge lizards. The quintessential Gonzo image contains everything from wild drug-induced horror to physical violence and excess, while also being funny.

LAS BOGUS

It was *Scanlan's* who found me in Long Island when I had arrived from England in April 1970 to seek my particular vein of gold in the land of the screaming lifestyle.

I was about to head for New York anyway, to look for work, when I got a call from the Art Director at *Scanlan's*, J.C. Suares, asking whether I would like to fly to Kentucky and work with an ex-Hell's Angel called Dr Hunter S. Thompson. Undaunted by the credentials and in my innocence, for I am an exceedingly trusting man, I readily agreed to go, packed my bags and said goodbye to my good friends Dan and Pam Rattiner, proprietors of Dan's Papers in the Long Island Hamptons, which had been my home for a week. I arrived in New York at the 42nd Street offices of *Scanlan's Monthly*, conveniently placed above a cosy bar serving Irish Guinness and flanked on either side by dark doorways harbouring drunks.

J.C. Suares greeted me with some caution as I remember, treating me like a hired hit man with a certain reputation which had arrived ahead of me.

It was only some time later that I learned that I had not been the first, get-Steadman-at-any-cost kind of choice. Hunter had suggested Pat Oliphant of the *Denver Post*, whom he'd got to know locally, when he first thought of the Kentucky Derby piece. Oliphant, as it happened, was off to London to attend a cartoonists' convention and had declined the invitation to be Hunter's sidekick. I have to thank him for that since he probably saved my first trip to America from being a total washout.

I was introduced to the editor, Donald Goddard, a kindly, shrewd man and an ex-foreign editor for the *New York Times*. Goddard had picked up a book of collected cartoons of mine in England, called *Still Life with Raspberry*, the very week I left for America. Natalie, his wife and a representative of Revlon, later gave me her whole sample kit of lipstick and make-up to replace my own colours left in the back of a cab.

Finding Hunter – or indeed anyone covering the prestigious Kentucky Derby who is not a bona fide registered journalist – is no easy matter, and trying to explain my reasons for being there was even more difficult, especially as I was under the impression that this was an official trip and I was an accredited press man. Why shouldn't I think that? I assumed *Scanlan's* was an established magazine. As it turned out, *Scanlan's* had just about got me a cheap hotel room at a jerry-built complex, called Browns.

I had been watching someone chalk racing results on a blackboard while I finished my beer and was about to turn and get another when a voice like no other I had ever heard before cut into my thoughts and sank its teeth into my brain. It was a cross between a slurred karate chop and gritty molasses.

'Er – um, 'scuse me, er – you – er – you wouldn't be from England, would you! Er – an artist – maybe – er – what the –!'

I turned around and two eyes firmly socketed inside a bullet head were staring at the funny beard I was wearing on the end of my chin.

'Er sorry – I – er –' the mouth hardly moved being firmly wedged between two pieces of solid jawbone. 'I – er – thought you might be – er!'

'I am from England,' I replied. 'My name's Ralph Steadman – you must be Hunter Thompson.'

'That's right. Where you been? I was beginning to worry. I thought you may've been picked up or something.' 'Picked up?!' I didn't quite understand.

'Yes – er, police here are pretty keen. They tend to take an interest in something different. The beard – er – not many of them around these parts. Er – why don't we grab a beer and maybe talk things over.'

I was beginning to take in the whole of the man's appearance, and his was a little different too. Certainly not what I was expecting, anyway. No time-worn leather shining with old sump oil. No manic tattoo across a bare upper arm and certainly no hint of menace. No. This man had an impressive head cut from one piece of bone and the top part was covered down to his eyes by his white floppy-brimmed sun hat. His top half was draped in a hunting jacket of multi-coloured patchwork. He wore seersucker blue pants and the whole torso was pivoted on a pair of huge white plimsolls with fine red trim around the bulkheads. Damn near six foot six inches of solid bone and meat holding a beaten-up leather bag in one hand and a cigarette between the arthritic fingers of the other. His eyes gave away nothing of what he thought he was looking at in me – a matted haired geek with string warts, I found out later.

I had so far made no sketches, or notes, being far too intimidated to do either. But my head was buzzing with strange impressions.

Hunter had hired a bright red whale of a car and had stored two buckets of beer on ice behind the front seats. We stopped off at a liquor store and bought a bottle of Wild Turkey bourbon – a drink I was not familiar with up to that point. It tasted good and went down even better, though compared to a good malt whisky it's still a clumsy way to get drunk.

I was beginning to settle in.

'Maybe we'll just get ourselves organized and we could meet my brother Davison in Louisville – he's expecting us.'

'OK by me,' I said. I was busy watching him drive the car. From the very first drive I could tell he could handle a car with considerable skill. He is the sort of driver who could never be a passenger. One hand held the wheel, the other held the cigarette holder and a beer can. Between his legs, resting on the seat, he kept a tall glass full of ice and whisky. His consumption of each is manipulated in nervous progressions. The cigarette holder with lighted cigarette is placed in the mouth, drawn on, taken out, then with the same hand holding the beer can and cigarette holder, beer is swilled. The other hand comes off the wheel for a moment, the wheel is held briefly with the other hand, the whisky is swigged and put back down then the driving hand is returned to the wheel – and all done whilst turning corners or overtaking in the fast lane.

Hunter's brother was also a big man. I think they breed them big in Kentucky, though they often have small mothers. He appeared darker than Hunter, much

darker, which prompted a drawing from me. We were sitting in a restaurant, Hunter and me on one side of the table and his brother and wife on the other. Not a very kind drawing as I recall, but to me only fun anyway. You could see he was visibly shocked and it took me quite a while – many drawings later, in fact – to realize that Kentuckians, and many other Americans for that matter, take things like that as a personal insult and in some cases as an attack, comparable only to a smack in the mouth. Even Hunter was shocked, and then horrified, as I persisted in drawing over the drawing, making it darker and darker and more hideous as lines covered lines. It is at a point like this that the drawing can take over and I become completely immersed in its development. It is no longer a sketch, or merely a personal insult, but a battle between it and my desire to mould and twist it. The drawing becomes more important than the subject.

Other people were watching now. It was no longer a private affair. Hunter fidgeted and made lame excuses for my preoccupation.

'It's a habit of his. This is nothing compared to what he did at the track this afternoon. Hideous things. We had to mace people to escape. That's enough Ralph. Stop it! Must be the Wild Turkey! He can't hold his liquor! Sorry about this!'

I was smiling as I stabbed one last violent stroke across the page and signed it with a flourish. I handed it over. My subject had become a victim and his dark features blackened to resemble my drawing even more.

I remember the waiter bearing down on our table and Hunter on his feet; I remember a black tube and a fine hissing sound. My eyes began to sting violently. I grabbed my sketch pad and staggered out. I remember eyes staring from all directions, dark corners and the door out to the street. The fresh air hit me and eased the pain in my eyes and on my skin.

'Crazy fool!' Hunter screamed. I don't remember any more.

I awoke on a bed in my hotel room. My head throbbed like a train's bumpers shunting trucks in a goods yard. There were pieces of sketch pad strewn around, covered in scrawls of half-formed faces I vaguely remembered. The drawings told me everything. They were the scribbles of some raving drunk and this would not do at all. My eyes were sore and my skin felt as though it was melting. I took a shower and massaged my head with a tepid spray to convince my body that I really was only waking up and in a while my eyes would shine with vigour and my cheeks would glow with health. An old boy-scout trick. Throw off the day before as though it never happened. Every day I am reborn. I felt better and tried to salvage the pieces of paper as though they were vital pieces of information for my assignment.

Today was Derby Day. I had taken breakfast and finally raised Hunter just before midday.

One hour later we were sitting in a roadside coffee shop. Hunter had drunk a litre of orange juice, eaten about 30 different kinds of vitamin pills, two grapefruit, two club sandwiches, four Bloody Marys and was just on his second Heineken with a

Scotch on the side. I have since come to suspect that Hunter is a secret health freak who works hard at it and devours great gobs of health food and goat's milk to build up his insides to concert pitch before any truck with humanity.

'Got to stoke up for the day ahead. It could get nasty.'

'Well, I did actually.' I replied. 'A couple of hours ago. I'm fine.'

'My god! You won't make it. This could be a day of ugliness. Horrible, horrible! People drinking and eating like pigs and vomiting everywhere. We'll be sliding in the stuff before the week is out. And keep that damn sketchbook out of my sight.'

I was idly sketching a few of the late breakfast eaters as he talked.

'Sorry,' I said, 'but I did come here to observe and draw. You must remember, Hunter, I am seeing everything for the first time and it's a culture shock that is affecting me strongly. Anyway, they're only drawings.'

'Don't even think that here, Ralph,' he replied, looking around furtively. 'These people are primitive head-hunters. You're liable to end up in a ditch kicked to death by a horse.'

I had begun to notice amongst all these stern warnings from Hunter a hint of a twinkle in his eyes, as though he was secretly enjoying the thought of the incidents that such a strange practice as mine might provoke. He had been used to working with photographers on other assignments and the detachment with which a photographer usually works gave over nothing against which he could spark. Here was something that could conceivably become a part of any story he worked on.

I was also looking at a worried man. Something was on his mind which he had not yet told me. He had no stomach for this story but he was going through the motions of appearing to be working on it. He had seen it all before and worse, he had been writing stories like these ad nauseam, about sporting events and Chicago riots, and right now it all seemed like a pretty pointless way to go through life. Neither had he yet informed me of how, since very early on, he had harboured a project to burn his own particular brand on life, and in the process burn himself too, by the time he was 30.

But here he was, as large as life, at the age of 32, back in his home town trying to crank up enthusiasm for some rich old vein of resentment he felt a long time ago while still a youth. The Kentucky Derby alone was certainly no reason to be here – it had been written about by armies of reporters since it all began. But to find oneself back on home ground with only a record of disillusionment in the soul, no prospects, and an unfulfilled wish to have snuffed it at 30, there had to be something else. Add to this severe family problems and the stage is set for a weird chain of creative responses in the mind of anyone on that particular high wire. This was no ordinary homecoming. This was the do-or-die attempt to lay the ghost of years of rejection from the horse-rearing elite and from the literati who sat in those privileged boxes overlooking the track and the unprivileged craven hordes who grovelled around the centre field where he had suffered as a boy.

'C'mon let's go. We'd better get over there. You've got to see inside that clubhouse before the big race. Maybe you'll see then just what you're up against. *Scanlan's* could get no passes so we'll have to talk our way in.'

At the time, talking our way in didn't seem as much of a problem as Hunter made out, but maybe that was eased by the number of people he seemed to know around the privilege stand. Real blue-glass rich, young, who had either inherited their hoard or started a second-hand car mart ten years earlier. They were pliant with the mint juleps, another drink I had only just discovered. They had their own fridges full under the seats. With their help we acquired the necessary Hail fellow, Hi there, anyone-who's-a-friend-of-Jake's-is-a-friend-of-mine kind of treatment.

I remember one particular young Kentucky belle, who was rather warm towards me – to such an extent that Hunter was whispering over my shoulder to be careful as she was the wife of a friend of his. Unfortunately, our mutual attraction was the cause of a rather nasty scene later on that night when I attempted to draw her, with unpleasant results, but by that time I was beyond the stage of gentle decorum and was reacting violently to the sights and sounds around me. I drew anything in sight and wasn't particular who saw the result.

The clubhouse was worse, much worse than I had expected. It was a mess. This was supposed to be a smart, horsey clubhouse oozing with money and gentry but the sight I saw was worse than the night I spent on skid row a month later in New York. My feet crunched broken glass on the floor. There seemed no difference between a telephone booth and a urinal; both were being used for the same purpose. Foul messages were scrawled in human excrement on the walls and bull-necked men in smeared stained seersucker suits were doing awful things to younger but equally depraved men in every dark corner. The place reminded me of a cowshed that had not been cleaned for 15 years. I stayed there resolutely, not only because of my own desperately befuddled and drunken state but somehow because I knew I had to look and observe. It was my job. What was I being paid for? I was lucky to be here. Lots of people would give their drawing arm to be able to see the actual Kentucky Derby and that was hardly an hour away. Hunter, I think, understood and watched me as much as he watched the scene before us. Green juleps and amber fluid heaved about in our stomachs like oil-slicked waters in a harbour storm.

Something spattered the page I was drawing on and I moved to wipe it away but realized too late that it was somebody's vomit. A ghastly-looking gargoyle-faced horse dealer had hurled from about five feet. The whole of his insides had miraculously missed me and caught the elevated plane of my sketch pad sufficiently to splatter down the page in an array of colour which would have been a wonderful effect artistically if it had not been for the evil smell.

'Seen enough?' asked Hunter and pushed me hastily towards an exit.

While the scene was as wild in the inner field as it was in the clubhouse, it had a warmer, more human face.

Drawing while away from home helps me to keep myself together, maintain a respectable front and sustain what would otherwise be a complete breakdown of my constitution.

Hunter is a different animal who seems to gain strength from rakish marathons. I am certain he learned the secret of maintaining a drug-enhanced body from an old Indian in the Appalachian Mountains (see *The Master Game* by Robert S. De Ropp, author of *Drugs and the Mind*). He has learned the balance between living out on the edge of lunacy and maintaining an apparently normal discourse with everyday events. Whatever reaction he may adopt towards a situation, whether it be giving a hell-raiser speech from the interior balconies of the Hyatt Regency Hotel in San Francisco or firing a Magnum .44 at random into the night in front of strangers, he will always convince those around him that it is they who are mad, irrational or just plain dumb and that he is behaving as a decent, law-abiding citizen.

We placed our bets and fought our way back to our friends on the privilege stand. They plied us with more juleps. I had chosen some religious-sounding name – later when I checked Hunter's Kentucky piece I saw it was Holy Land.

It was then that I conceived the idea to turn and face the spectators the moment the race started. What better way to observe the crowd? Utterly engrossed in their hopes out there on the track, they would be oblivious to me. I would photograph them constantly throughout the race and get myself a group of pictures which would surely reveal the true Kentucky face.

It was an unnerving experience. I was experiencing the full weight of an actor's-eye view of his energized audience, whose emotions individually and collectively pulsed forward towards the track as the moment arrived, one second before the race.

'Hey boy! You're facing the wrong way boy.'

'Hey Steadman! Hold it!' Hunter was already anticipating trouble.

'But he called me boy!' I protested.

'Leave it, they call everyone over eight boy in this town.'

'I still don't like his tone.'

'You'll like his anger even less so put your book away.'

'I'll take his picture instead and do the bugger later. He's the type I think you are looking for – the Kentucky face.'

'I'm looking for something worse than that, and the nearest you've come to it so far was the picture of my brother and that worries me. My mother is Dorothy Lamour compared to that twisted pig fucker you were about to tangle with.'

The race was now getting a frenzied response as Dust Commander began to make the running. Bangles and jewels rattled on suntan-wobbling flesh and the pillar men in suits were on tiptoe. The creased skin under their double chins stretched into long furrows curving down tight collars.

All mouths opened and closed and veins pulsated in unison as the frenzy reached its climax. Sweat rolled down the fleshy furrows. One or two slumped back as their

horses failed but the mass hysteria rose to a final orgasmic shriek which bubbled over in whoops of joy, hugging and back slapping.

I turned to face the track again but it was all over. That was it. The 1970 Kentucky Derby won by Dust Commander with a lead of five lengths – the widest winning margin since 1946 when the Triple Crown champion, Assault, won by eight lengths.

Already people were making for exits. There's nothing after that except a few minor races for the diehards and betaholics followed by the presentation, but you can get all that from the newspaper.

I had watched the Derby through the behaviour of the crowd and their wild responses. I was probably the only person on the track to have done so, and it separated me.

The only thing to do now was collect all the newspapers I could lay my hands on about winning trainers, their ladies, jockeys, champagne bottles and owners, have a last night in town and get out with my freshly struck vision of it all.

Hunter suggested that while the crowd dispersed we spend a little more time at the press box where we could top up on a few more whisky-and-beer combinations. I'd had enough juleps and needed something to turn my stomach back from green to its natural colour of lumber brown.

We must have been blind drunk for I don't remember the drive back to Louisville where Hunter suggested we call in at an old-world club called the Pendennis.

I vaguely remember getting out of the car and almost by magic the girl with the southern drawl was climbing out of one side of a sleek low two-seater and her man the other.

I was feeling pleasant now – and drunk enough to ignore her husband.

We stumbled through to the drinks room – I presume it was the drinks room. Drinks appeared miraculously wherever I put my right hand. There were pool tables in the room and I fancied my luck with the southern beauty and challenged her to a game.

'Ah cain't play but you can teach mer.'

'Fine,' I said. 'I play a lot in England.'

That was a lie. The last time I'd played had been at the age of 16 in a Welsh golf club. I never was one for games except at moments like this.

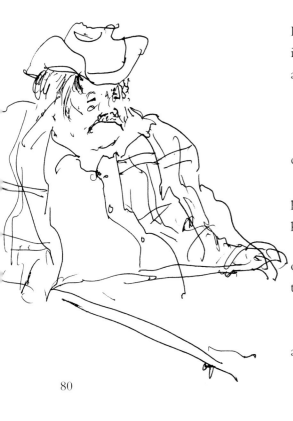

My eye must have been particularly acute at that time in spite of the drink – or perhaps because of it and wanting to show off in front of this lovely young thing. I put down everything I had and left her helplessly full of admiration.

The rest of the party were sitting in easy chairs half-watching and mainly chatting over old times. We joined them and I picked up my sketch pad again to try drawing the young lady.

'Steady Ralph, you're drunk. We don't want trouble here. We'll get thrown out.'

She seemed to be fascinated so I set to work, drawing freely. I ripped off the page and handed it to her. She smiled as she took it but as her eyes struggled to decipher

my lines a horrified look crept over her face. Her smile fought to stay there but turned instead into something resembling a twisted grimace.

'That ain't purty – I'm purty ain't I?' she blurted.

'You're beautiful,' I said, 'but this is just a fun drawing. Don't take it to heart. Oh, I am sorry, I really didn't mean to offend you. Here let me try it again,' and I started another. It somehow got worse than the first and the atmosphere around me became quiet and fascinated, though weirdly cool.

'Wha'd'ya draw me lark theyat,' she drawled, 'ain't I purty? – Ah'll draw you, leyen me yower pean and yower paper.'

She took them and began to hack at the paper desperately trying to twist the lines into some awesome image of me. It was a desperate attempt to get her own back. I had beaten her at pool and then it was as though I were mocking her with a drawing. I knew then I must never do this kind of thing again, or must keep it to myself.

She was mortally offended and any assignation we might have planned now lay in ruins in the pathetic scribble she was fighting to bring to life.

The husband had his coat off but I really didn't realize it was for my benefit. There were lots of asides.

'Let's get drunk,' I said for something to say.

'You are drunk, goddamn you, and helplessly out of control. That filthy habit is getting worse. You'd be better off doing needlepoint.'

Two hours later, in a coffee bar, we laid the drawings out as we ate capsized omelettes and drank stewed coffee.

I was feeling pretty bad now. Hunter was somehow preoccupied – worrying because he had no story, I thought at the time.

'This whole thing will probably finish me as a writer. I have no story.'

'Well I know we got a bit pissed and let things slip a bit but there's lots of colour. Lots has happened.'

'Holy Shit! You scumbag! This is Kentucky, not skid row. I love these people. They are my friends and you treated them like scum.'

'Well I'm sorry. I just tried to be objective. I'm here to find something worth publishing. It wouldn't do to go back with picturesque landscapes of Kentucky and elegant horses. You showed me the depravity. You must remember I've suffered some kind of culture shock. It's not easy to stay normal. I'm sorry. I'm more worried about your story, otherwise my drawings are worthless. They lack authenticity without the words.'

'Fuck the story. At this point there is no story. I grew up here. I went away and I came back. You appeared on the scene with this stuff like some kind of travelling priest peddling twisted morality.'

'I'm just trying to do my job.'

Hunter had brought his fist down on his omelette. I wiped feebly at the scrambled substance sticking to my already crumpled sports jacket in an attempt to lessen the shocking effect this would have on my already alarming countenance.

'My drawings – where are my drawings. I can't see.'

'I've got your drawings you worthless faggot. Get in the car – you're causing a scene. Do you want to end up in jail too?'

There was no sympathy in Hunter's voice now. It was as cold and hard as a war memorial. It was then he maced me – a short sharp hiss of reptilian spite. I crawled into the open door of the car and grabbed wildly for the ice bucket I knew was behind Hunter's seat, splashing the still cool water over me with a cupped hand.

'Mind the seats goddamn it. This is a rented car.'

The cool water eased the searing sting momentarily. The car roared forward as Hunter threw it angrily onto the freeway.

Back in New York I was awoken from my torpor by the phone. It was Warren Hinckle III, the editor of *Scanlan's*.

'Yeah?'

'Hey Steadman, is that you?'

'Er – yes – did you get my stuff?'

'You're a messy worker Steadman – I like it. Let me ask you – didn't you see any horses?'

'Quite a few.'

'Den why ain't we got any?'

'Ah that, yes, well I'm doing the horse one today.'

'Okay, let me see it. And whatd'ya do to Hunter? He says he can't write and he's blaming you for arresting his creative flow.'

'I'm sorry, he seemed to have personal problems to overcome. Home town, past memories, meeting old friends, mother, that kind of thing. I'm sure he'll produce something soon.'

'Didn't you two hit it off or somptin?'

'Like a house on fire,' I said. 'I'll be along to the office just as soon as I finish this horse drawing.'

I rang off and stood silently for a minute or so. I stared blankly at my shaking right hand and raised it to wipe the sweat from my brow. It was early May and the heat was beginning to build up in the city...

Excerpt from interview with Hunter S. Thompson by P.J. O'Rourke, Rolling Stone, *28 November 1996.*
Reprinted by kind permission of Jann Wenner.

Q. I can see the layout problem they might have had. Was Ralph Steadman in Las Vegas during any of this?

A. No, we sent it to him all at once when it was finished. When I went to Las Vegas one of my jobs was to find physical art: things that we used, cocktail napkins, maybe photos – we didn't have a photographer. But that concept didn't work. I rejected it.

It was a cold afternoon, Friday, on a deadline in the *Rolling Stone* offices, when I reject-ed [Art Director Robert] Kingsbury's art for the 'Vegas' story. It was a real crisis: 'What do we do now?' This is one of those stories that you read in bad books. I said, 'What the fuck, let's get Ralph Steadman. We should have had him here in the first place.'

We'd worked together on the Derby piece and also on the America's Cup night-mare. It never got published. *Scanlan's* had gone under. Ralph and I had become some-what disaffected, estranged, because of his experience in New York – his one and only experience with psychedelics, with psilocybin. And he swore he'd never come back to this country and I was the worst example of American swine that had ever been born.

If I had had my way, Ralph would have gone with me to Las Vegas. It was some kind of accounts thing: 'Save on the art,' you know. I didn't like the cocktail-napkin thing, but it wasn't that big a story, really. And, you know, Ralph wouldn't do it unless he was paid $100,000 or something like that. But when the other art was rejected, I think Jann was there: 'Let's call Ralph.' The story was done. It was one of those, 'How fast can we get it to him? How fast can we get it back?' And you know, we got him on the phone. You know [British accent], 'Thot bastuhd. Well, ah'll hav a luk at it. A, yes, I cahn probably do it.' The manuscript was sent off. He'd never been to Las Vegas.

I don't think it was probably necessary for someone to have been to Las Vegas to illustrate that story. I mean, the visuals were kind of 'internal'.

Yeah. But there was no more communication with him for, like, three days. We were all a bit nervous. And I would say, 'Don't worry, he said he would do it.' But his heart was full of hate. In about three to four days, a long tube arrived at the office. Great excitement. I was there when some messenger brought it in: a big, round thing. And we went to the art department. It was huge. Very carefully, we pulled the stuff out and unrolled it. And, ye gods, every one of them was perfect. It was like discover-ing water at the bottom of a well. Not one was rejected; not one was changed. This is what he sent.

I know this man. He was wrong but I love him. Twenty-six years I have known him, 26 summers with the length of 26 bitter winters. I doubt if I will ever meet his like again. His presence cauterizes my nerve ends and leaves me sickened with a joy of abject misery and downright wretchedness. *Fear and Loathing in Las Vegas* was never a book. It was and is one man's attempt to come to terms with the loneliness of pure perception, unutterable fatigue with, and flight from, America's dysfunctional over-indulgence. The fright of confronting America's sickness inside his own skin drove the poor bastard on a trip to his own destruc-tion, bringing him face to face with a mirror image of himself. In his heroic attempt to escape the dark morass of America's screaming lifestyle he sold his soul to the devil for one moment of happiness. Like Faust he lives in mortal torment, but unlike Faust he quite enjoys it... but the sonofabitch would, wouldn't he?

Overleaf Such is my preoccupation with the character of Hunter S. Thompson that I wondered what his mother and father were like. His father, Jack, died when Hunter was 15. His mother lived out a lusty old age in the Episcopal Church Home on the outskirts of Louisville. She was the only person I can imagine who could have been the mother of Hunter. I loved the woman. She was my kind of girl.

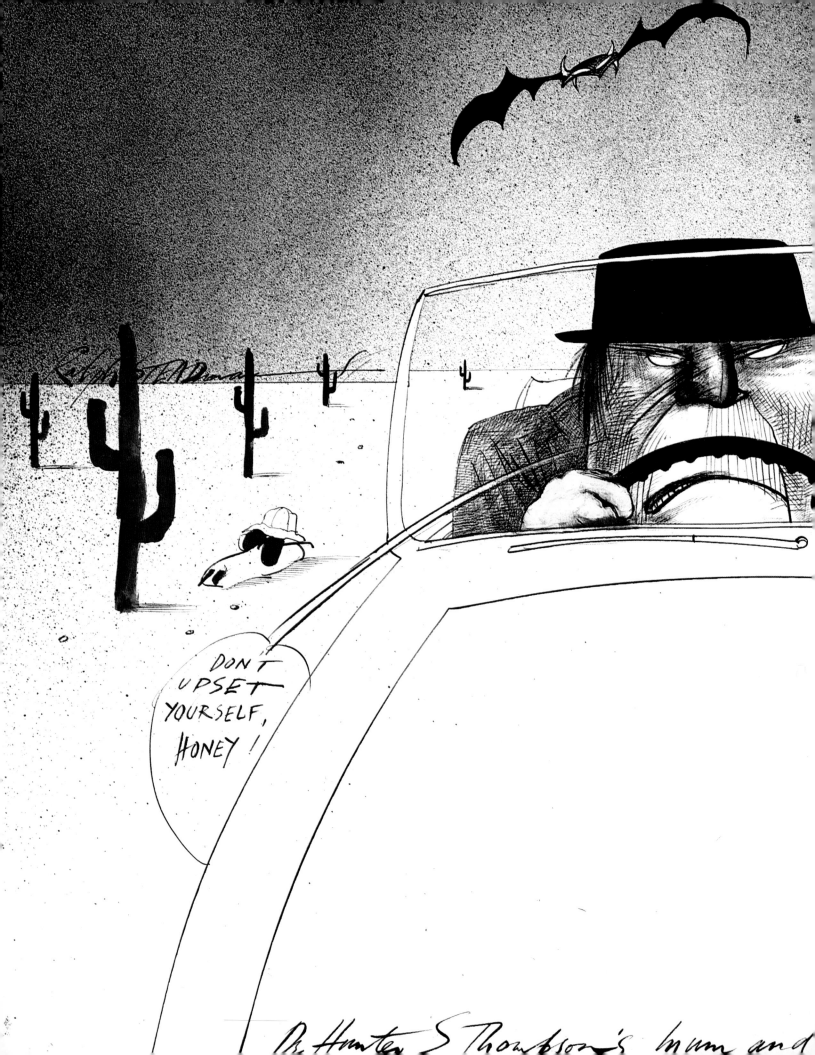

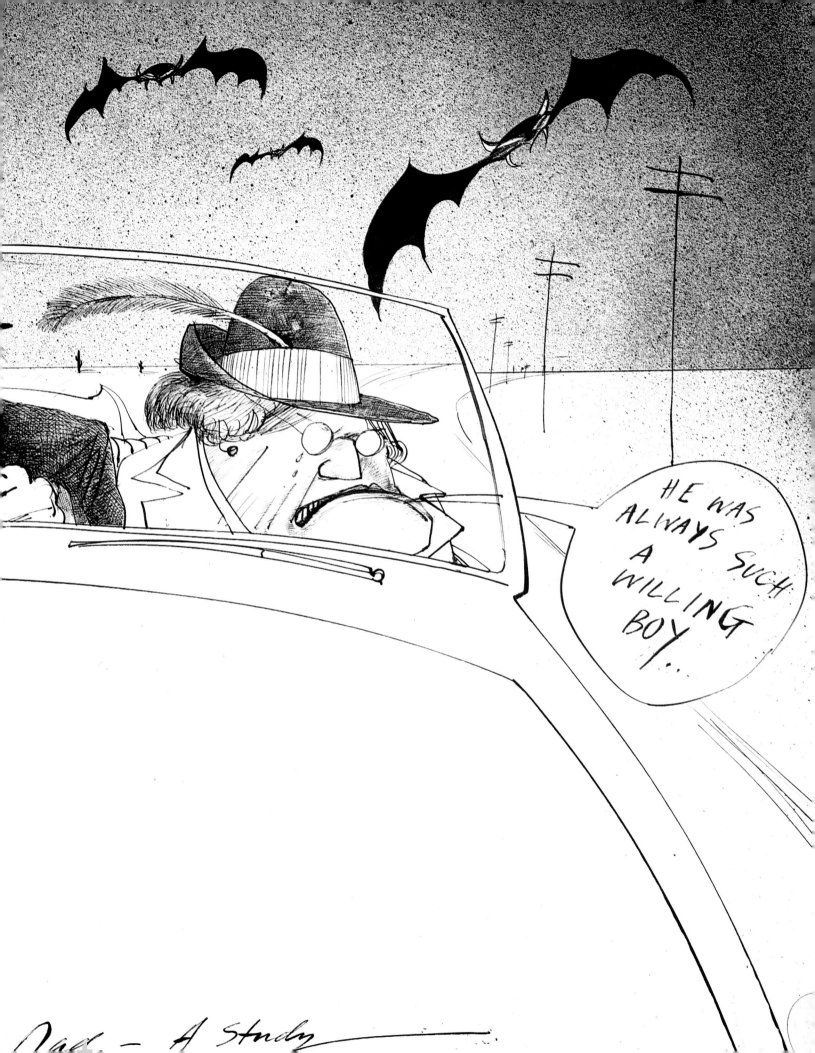

Journey to Las Vegas.
The original.

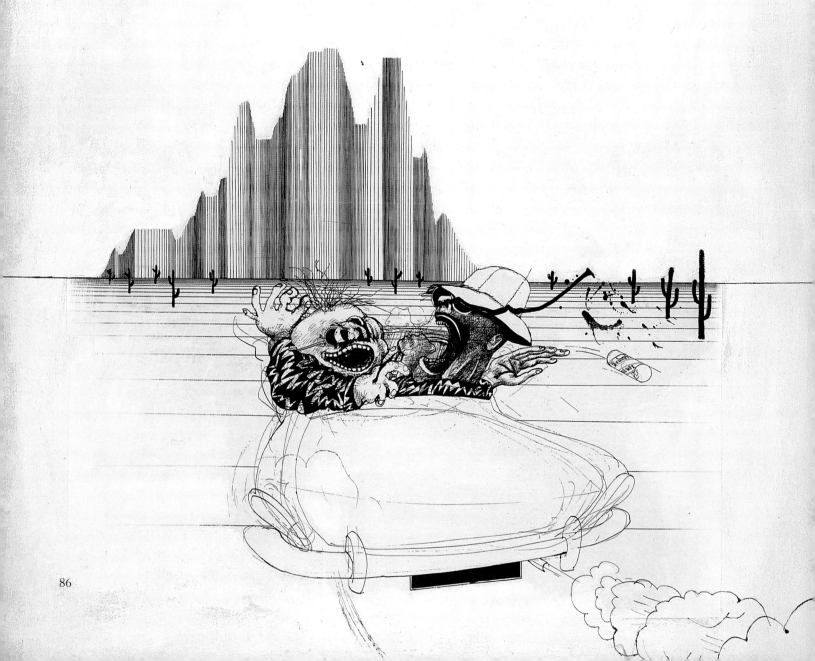

The driving sequences in *Fear and Loathing in Las Vegas* often infer that I am the second passenger and was witness to the whole saga. This is not true. I would not be seen dead in a car with Hunter. He is too good a driver for that.

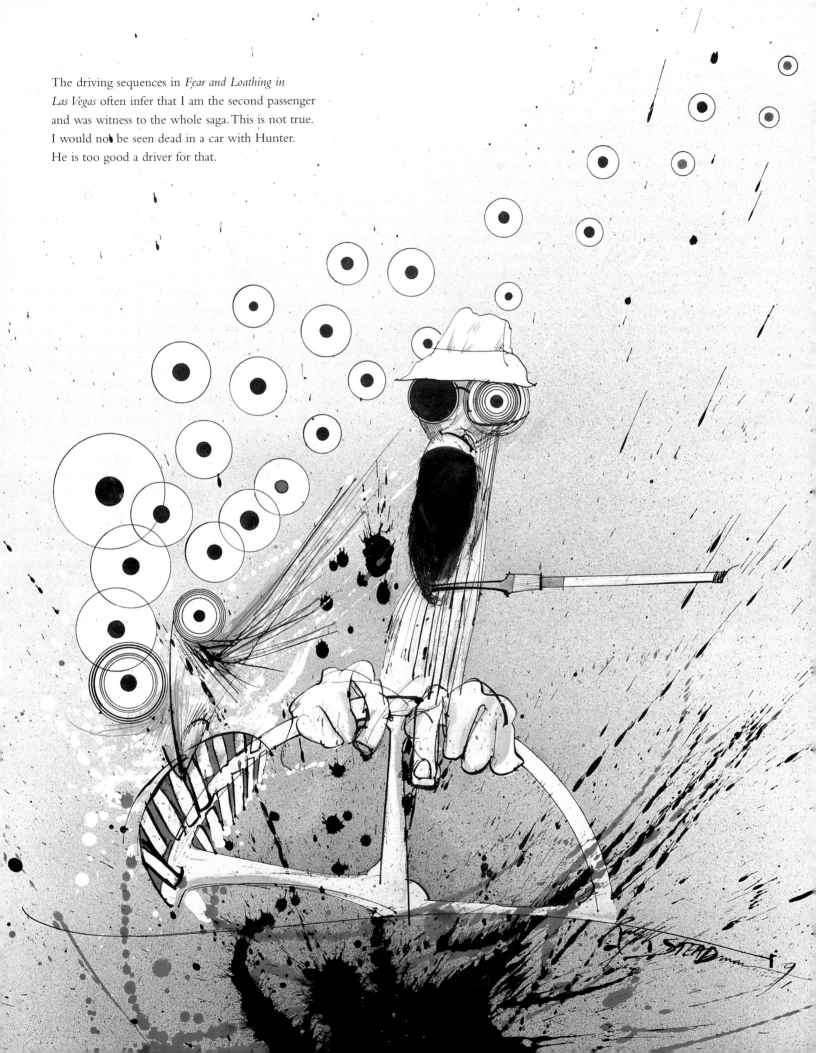

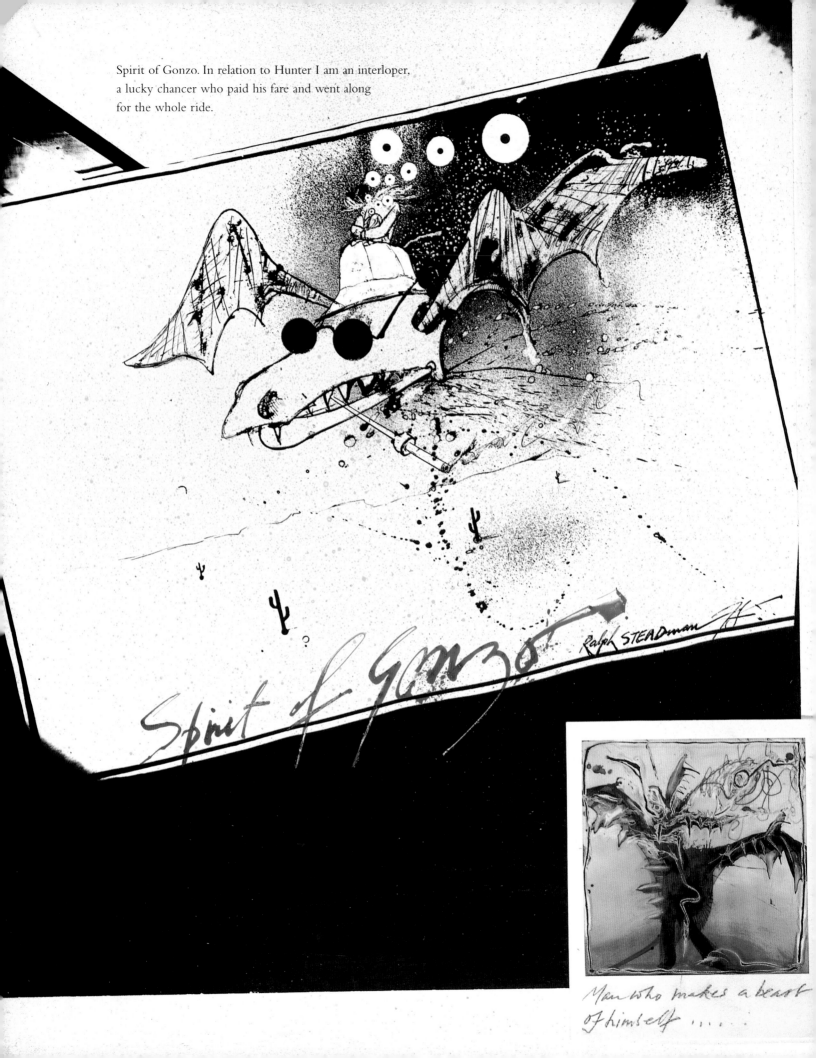

Spirit of Gonzo. In relation to Hunter I am an interloper,
a lucky chancer who paid his fare and went along
for the whole ride.

Bat Image ①

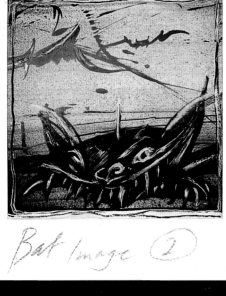

Bat Image ②

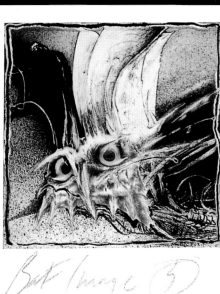

Bat Image ⑤

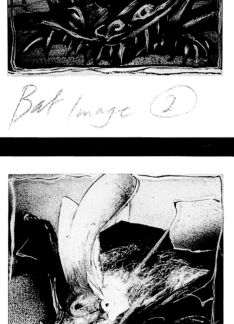

Bat Image ⑥

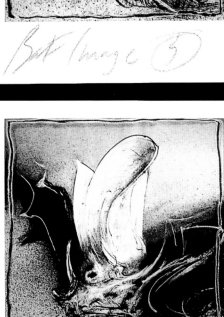

Bat Image ⑦

Bat Pig ①

Previous page Paranoid bats. Laila Nabulsi, producer of the film *Fear and Loathing in Las Vegas,* needed some images, especially for the drug sequences which would be augmented with paranoid manipulation. Bats and vultures and Gonzo are inseparable.

Right A devil's banquet. Hyenas chase off the vultures.

Below Nixon as vulture.

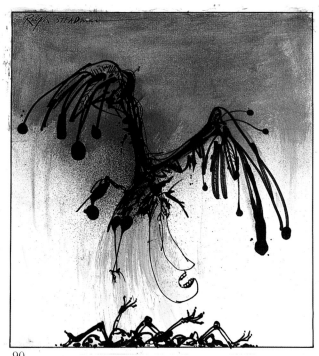

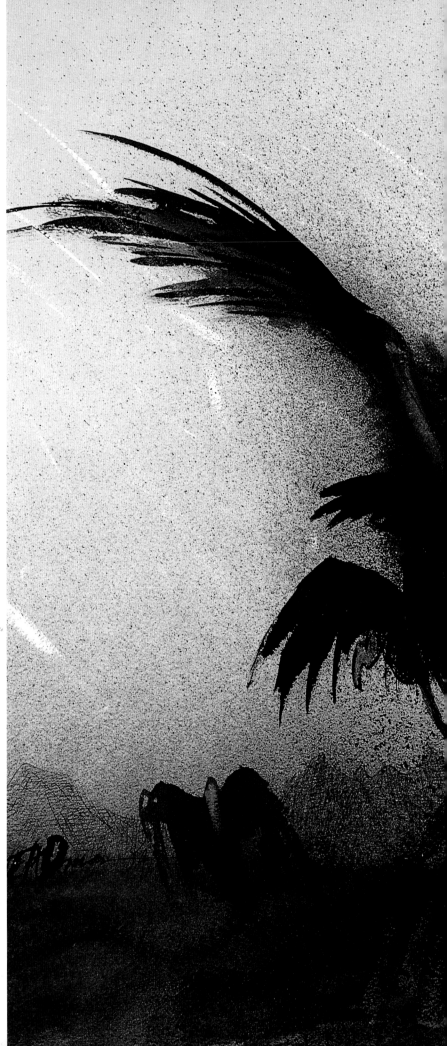

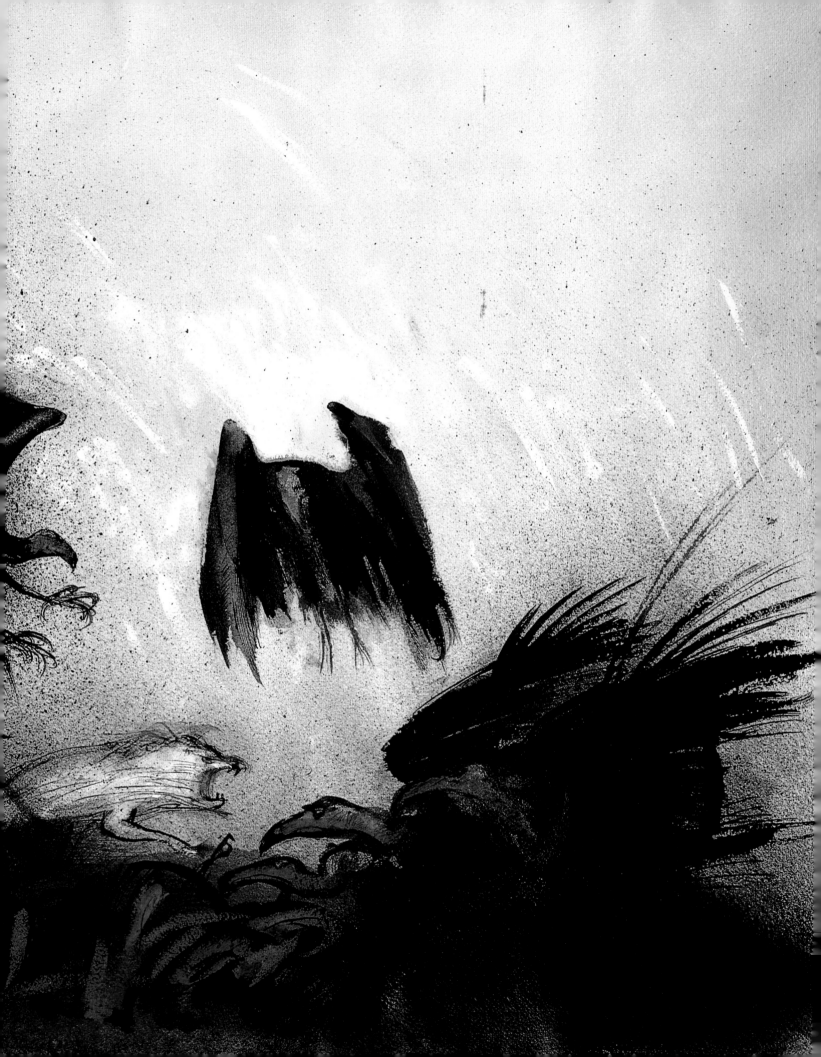

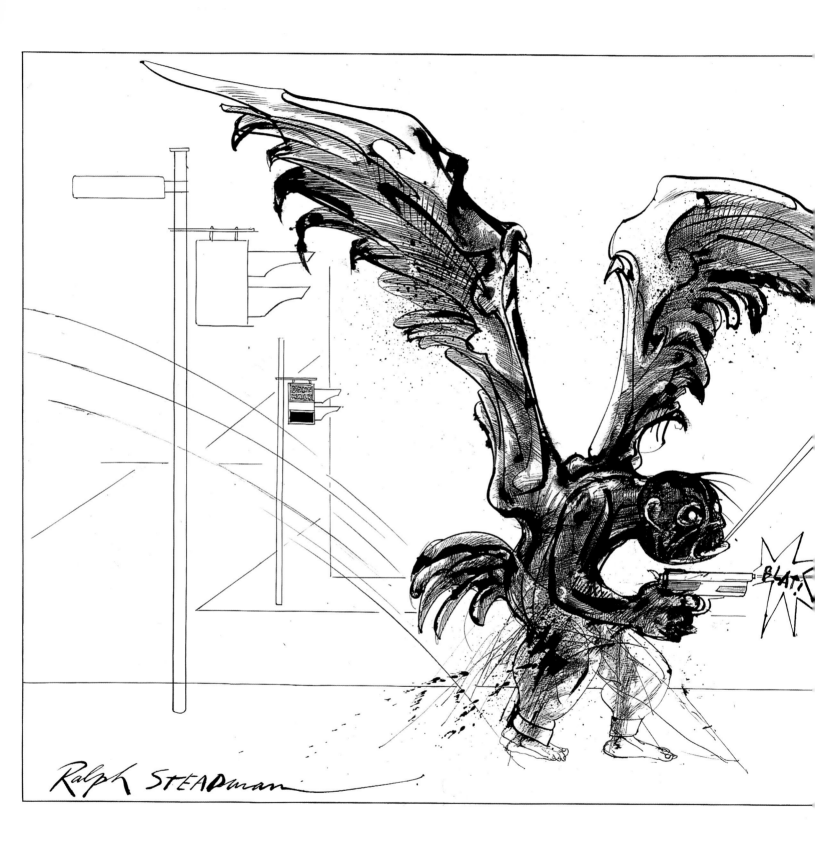

BLAT!

Ralph STEADman

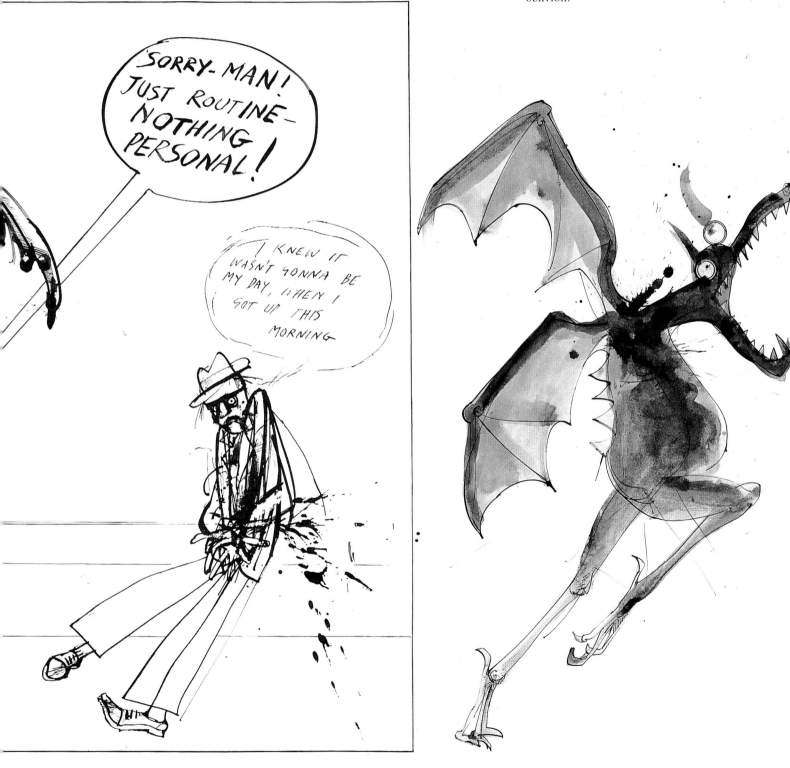

Left A Los Angeles street scene. Moments before a death. This was not his day.

Below Welsh dragon. Moments before oblivion.

93

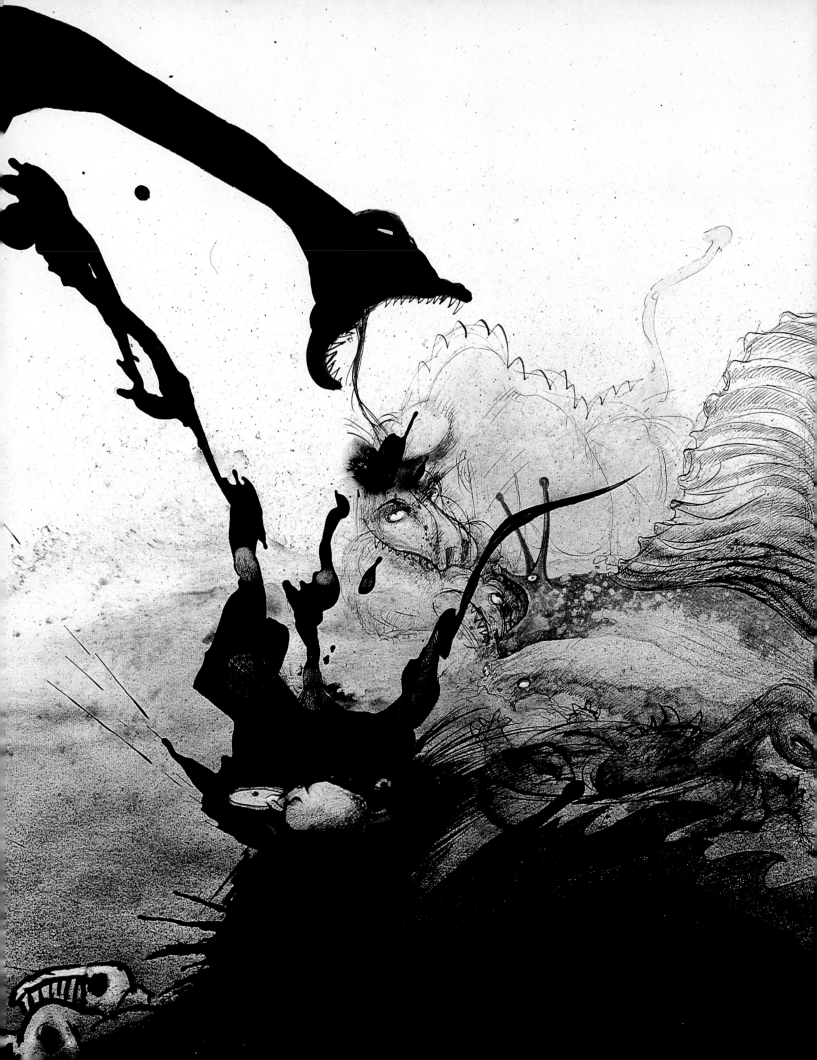

Primeval scene from *The Big I Am*,
the story of God.

Fido. I lived in fear of dogs but then I learned to come to terms
with their loyalty. Their teeth are only there to tear your
enemies limb from limb.

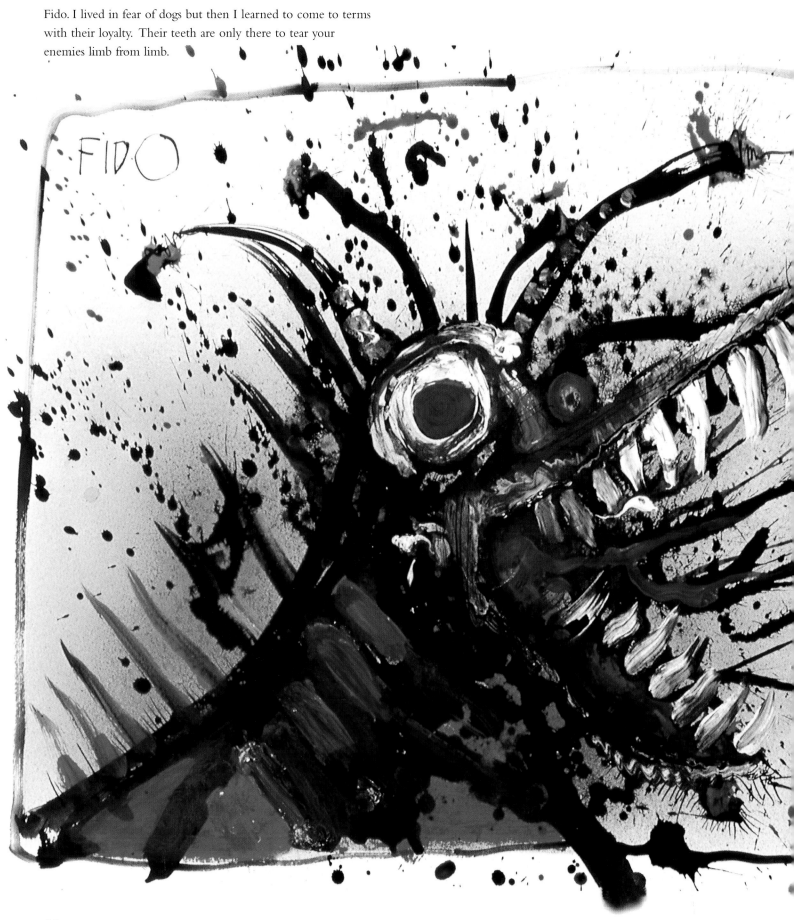

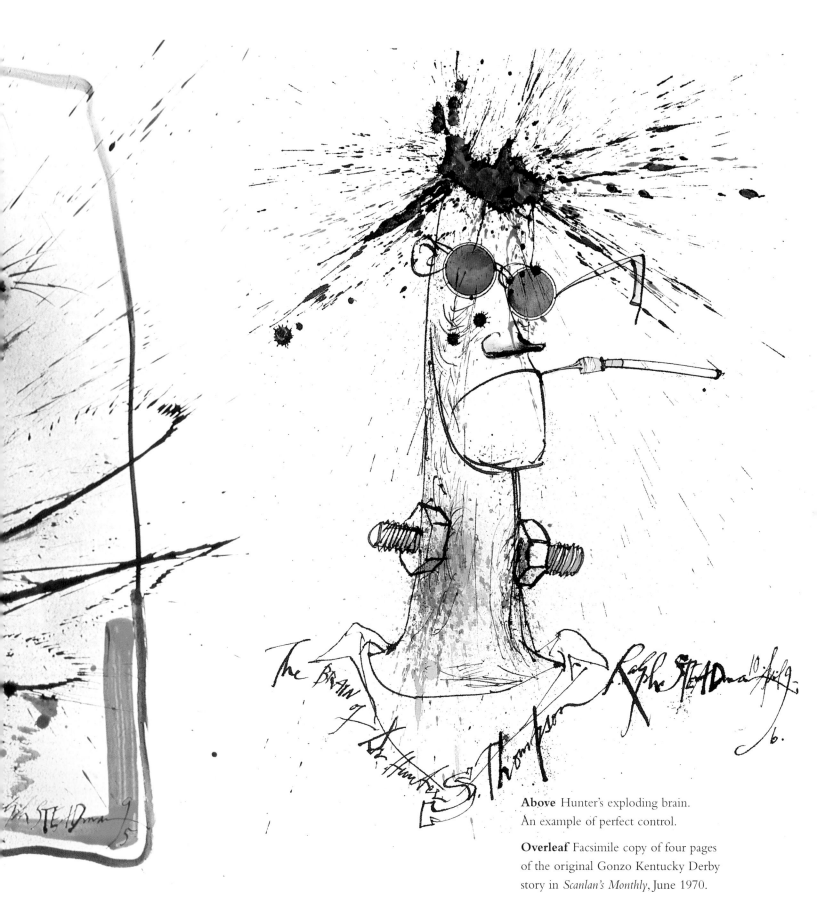

The BRAIN of Dr Hunter S. Thompson

Ralph STEADman 10 April

Above Hunter's exploding brain.
An example of perfect control.

Overleaf Facsimile copy of four pages
of the original Gonzo Kentucky Derby
story in *Scanlan's Monthly*, June 1970.

The Kentucky Derby Is Decadent and Depraved.

Written under duress by Hunter S. Thompson

Sketched with eyebrow pencil and lipstick by Ralph Steadman

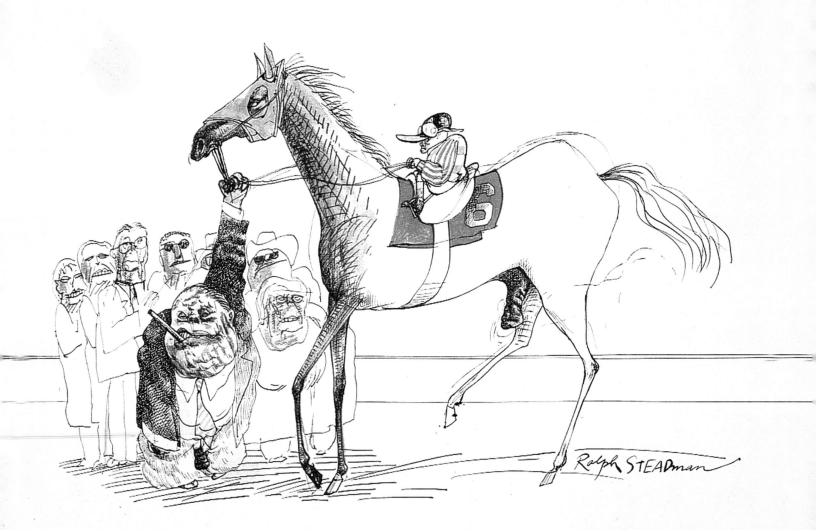

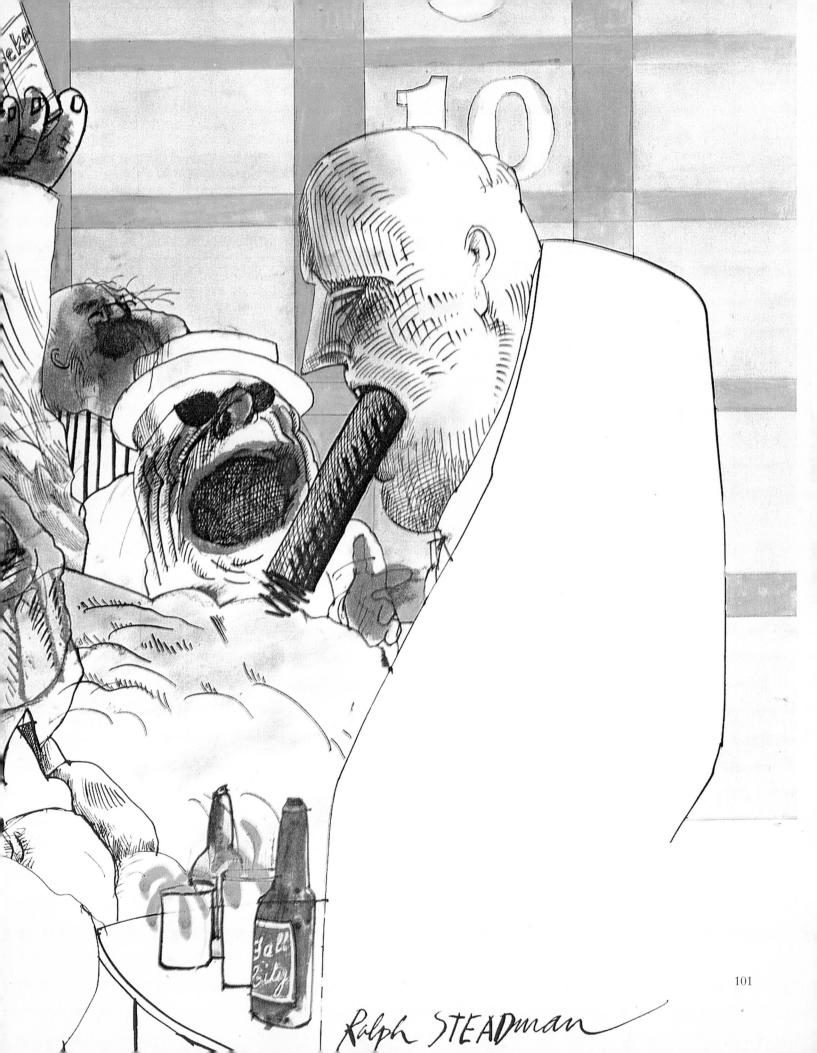

Ralph STEADman

101

[Cont. from 39] finishing each scene with the classic refrain: "Cut! Print! Perfect! Do it again!" It must have been hell on earth inside his mind, especially at the start.

This was the first film Art Linson, producer, had directed, having taken a four-month crash course to acquire some of the tricks. I can appreciate his apprehension, nervousness and obsessive caution and respect them as qualities, and though he's no John Huston, I'm prepared to give him the benefit of the doubt. The script wasn't *The Treasure of the Sierra Madre*, either, nor for that matter is Bill Murray Humphrey Bogart, though one day, Bill, I believe that you *will* be, bless your heart, when the pain of living begins to score lines across your lovable features. Hunter Thompson isn't Joseph Conrad. Jimmy Carter isn't Harry Truman, though strangely, Richard Nixon *is* Richard Nixon. I'm no Pablo Picasso, but there's no harm in straining. After all, the charm of any activity is in the trying and so rarely in the finished article.

Watching Linson at work, it was pretty obvious that he was in no frame of mind to catch the abandoned pure essence of gonzotic madness, which can only happen in uncontrolled conditions. But with all those Universal millions plus some of his own, no doubt, lying heavy on his shoulders, and enough film to stretch from coast to coast, it must be difficult to relax. Art's fanaticism for the subject he was trying to portray was undoubtedly there, and his sincerity, too, but I feel he was blinkered by the idea that the movie was a runaway hit (and it might well be) before he'd even begun to film it, and therefore nothing must be left to chance.

This opinion was reinforced when Hunter decided to take a walk around the location to relieve the boredom of being an idle spectator. He absently walked by the dirty window of a shack that was part of a scene and on camera at the time. Art's voice, amplified by a bullhorn, thundered out across the valley: "Cut! Get Hunter out of the movie!" If there was ever a perfect Hitchcock cameo, that was it, and I don't think it even made the cutting-room floor.

When confronted by a situation in which nothing creative is happening, one tends to set about on an idea of one's own. This seemed like a perfect time. I had drawn a picture of Hunter as a buffalo, inspired by Art's title for the film, and for no apparent reason had named it *Gonzo Guilt*. It appealed to Hunter, but being Hunter, he wanted to extend the idea and make it into a set of buttons. For anyone to receive one of these buttons would immediately make him a member of some

Producer-director Art Linson; Bill/Hunter (right)

Linson was in no frame of mind to catch the abandoned pure essence of gonzotic madness.

secret brotherhood, and the object of the exercise was to leak these buttons to various members of the film crew until everyone had one—except the director. It provided a suitably nerve-racking undercurrent—an alien force—off which the director could feed. The plan worked up to a point. Everyone who did not have a button knew they had to have one or face being ostracized. I think it was a nasty thing to do, and things like that don't make me proud.

But don't take a blind bit of notice of me. I haven't even seen the film in its entirety yet. Steadman, eat your heart out.

The only other event that has any bearing on my involvement in the film was the writing and performing of a certain song. Hunter occasionally gets to know people who have good places to while away an hour or two, and on one of these occasions, I decided to invite Mo Dean over to meet Hunter. I met Mo after John Dean and I covered the Republican convention for ROLLING STONE in 1976. Being as we were a strange mix of very different spirits, it was an extremely creative atmosphere, and six hours later we had a song, or the bare words anyway, and all it needed was a few more stanzas, which I wrote later. They didn't use it in the movie and it now gathers dust inside its cassette case on a library shelf. Maybe no one realized its potential. God knows how much crap got through the net. Those questions cannot go unanswered, so for those of you who crave to know what the hell it was that six hours of pure, unadulterated creativity produced, here are a

few bars. Unfortunately, we cannot hear it, for after almost thirteen years, ROLLING STONE is still not wired for sound.

Those Weird and Twisted Nights

Drive your stake through a
 darkened heart
In a red Mercedes Benz
The blackness hides a speeding
 tramp
The savage breast pretends

Ooooooo-ooo-oh yesssssssss!
Ooooooo-ooo-oh yesssssssss!
These long strange nights
These long strange nights
These long strange nights
Ooooooo-ooo-oh go-oo-o-od!
Ooooooo-ooo-oh go-oo-o-od!
These warped and twisted
 nights
These weird and tortured
 nights

If you write words shocked
 through with truth
Hunger dirt and gutter sharp
Eat the words and spurn the
 gutter
Climb the rise and surf

Ooooooo-ooo-oh yesssssssss!
Ooooooo-ooo-oh yesssssssss!
These long strange nights
These weird and twisted nights
These warped and civil rights
Ooooooo-ooo-oh go-oo-o-od!
Ooooooo-ooo-oh go-oo-o-od!
These warped and twisted
 nights
These warped and twisted
 rights

Ah, but never mind your rights,
 my love
Because . . .
They never really happened
 anyway

They never really happened . . .
anyway

But days go by
And love goes by
And sooner or later
We both must lie
And sooner or later
We all must die
And sooner or later
We all live a lie.*

WITH HUNTER around, Bill Murray was able to closely study the man he was portraying. I talked to him about my impressions and observations of Hunter, especially his mannerisms, which are a combination of forward swaying lurch, nervous rearing twitch and grimacing clumsiness with a dignified monotone voice that lends the whole a certain nobility. Maybe that's a bit kind, but you know what I mean. It is to Bill's credit that within two weeks there were two Hunters on the set. This gave me an unexpected difficulty so far as drawing was concerned.

I didn't have the same hang-up with Peter Boyle's interpretation of Oscar Acosta. I had only met Oscar a couple of times in San Francisco before he disappeared, and my vision of him was not colored in quite the same personal way. Consequently, Boyle's strong, wild personality took over easily, and his virile performance gave me some marvelous feedback. As did Art Linson, playing the browbeaten first-time director riding his bucking steer at a rodeo show. He became so much a part of his own work that it made him very much a part of mine, and thankfully he enjoyed the result, I believe, vicious as it is.

If I had to recall one sequence that captures the very taste of Hunter's personality, it would be the toilet scene. Bill/Hunter, posing as "Harris" from the *Washington Post* in a suit four sizes too small, is shaving when Nixon comes in for a pee. Hunter turns as he realizes who has just walked in and, taking off most of his clothes, starts to wash the sweat out of his white tennis shoes. Warming to his own performance, Hunter launches into a dissertation on the problems with screwheads.

Nixon, who appears to be suffering from cystitis of the bladder, asks how Harris' family is, and I quote from memory:

"The screwheads have got my daughter, sir," replies Hunter, beating his shoes on the basin as he talks, "and they'll get yours too, sir. Well, maybe not Tricia, but Julie. They hate Julie, sir, and you, sir." The wet tennis shoes hit the tiled lavatory wall with unforgettable dramatic effect.

* © 1979 Ralph Steadman. © Dr. Hunter S. Thompson; © Amalgamated Screwhead Companies Inc.; © Mo Dean (Incorporating Cashflow U.N. Limited).

Ralph STEADman

"They *really* hate you, sir."

Nixon winces and leans his forehead on the urinal mirror.

"And, sir," continues Hunter, who hits the buttons on two hand dryers simultaneously, then hangs the shoes on them to dry off. "Sir . . ."

"Yes, Harris?"

"What about the weak, sir [wap], the silly [wap], the dispossessed [wap], the Italians [wap] and, sir . . ."

Hunter's voice has reached its most poignant, pleading tone.

"What about the doomed?"

The index finger of Nixon's right hand beckons Hunter toward him. He moves forward, his face a marvelous portrait of comic sadness.

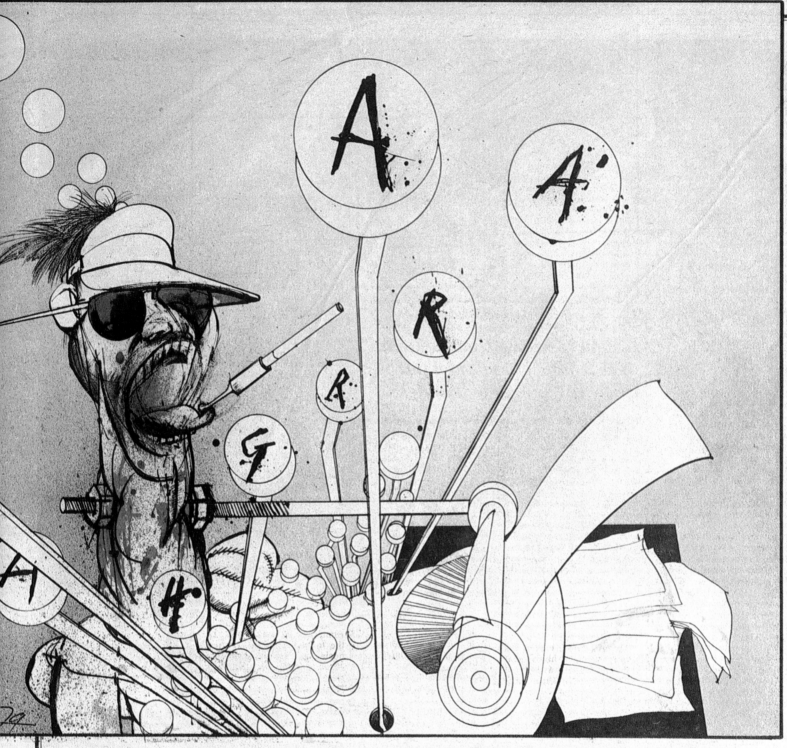

"Harris..."

"Yes, sir?"

I won't tell you what Nixon says. It's well worth seeing the film to find out.

IT DIDN'T END THERE. Extremely early one morning in December of 1979 the phone rang. I was still very much asleep when I answered.

"Ralph, it's me, Hunter. Where's that song? How are you? We need it."

"I'm still working on it with a group called Tax Loss."

"Tax Loss! Holy shit! That'll create some attention! Send me a demo. You've just done a drawing of Bob Dylan, Ralph. It means a lot to me, but I can't explain why, but the signature on the horizon, *Slow Train Coming*, you wouldn't understand. It's good, Ralph. I need the drawing."

"I haven't got it."

"What!"

"I haven't got it."

"You treacherous swine! Where is it?"

"Still at ROLLING STONE, I hope."

"Holy shit! Jann will have it locked away by now."

"No, he won't. I specifically asked for if to be sent back because I wanted it myself. He would never break his word with me. I taught him how to be honest."

"But you don't know Jann. You don't understand real greed. It's like a vulture after meat."

It was too early in the morning and the light touching the chimneys over the Wandsworth rooftops was too poetic to think about vultures — or early-morning light.

"I'll get it," I said.

"When?"

"I'll ring today and ask."

"No, don't do that. Jann's bound to get suspicious. He'll grab it and you'll never see it again."

"Not if I want it."

"Well, okay, if you're sure."

Two telephone calls later, the drawing was picked up. No one bothered and nobody appeared to show signs of suspicion, but the enjoyment of paranoia, gonzo style, prevailed. It never fails.

I went back to bed.

"Who was that?" asked Anna.

"Hunter. He wants the Dylan drawing."

"Oh."

The phone rang again.

"Ralph, it's me, Hunter. I'm going to Hollywood. No one must know. It's important. I'll be at the Sheraton. Bill Murray is there. We've got to get into the editing room and change the beginning and the end. The film has no message. It doesn't mean anything. This is an absolute secret [*Et tu, Brute*]. No one, Ralph, must ever know I called. The words of the song — 'They never really happened anyway.' Remember? I never went to Hollywood. I didn't meet Bill. I didn't call you. It's important, Ralph. And we need that song."

"I'm working on it. It's taking time. I'm not used to the process."

"Okay."

He rang off and as far as I know the film is now better or worse than it would have been.

I'd like to think he made the effort, though without appearing to be involved. It was the least and the most he could do, bless his heart. No jack rabbit just *lets* himself get run over.

Drawings from *Polo is my Life*. Below: Hunter
as horse. Right: Unpublished studies of horses.

Previous pages Facsimile copy of my account
of the making of *Where the Buffalo Roam* in
Rolling Stone, 1979. A Gonzo fiasco.

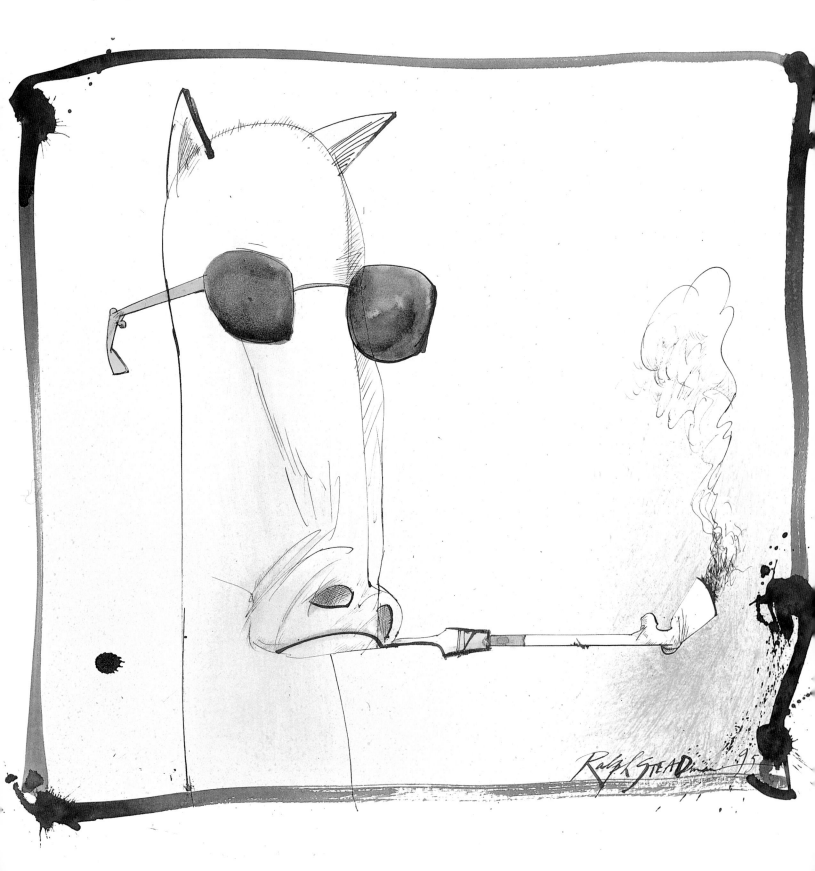

Four lithographic prints. Genghis Khan used
the heads of the vanquished as balls.

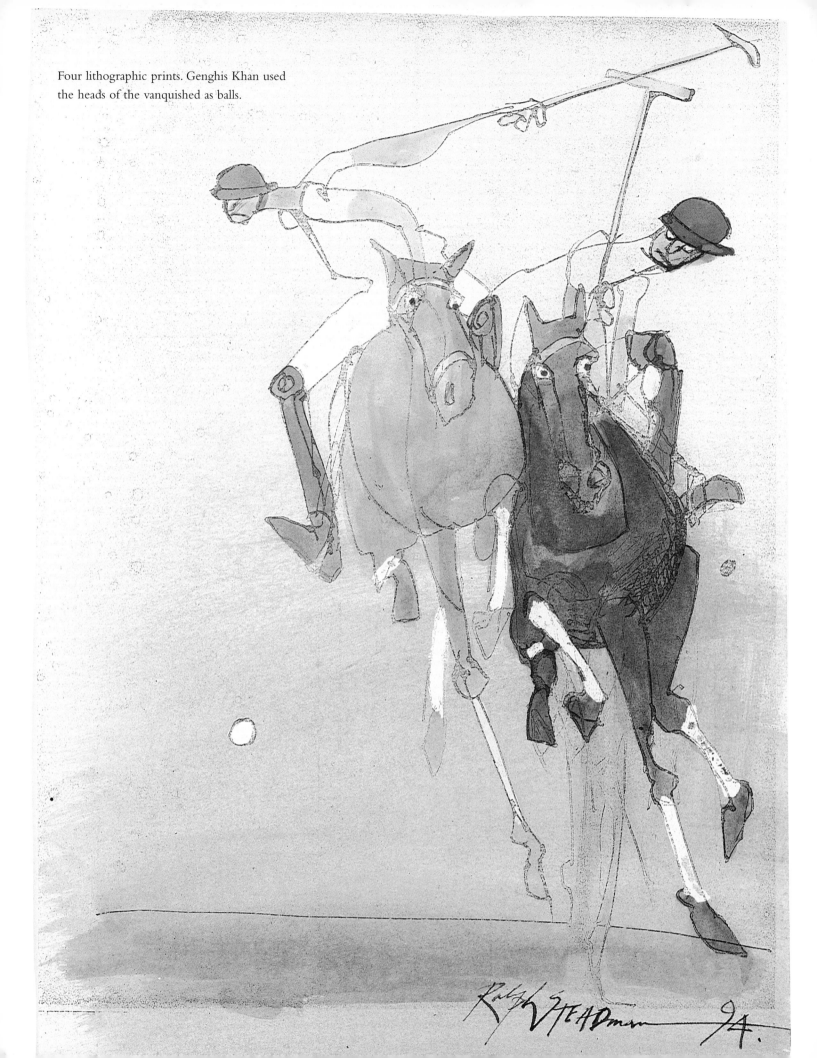

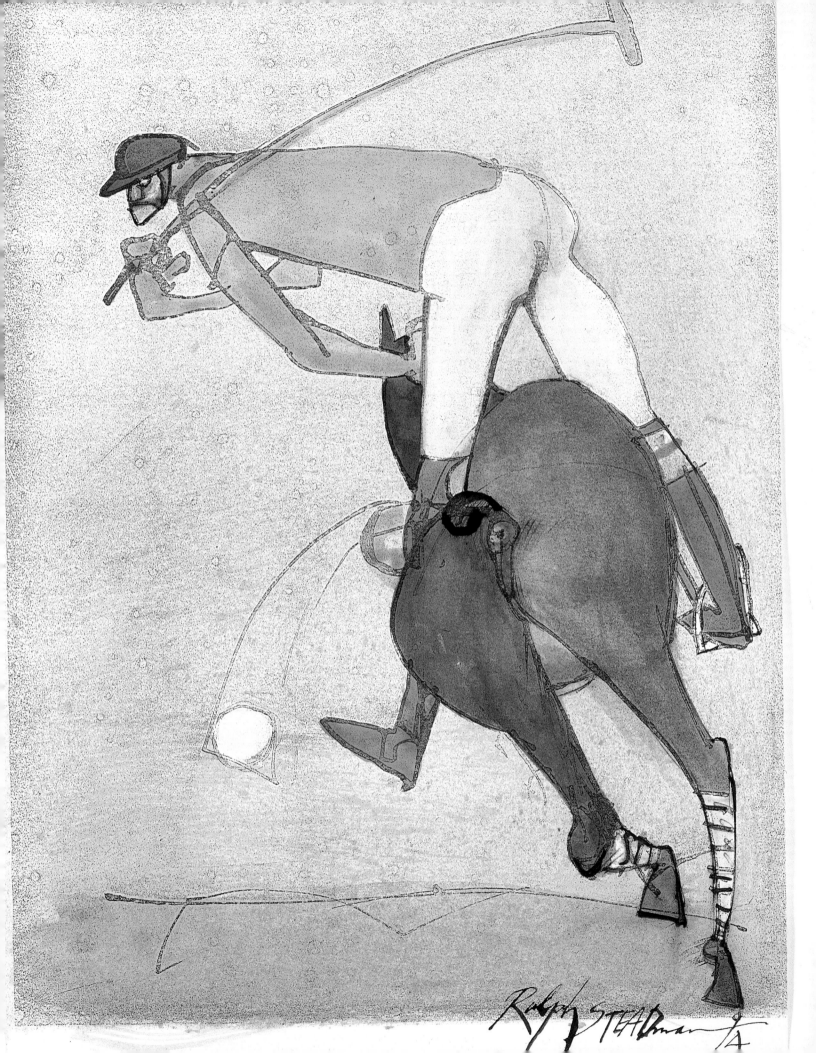

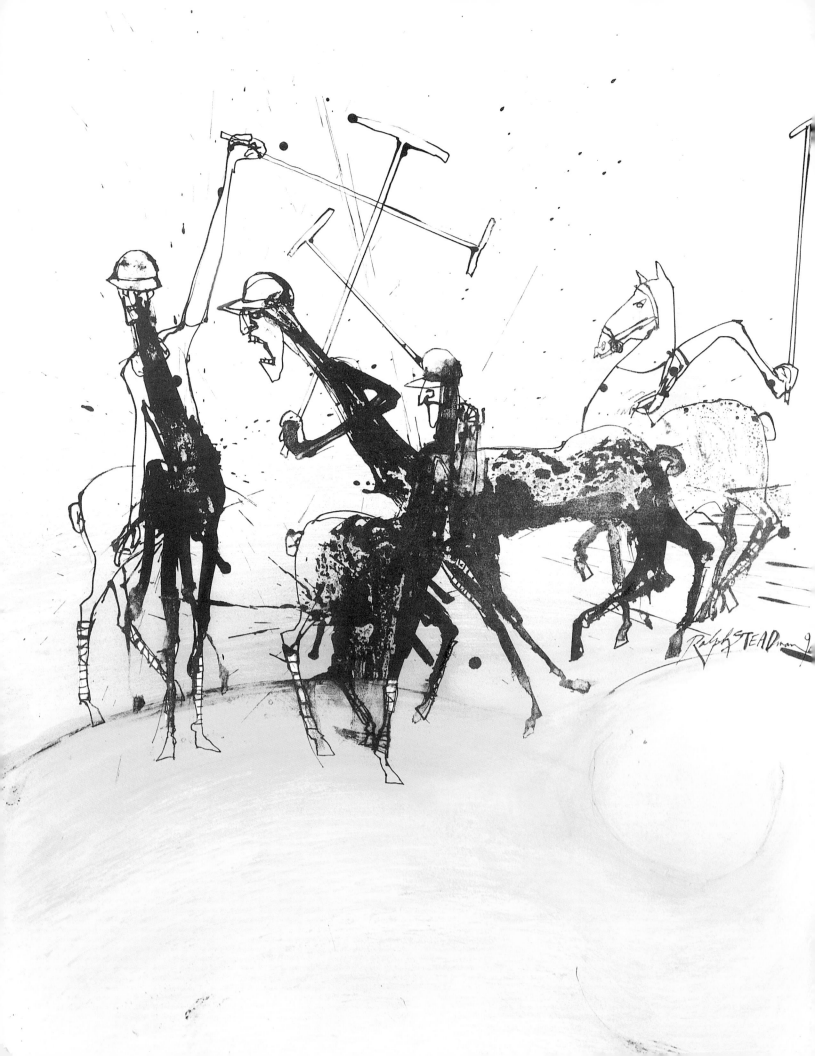

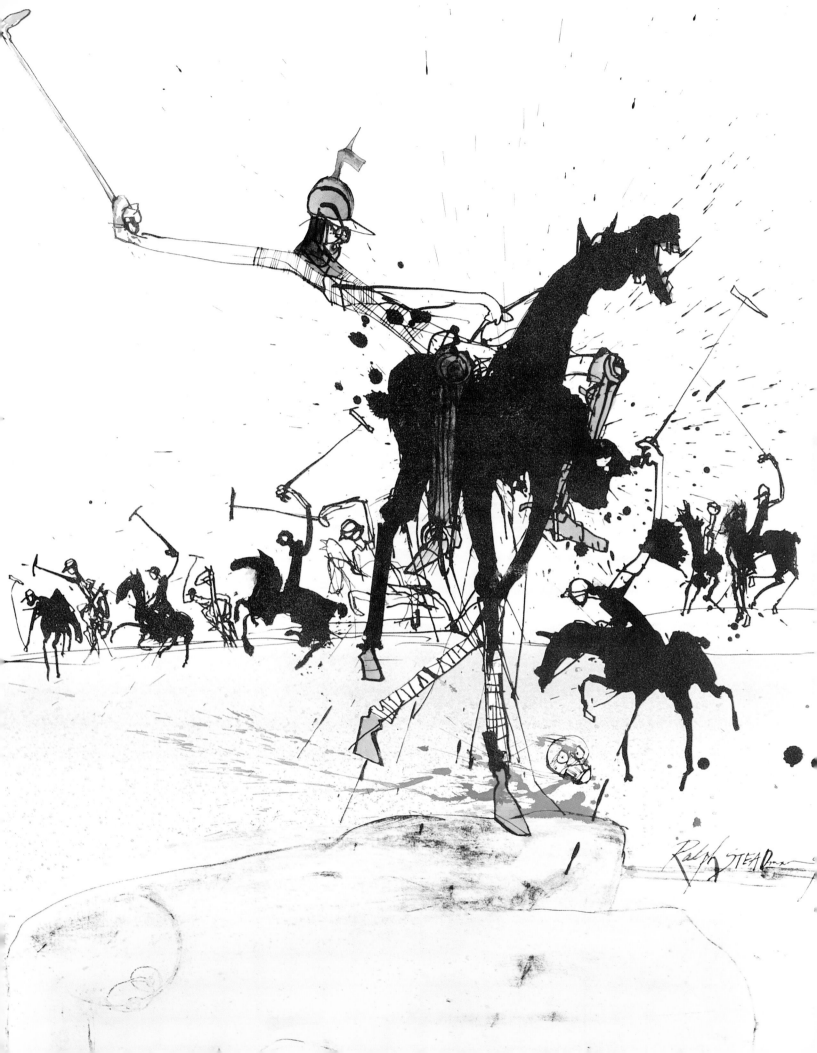

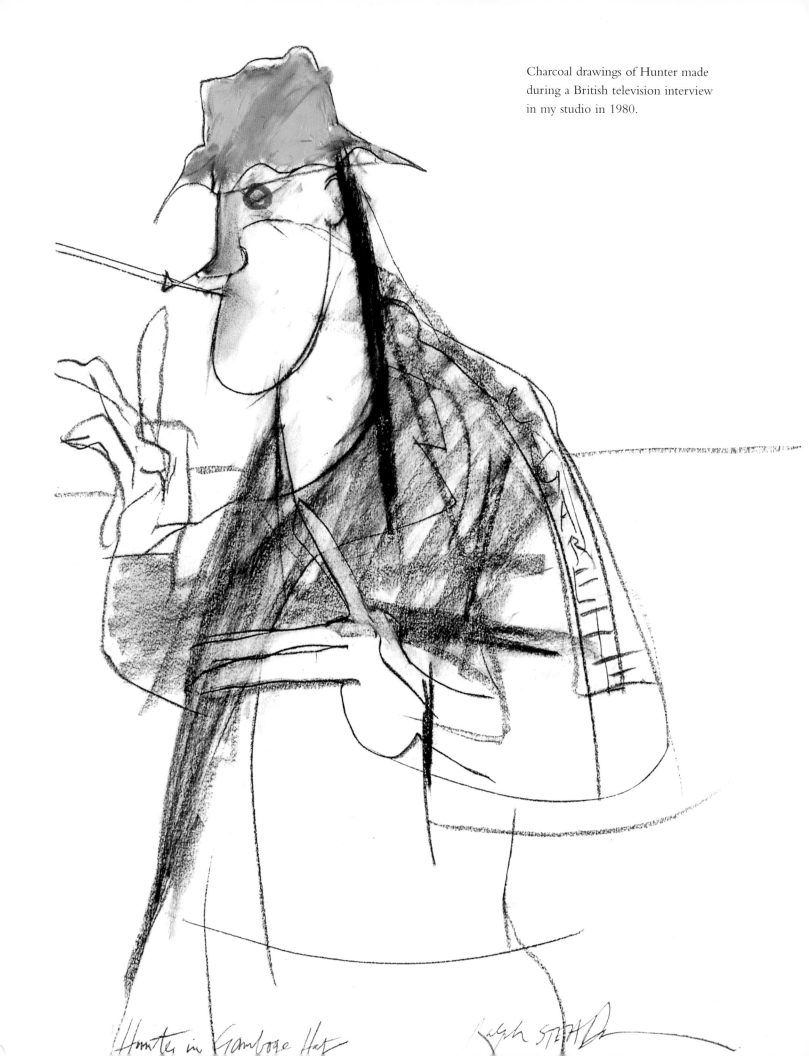

Charcoal drawings of Hunter made during a British television interview in my studio in 1980.

Hunter in Gamboge Hat

Ralph STEADman

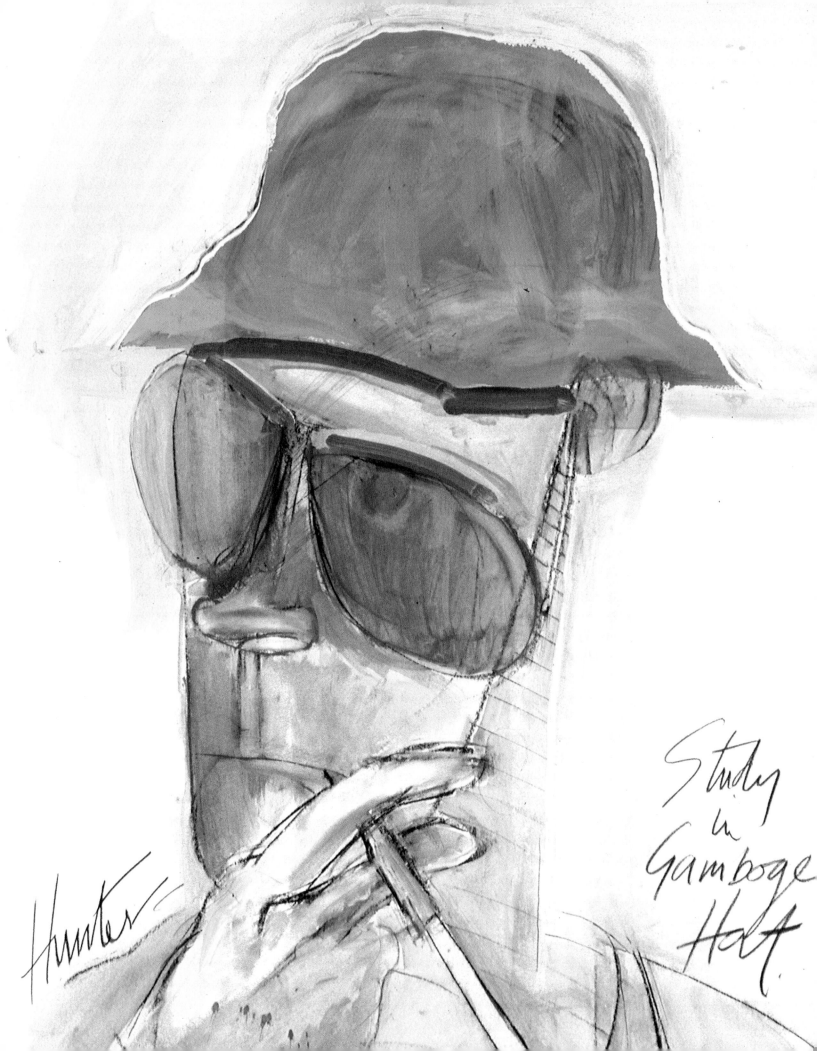

Hunter

Study
in
Gamboge
Hat.

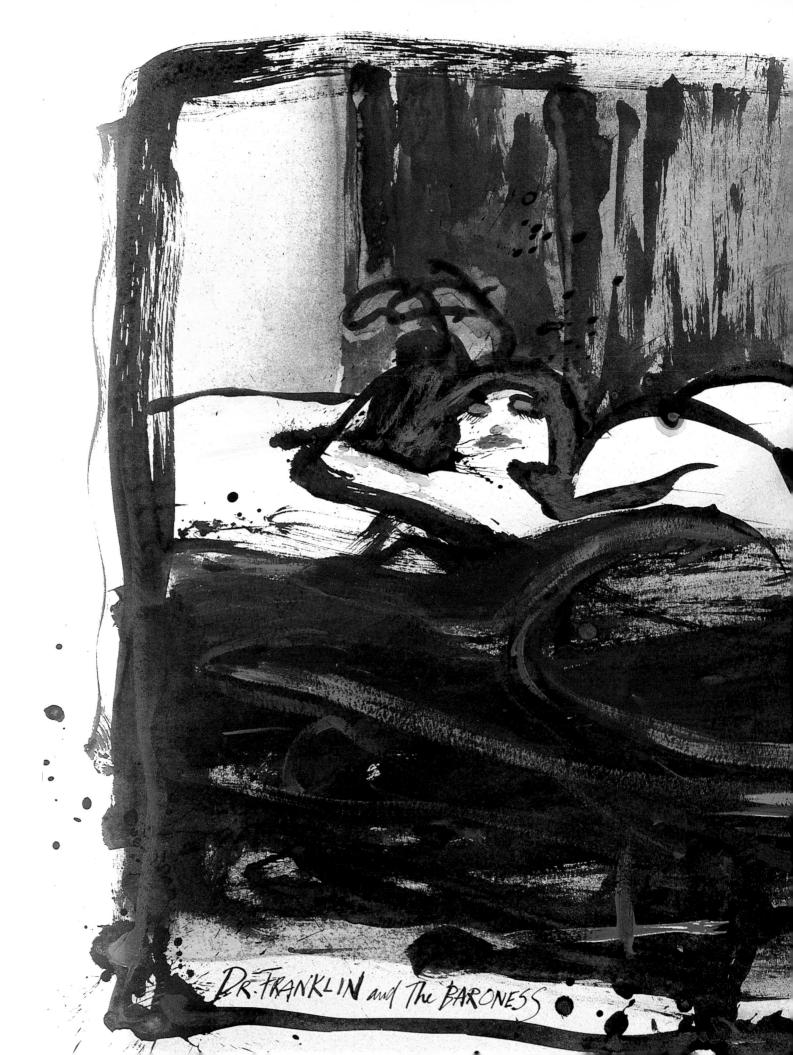

DR. FRANKLIN and The BARONESS

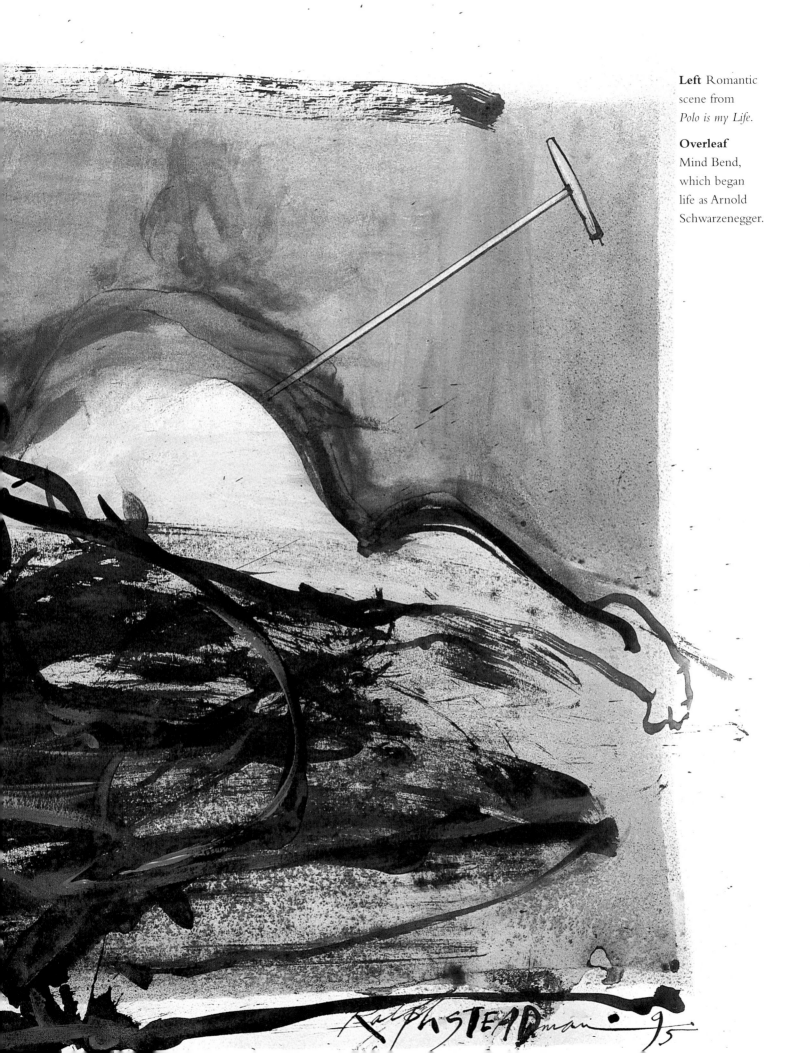

Left Romantic scene from *Polo is my Life*.

Overleaf Mind Bend, which began life as Arnold Schwarzenegger.

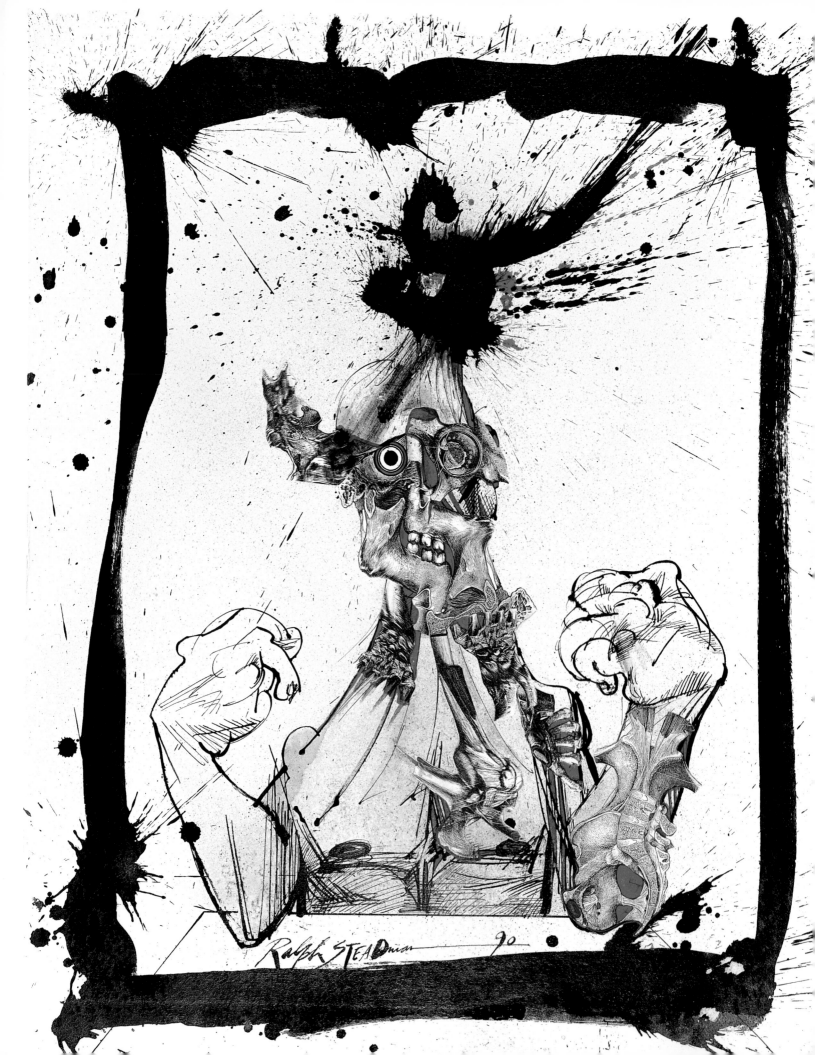

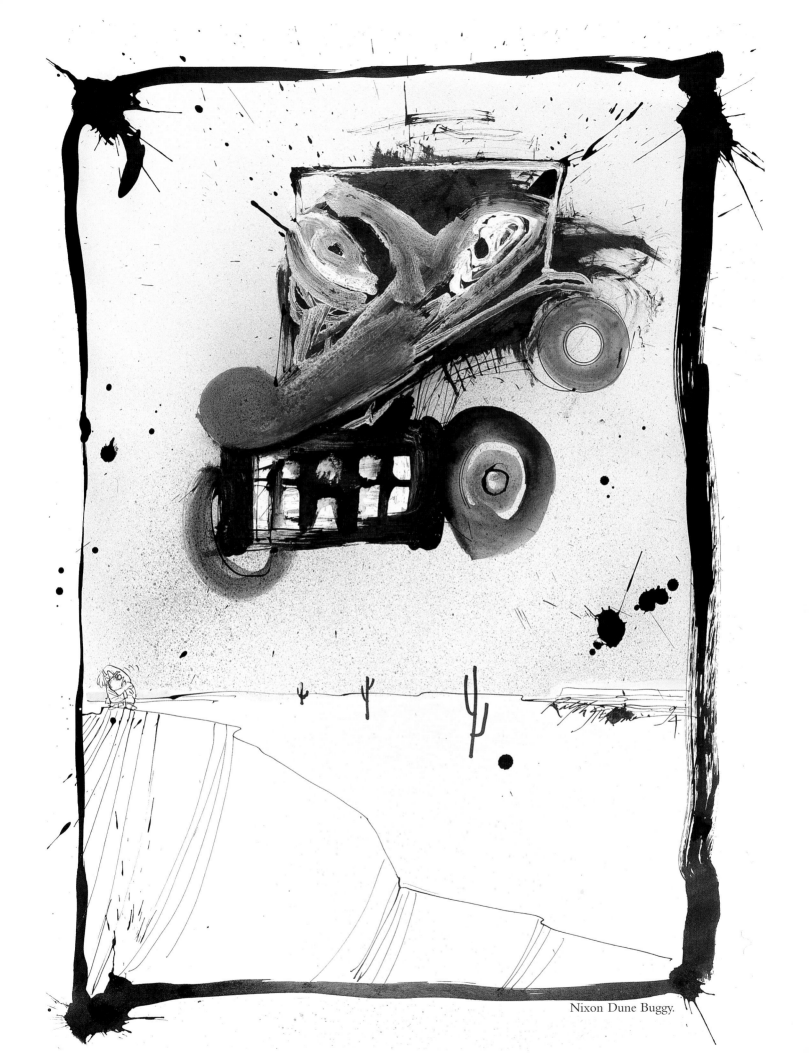

Nixon Dune Buggy.

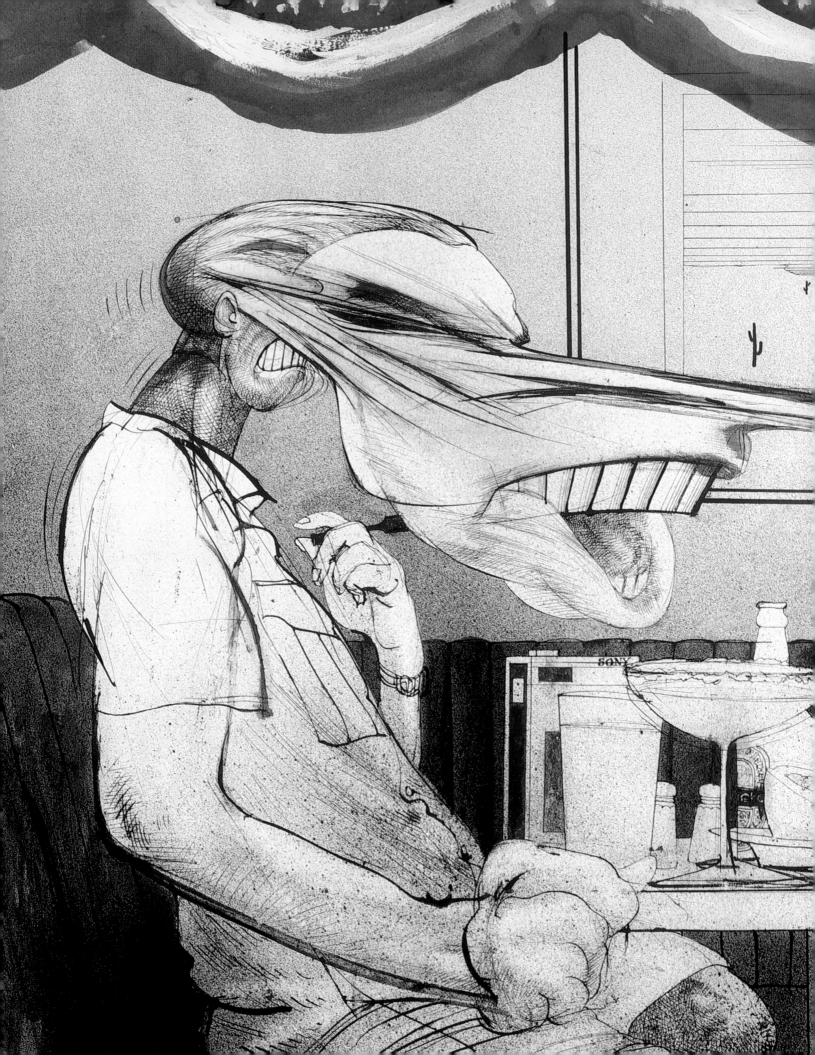

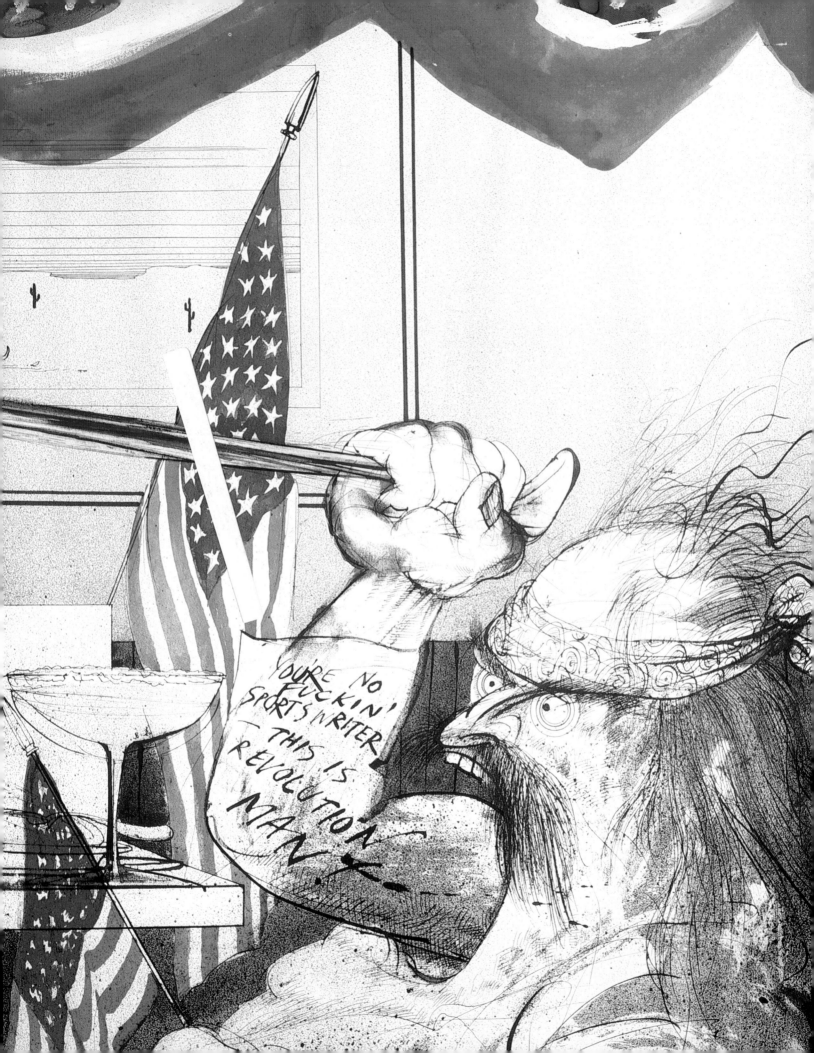

Above *Fear and Loathing on the Road to Hollywood*. Sequential images from Nigel Finch's 1977 film for BBC's *Arena*.

Previous pages Nixon mask. A scene from *Where the Buffalo Roam*, starring Bill Murray and Peter Boyle.

119

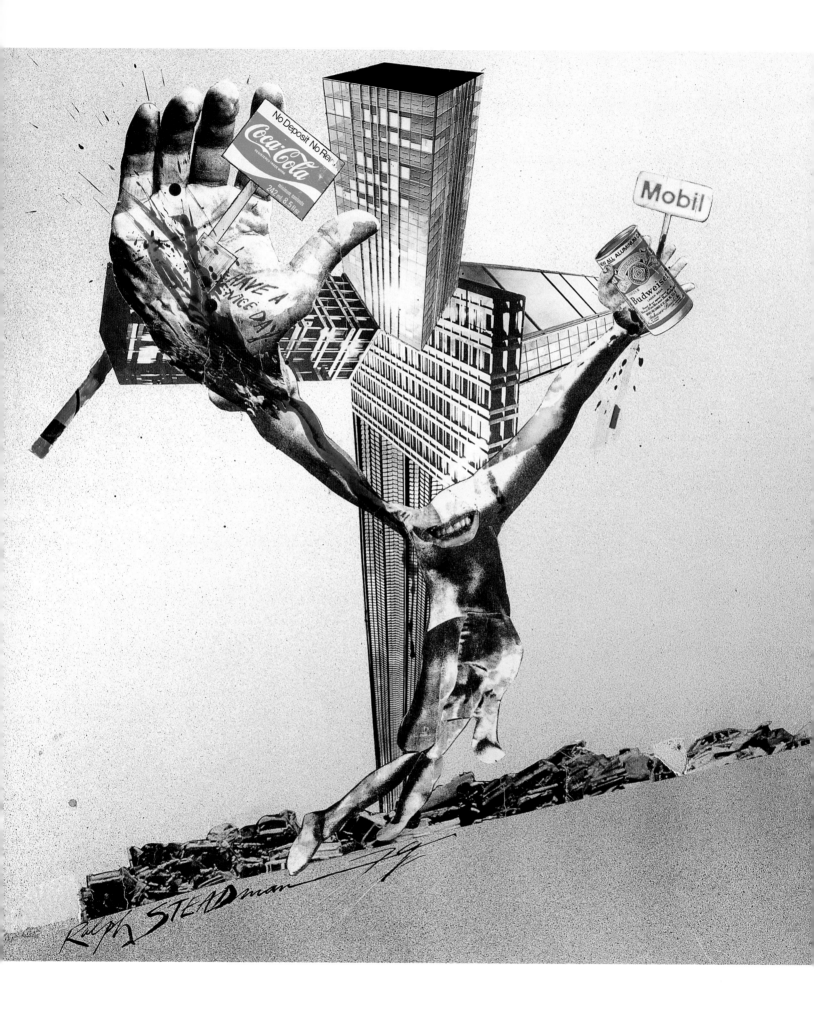

Left Good time crucifix. If you look at a sunset in Beverly Hills you will see the orange smog of self-indulgence hanging above the city.

Below Nixon crucifix. He was always part of my landscape, strong as a tree.

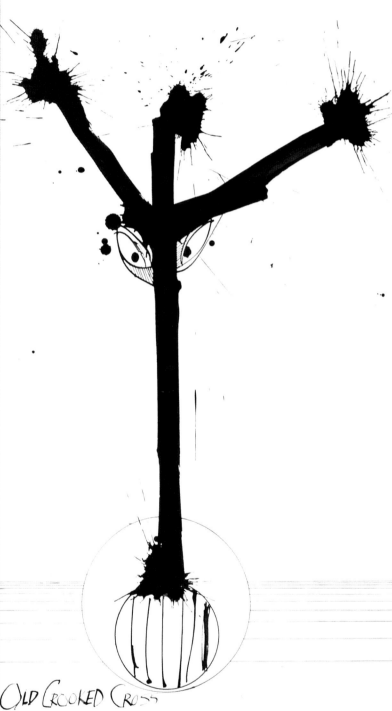

OLD CROOKED CROSS

Overleaf Erlichman and his lawyer. All I could see at the Watergate Hearing were surreptitious whispers into the ears of defendants as they worked to subvert the course of justice.

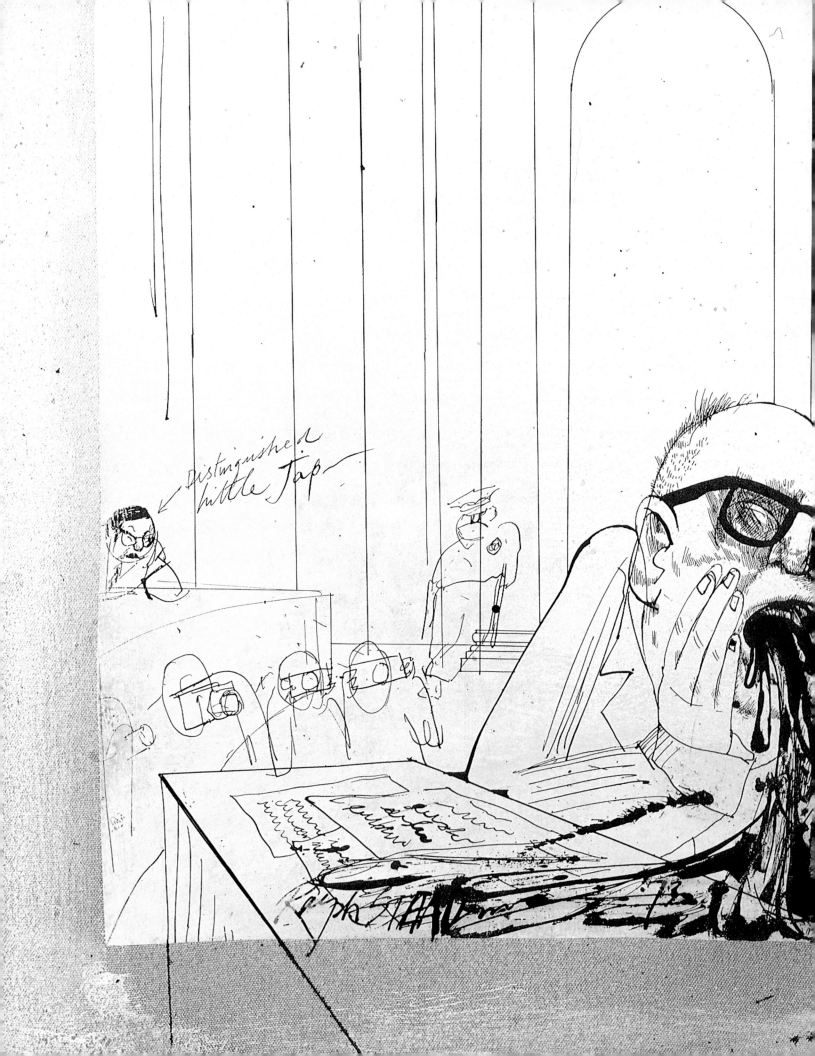

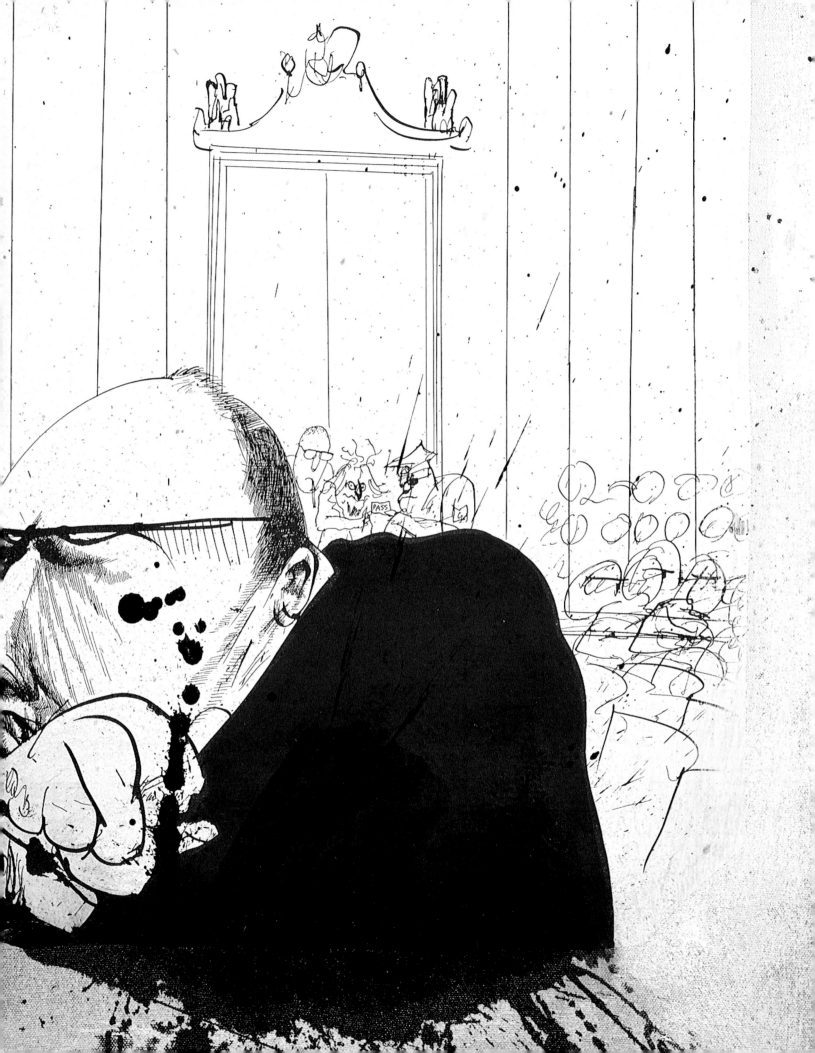

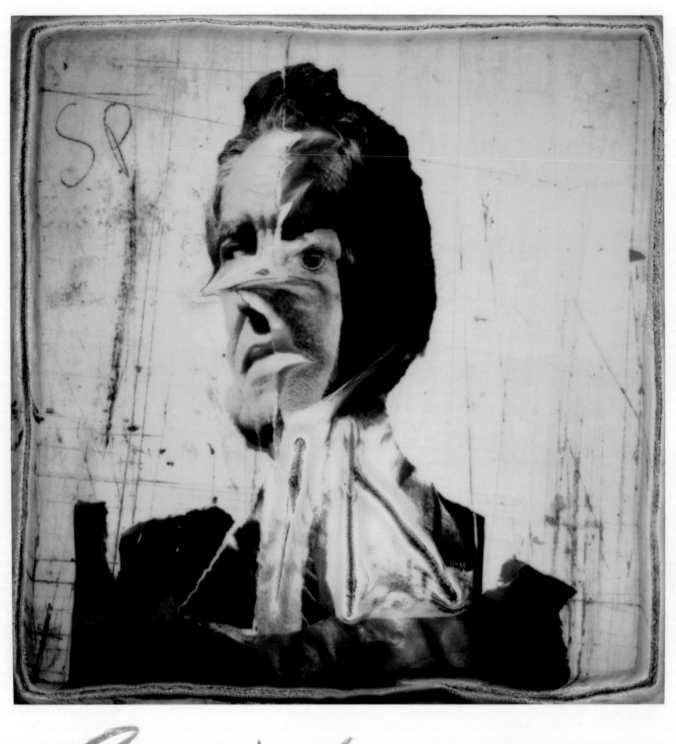

Paranoids. My way of achieving unexpected results with photographic immediacy.

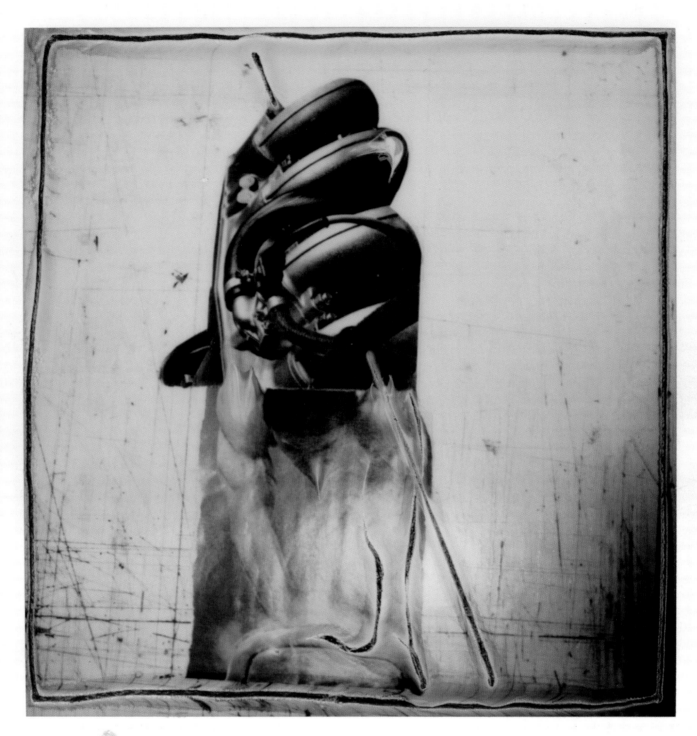

Revolutionary

Ralph STEADman 5 Mar. 76

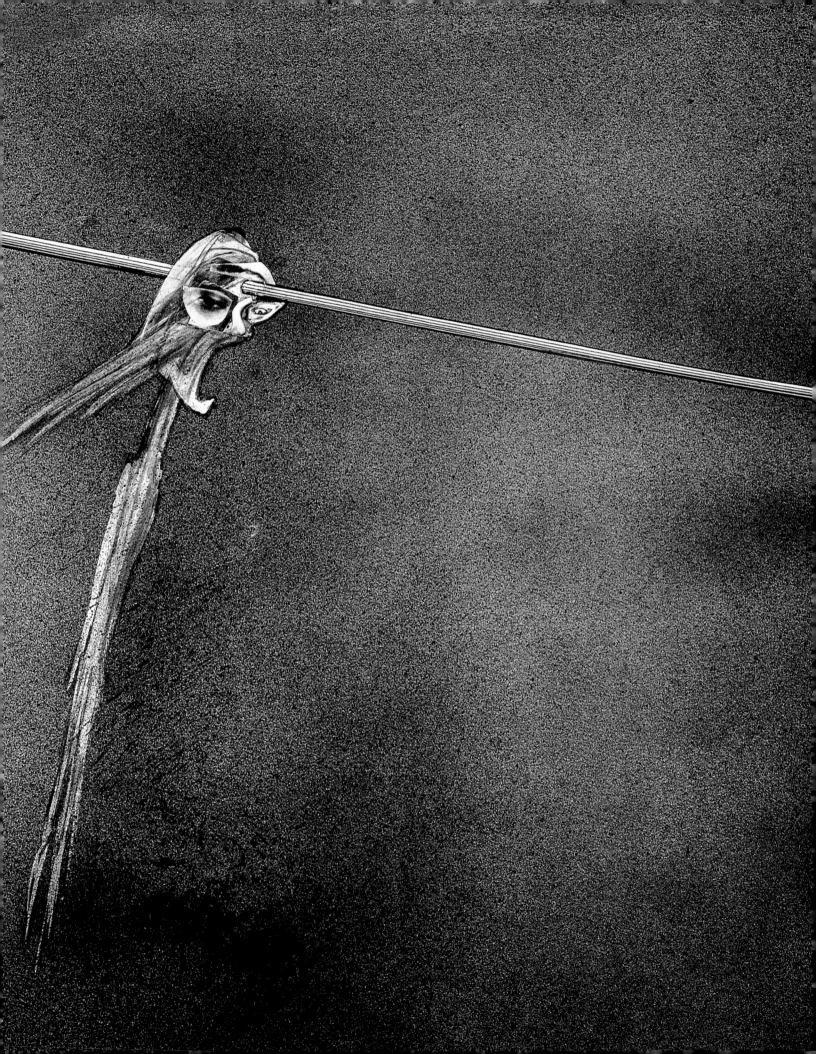

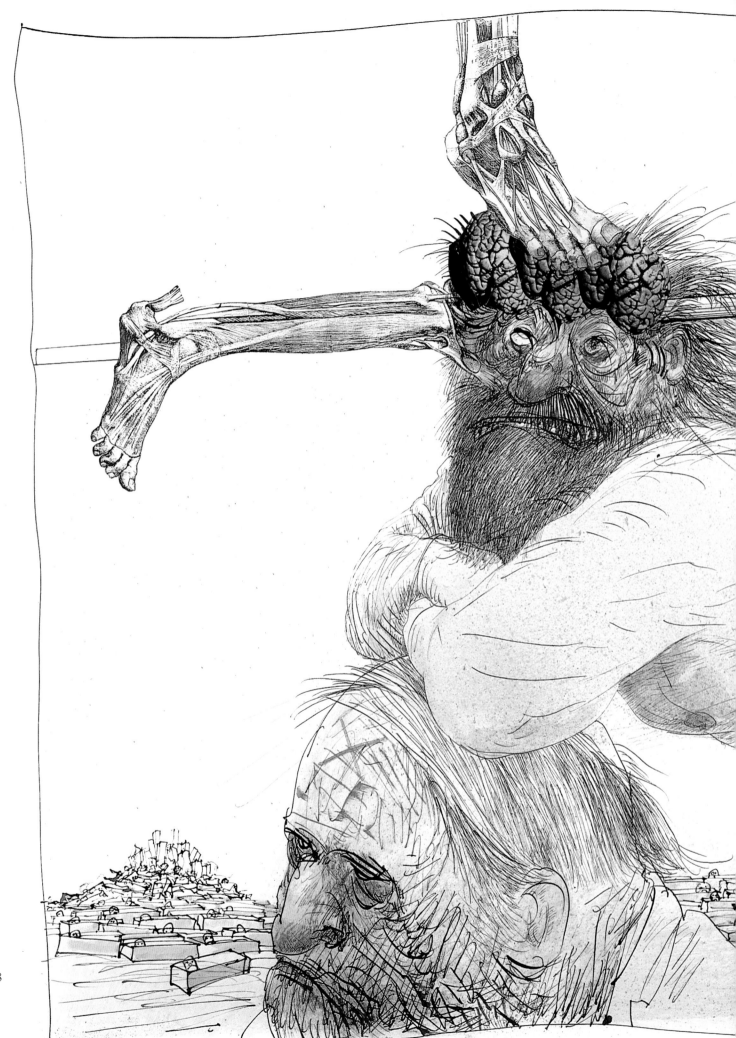

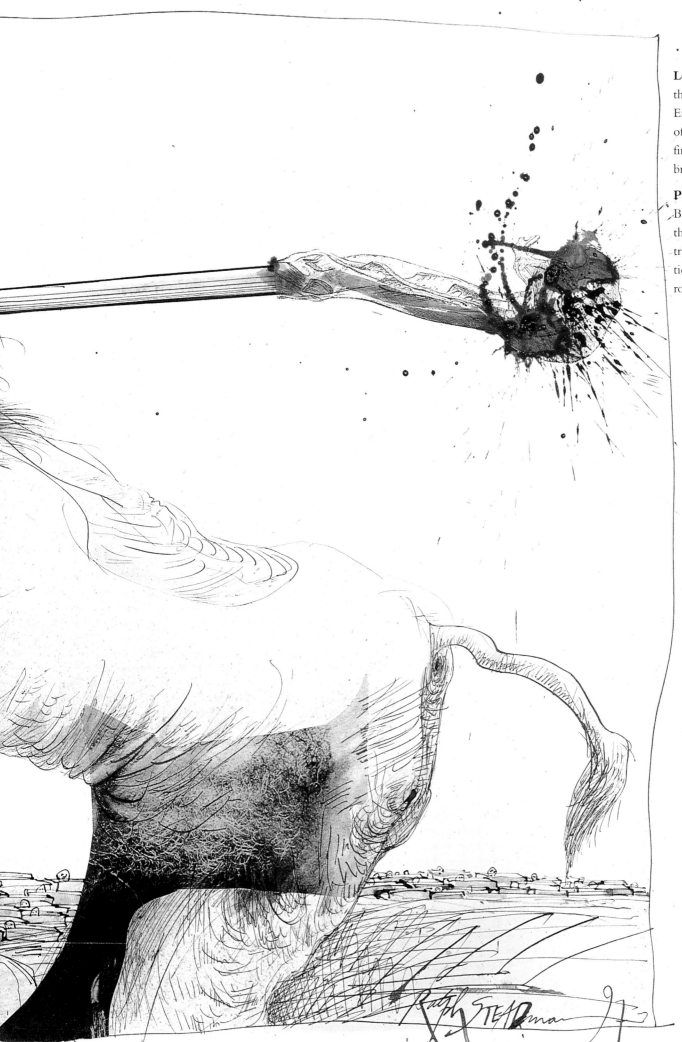

Left Can't think, can't vote. Eighteen years of Thatcher has finally done my brain in.

Previous pages Brain-dead at the Patty Hearst trial. A one-way ticket along a rod of steel.

BLACK IS WEIRD

INTERCONTINENTAL HOTEL

H.S.T. in the pool during the 8th round. 30.10.74

Escaping from
Kinshasa
Oct. 74

Rolling Stone
lightning artists
impression

air zaire

PROPERTY DEVELOPMENT COMES TO HAWAII. *Ralph STEADman*

Left Zaire, 1974. Hunter and I covered the Ali-Foreman fight.
Top: Black is weird. Hunter wanted to hire the aeroplane which
declared 'President Mobutu welcomes you to Kinshasa'.

Bottom: Fight organizer John Daly's escape after the Zaire debacle.
Above No escape, from *The Curse of Lono*, 1980. Vultures bear
down on the corpse of Hawaii in a real estate feeding frenzy.

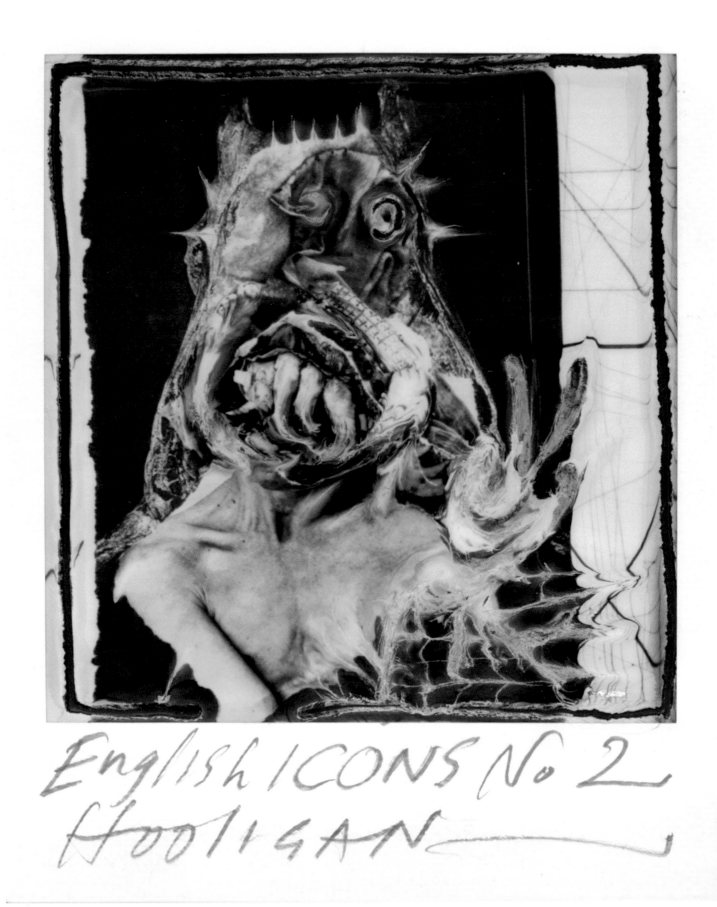

English ICONS No 2
HOOLIGAN

Left Running God, from *The Curse of Lono*. **Above** Icons we could live without. Paranoid, 1995.

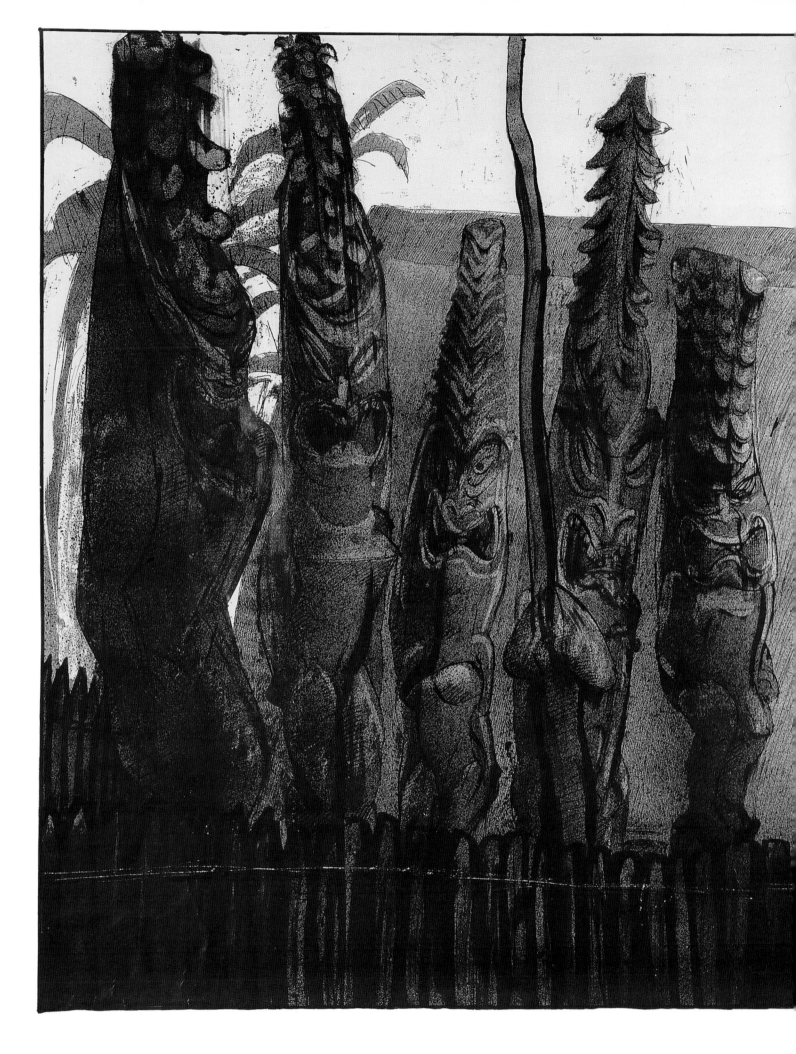

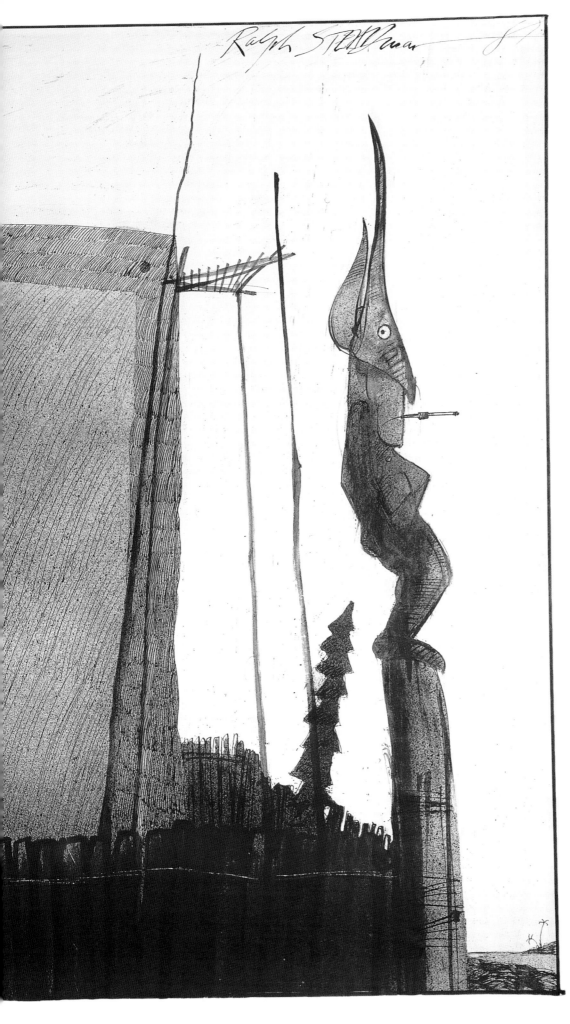

Left The City of Refuge, from *The Curse of Lono*, 1980.

Previous pages Christmas Eve, Hawaii, 1979. Hunter presented us with an enormous bunch of bananas which he decided would look best on the end of a diving board over the Pacific Ocean. He was right. An example of Conceptual Art.

Overleaf A Gonzo assemblage. Black and white acetate over a painting which has sat in my studio unfinished for more than three years.

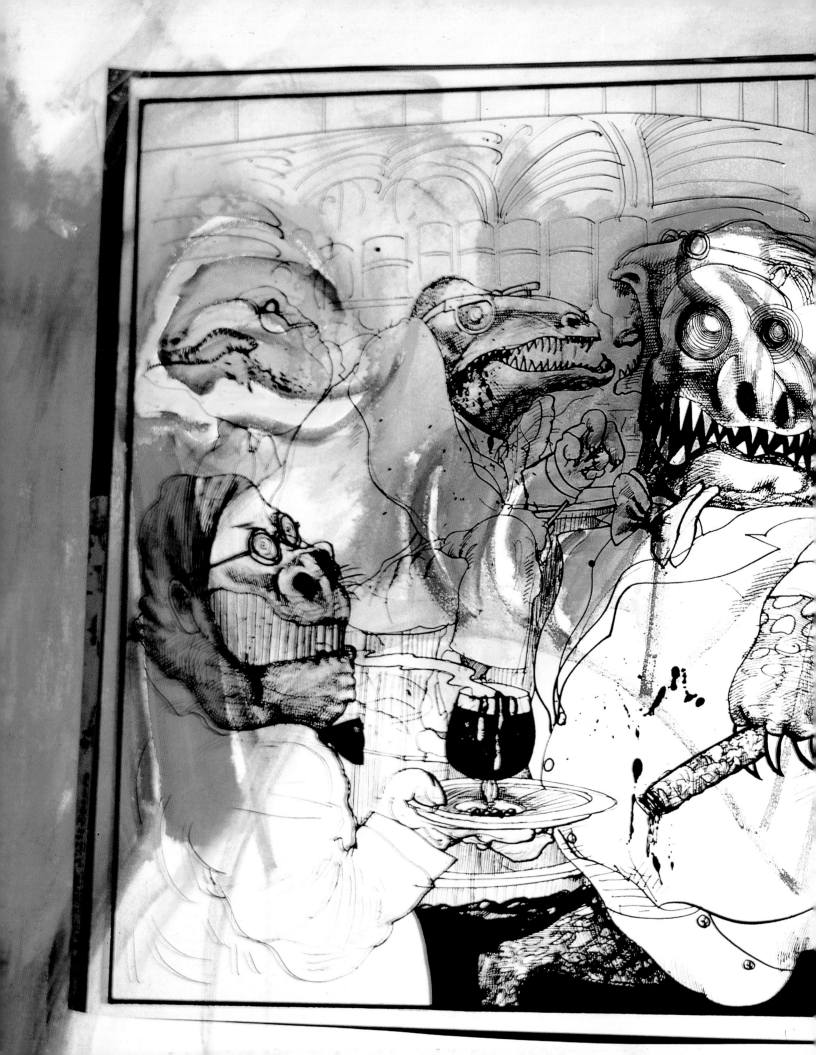

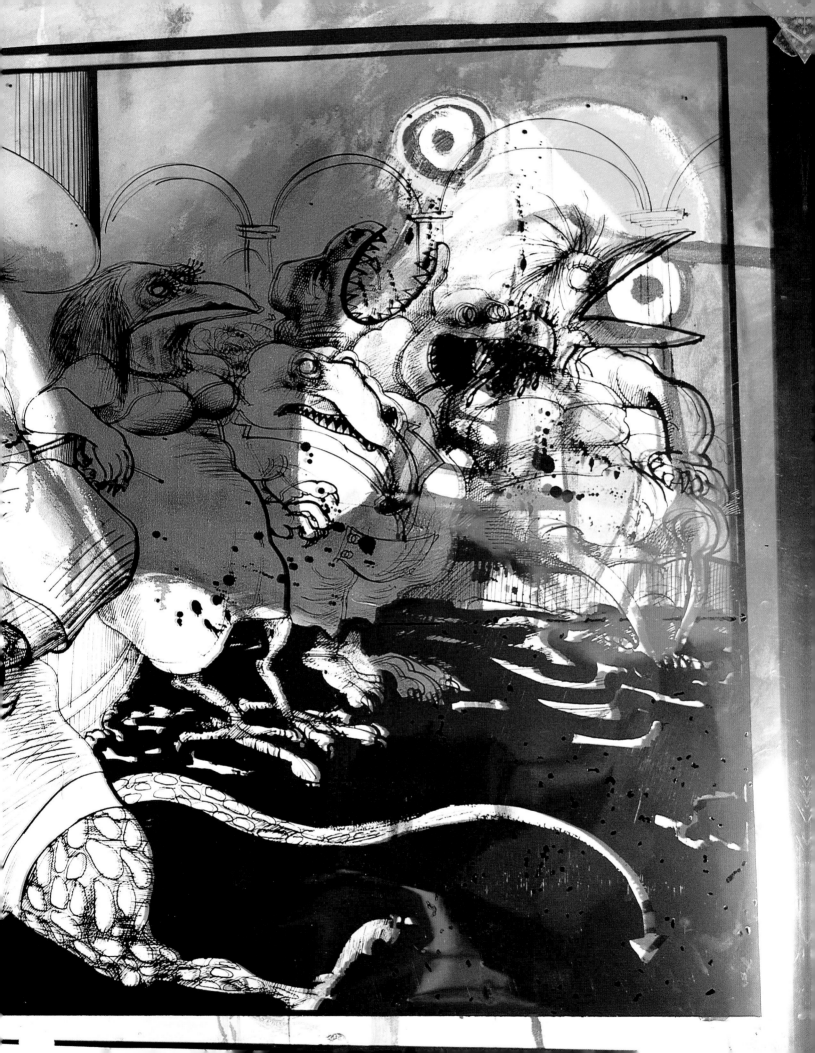

ALIENATION

13 May Kaiser Wilhelm Kirche – the Platz with the bombed church left as a reminder of how things had been and what happened. Accosted by a young girl who really laid into me. I was abusing my privilege of being able to gawk at the wasted lives hanging, lying around on benches, beyond my reach. She managed to make me feel like a real bimbo voyeur, probably right. Her language poured scorn upon me in profusion. I gasped with an overwhelming puerility. She cast her contempt upon me with withering looks and spiteful German profanities. My bland incoherence reinforced in her some already rooted belief that all wandering Westerners were shits and I was an archetypal example. I was chastened, ashamed, and for most of the afternoon, making our way to the Bauhaus Archiv Museum and its cheap austerity, I could not raze the incident from my mind. She had touched a tender spot. Why wasn't I drawing what I saw instead of snapping away like a package tour freak?

The reasons are strange and diverse and I am haunted by the possibility that I am not really an artist at all, but a poseur who makes convincing images of life hoping to touch the irony.

Then I was annoyed and wished I had been more assertive. Who the hell was she anyway? Throwing herself in front of the lens and then smacking my shoulder. That is what caught my attention. Hang on, lady! She was right, for God's sake, but she was also wrong.

Maybe in her wreaking German she was demanding money. Instead I decided that she was a noble creature protecting the ethnic wretchedness of life on the street.

At the centre of the Eastern sector of Berlin is a street called Unter Den Linden (Under the Linden Trees). It's a pretty name for an avenue of opulence and magnificent architecture, which the Russians must have been fully aware of when they pushed themselves as far west as the Brandenburg gate – annexing it completely for themselves before the 'allies' knew what was happening. If you look at a map

of Berlin you will see the border at that point stick out like a phallic thumb.

A must is the block of flats designed and built by Walter Gropius in Lipschitzallee. A dream lived out as a nightmare. The sense at the Bauhaus Archiv Museum was that we were in an underfunded art school. A depressing experience for what should have felt like a pilgrimage to a shrine. It occurred to me that it is not the work the Bauhaus created which is important so much as the spirit of resurgent power which infected the course of twentieth-century design.

The satellite town of Marzahn was perverse – like a show house, but the houses were blocks of flats, a whole city of them marshalled into avenues and occasional squares across vast acres of flatland. Some parts looked cared for and others were suffering the fate of most high-rise schemes where development has overcome the sum of the people's attempts to make something decent out of not very much. Battery farms for breeding more little communists, with the sparsely stocked shops situated beneath the living quarters. A few stalls selling Western rejects were scattered along the promenades along with cigarette pedlars operating on the tops of cardboard box stalls, each with a total stock of probably no more than five hundred cigarettes.

One man wandered around offering cheap West German novels – remaindered books. We ate good, bland peasant food, boiled potatoes, bockwurst and sauerkraut with decent beer.

To reach this oasis had cost only 20 pfennigs each – you punch your own ticket and you're in! And if a fine pair of leather shoes had fitted me at 19.50 Deutschmarks it would have been a steal of a day out. The bleakness of the area says that community had been sacrificed to the ideology. Spirit surfaced as indomitable human idiosyncrasy, which does not succumb to numbing standardization. Balconies express a difference and shine out like beacons of hope on grey facades of defeat.

14 May Took the U-train from Urlandstrasse to Kottbusser Tor. It was raining and dreary. We walked up to Oranienstrasse in search of Elephantum Press Galerie where we expected to see pieces of the Wall on show. Instead there was a show on the Gulf War. Impressive atmosphere of destruction, and war sculpture figures made from jagged rubbish and gas masks. Spiked mattresses used in warfare to impede an enemy's advance. A sound system sent out rumbling explosion noises in the distance, reminiscent of sea pounding rocky shores. Continued up Oranienstrasse towards Checkpoint Charlie through the Turkish quarter. Stopped for a strong coffee in a café full of card-playing Turks and thick cigarette smoke. The phone rang intermittently. A card player would answer, or not. Through the rain and dour street scene passed Moritzplatz into greener areas. (Axel Springer Haus on our left looked very ungreen.) Now running parallel to the Wall just a hundred yards north on our right. Made for Friedrichstrasse, the street on which Checkpoint Charlie is situated. On the corner is the museum of the Wall's history.

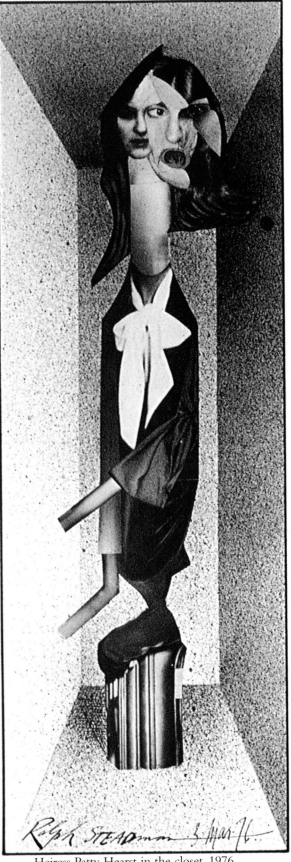

Heiress Patty Hearst in the closet, 1976.

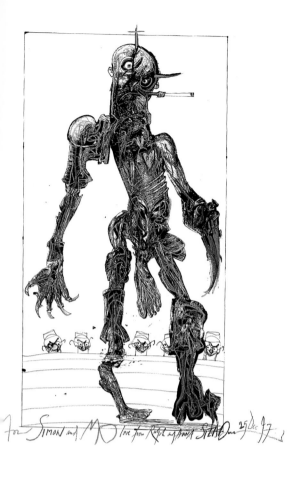

The thought of the Wall and the pieces that remain scream of the bureaucratic idiocy that built it. The arrogance of political decisions leaves the mind gasping for air...

Along the Oranienstrasse vivid reminders of Bauhaus influence stood alongside old blackened survivors from an older Berlin. Functionalism reflects grey slabs in dark windows. Grey seems to be the colour that inspires a graffiti artist to create his original language of protest, resentment and a particular brand of sickly joy.

I remembered looking over the Wall the last time we came to Berlin, four years earlier. I'd shuddered. Ugh! Where is the life? All around we could see nothing but grey across a bleak no man's land, not realizing that beyond it all, pockets of colour thrived. Little shops, cafés, markets – people made their life the best way they could. The official facade hid a million squeals of brief joy as people got on with their day, between the heavy slabs of authority. Everyone had a job, whether they wanted one or not.

Walking through the streets around the Rosa Luxemburgstrasse life had not been still. Sometimes a brashness of graffiti-coloured walls exploded amongst piles of rubbish as though for a moment – maybe...

15 May Today is my birthday and therefore special. Birthdays always are. Mine especially, and the brutal dark edifices of Berlin, East and West, will not crush my spirit.

Took the train from Charlottenburg station to Lehrter Stadbahnhof just outside the boundary wall and made our way towards the Reichstag across a field, an area of parkland. Got there just as a heavily guarded entourage with police escort arrived in a convoy of five Mercedes. It rained and got very cold. We were still on the Western side. A memorial to people who had tried to escape after the Wall went up, close to the Spree Canal and along the back of the Reichstag. A line of asphalt marked the place where the Wall had stood. In the mind it still existed. Looking along the Clara Zetkinstrasse the line curled around the open square, the Brandenburg Gate and across the Strasse des 17 Juni and onwards south towards Potsdamerstrasse where excavation was moving on as though a desperate attempt was being made to obliterate a hideous curse. People had suffered inside someone else's grubby idea and now the wind blew fresh and cold across wide open ground – the wrong place at the wrong time 30 years ago.

We turned left through the Brandenburg Gate, past a military statue which had graffiti on its base saying NEIN KRIEG – No War; past the concrete sellers with their fake pieces of graffiti wall. Workshops are thriving somewhere in the city making broken concrete and employing graffiti artists to work the surface. The pieces lack that potent protesting voice that energized the political art of desperate souls. Military hats and uniforms were sold and you could take home a whole kit to recreate your own Checkpoint Charlie between yourselves and your neighbours.

The Unter Den Linden drives directly north on the Eastern side, an elegant boulevard reminiscent of the Champs Elysées in Paris – not quite so grand but with the same eighteenth-century idea of grandeur in mind. It is now embassy property. There

are some expensive shopfronts. Several were selling the normal Western electronic music equipment and other goods long denied to the East Germans. Had coffee in what appeared to be a literary café from the Wall days. Drawings of literary figures and photographs of poetry readings peppered the walls. Since it was my birthday we had a Rémy Martin Cognac with our morning coffee and I read a birthday poem out loud.

We arrived at the intersection with Friedrichstrasse which to the right leads south again towards Checkpoint Charlie. The buildings were getting grander and older, a more elegant Berlin which survived the mess of structured civilization, standing proud and bullet-scarred. Strong signs of earnest reconstruction and repair are evident, and examples of jutting new architecture, in bronze and white, masquerade as denizens of the new world order, blocks of authority, the official new thrust towards the twenty-first century.

We arrived once more at the Spree Canal, which had curled round to meet us, and took the boat ride offered at nine Deutschmarks. It showed the gentler side of the city, the rolling rumbling guts which had obviously seen the savagery of past conflicts from a sleeping position. The green-black mossy walls were peppered with bullet marks and here and there small tunnels large enough to take a secret rowing boat at night appeared at intervals along the waterline. The massive baroque church of the Berliner Dom heaved upwards on the island like half the world's weight, and cast a shadow of relief across our sauna-bath boat. We were enclosed in glass.

A German police motorcyclist in green leather sat on his bike at the bank and watched us turn at the end of our run up the canal. Beneath him on the upright bank, which he could not see, was written FREIHEIT. Freedom. A touch of irony.

On the opposite bank we could see further over the edge. We passed a concrete wall-monument, painted black in sections and picked out in white. Above each black section was a year: 1971, 1972, 1973 etc. At one end the Jewish star and other symbols in black on white. A people's home-made memorial, reflecting a memory of the Wall itself.

We passed huge new building projects with diverse architectural styles using surface colour and chiselled moulding in De Stijl-Mondrianic simplicity, and late twentieth-century versions of old geometric shapes, triangles, arches, diamonds and circles. The reconstruction stretched all along the Friedrichstrasse right to Checkpoint Charlie and there seemed to finish. It pulsed with stolid determination and though the money was running out a new age must be seen to be happening at all costs.

Again the outrage of the border and the tacky souvenir sellers irritated my spirit and I was forced to mumble fervent curses against the faceless instigators and upholders of such an arrogant presumption as the Berlin Wall. That any human being on the face of the earth should be allowed such swingeing and mind-crippling powers is beyond patient understanding. It is the right of no man. The mind wrestles to comprehend a sequence of events that can lead to such an impasse of reason, that

can foster an army of halfwits to impose the regulations that hold a divided nation in mortal fear and can at the same time inspire such ingenuity in those whose only ambition was to escape. It was as though some people, the majority, who had hardly left the strictures of a world war behind them, were now led to accept like lambs the patently insane idea of a toy wall, a concrete copy of the real thing, because their minds were still paralysed by the recent experiences of their formative years or, in the case of the old, were too feeble to object or even to remember a better time. It was somehow normal. Of course a concrete insult must be smashed in place across roads, along the sides of buildings, through private living rooms, across windows and along river banks, around monuments, and down already miserable side streets to emphasize a madness long out of control. Why should it be otherwise? Life always was a wall, so to build a replica of life was like a statement of fact. A piece of state art.

Not all FUN and BALLOONS

Caricature and the satirical graphic print are as serious an art form to the eighteenth century as Cubism, Surrealism, Futurism and especially Dada are to the twentieth.

The directly drawn social image is as aesthetic as it is cogent, as much the marks of a deliberately drawn magical shorthand as it is rumbustious travelling street theatre, cheap and accessible for the best of possible reasons – to reach the people. These works would not have hung as pictures on tastefully decorated drawing room walls. They were portable broadsheets easily secreted and nonchalantly slipped, like gossip, into the hands of some other mean swine who longed for a joke at someone else's expense. Which is why they earned their reputation as examples of 'low art', but art nevertheless, for in the hands of masters like Hogarth, Rowlandson and Gillray great levels of composition were achieved and displays of brilliant draughtsmanship accomplished – something which was not accidental.

Goya's great series of satirical prints, the *Caprichos* (Caprices), etched during the closing years of the eighteenth century, for me provide irrefutable evidence that the

spirit of the cartoonist has always thrived and will continue to thrive deep inside the great art of all time – subject only to degrees of excellence, or lack of it. There is no dividing line. There is only good and bad art.

A common bond unites all visual expression. Painters are frustrated cartoonists, tortured Hamlets wanting to play clowns. Hey! Hey!

The conventional idea of the cartoonist is inadequate. The cartoonist is no longer the official court jester.

The anger in my drawings is an expression of frustration with the limitations of a newspaper and what is expected editorially. The only time I can remember feeling at home was during the years when I produced a great deal of work for *Rolling Stone* magazine, the NIXON years. Maybe I owe him more than I realize.

Imagine a world without television exposés and well-organized journalistic investigations and you can grasp the startling responses these damning printed images had the power to provoke.

There is a dark primeval spur in all drawing, a deep desire to wield a supernatural power over a victim, the subject of the portrayal. Cave painters were the originators of caricature, their victims being the animals they were about to hunt to survive. The marks on the walls of caves would not have been mere decoration, but an attempt to exorcize fear, to encapsulate within a line the tangible identity of the next meal. That isn't art at all, any of it, but the very real need to confront danger and to overcome it. An awareness of the aesthetic potential would have been a slow process of human enlightenment and sophistication, fully realized and exploited subsequently throughout the history of all great civilizations.

Overleaf Masks. Behind a mask of anonymity, tribal identity and group strength are maintained. From *The Big I Am*, 1988.

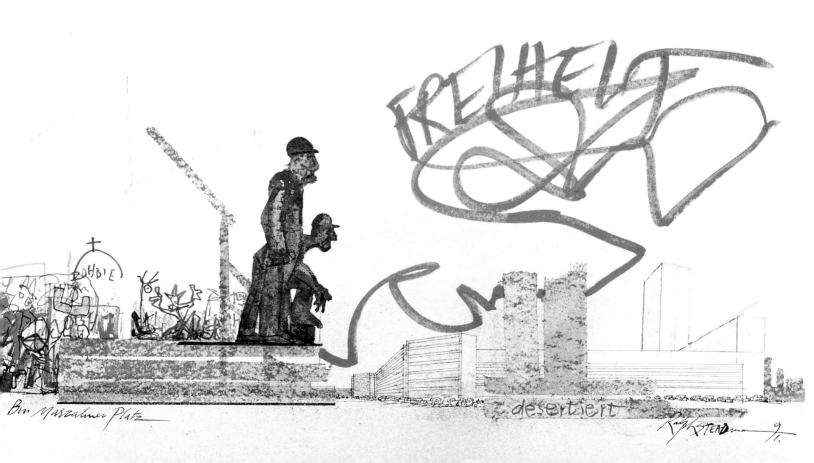

Bln Marzahner Platz desertiert

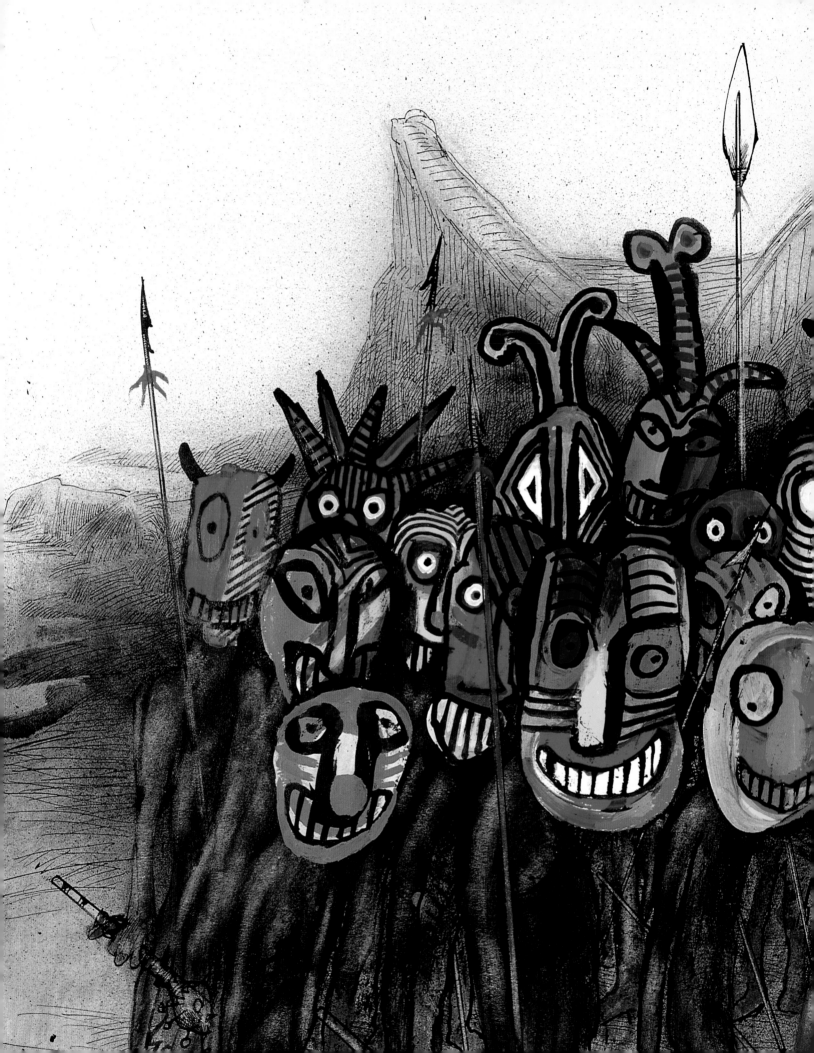

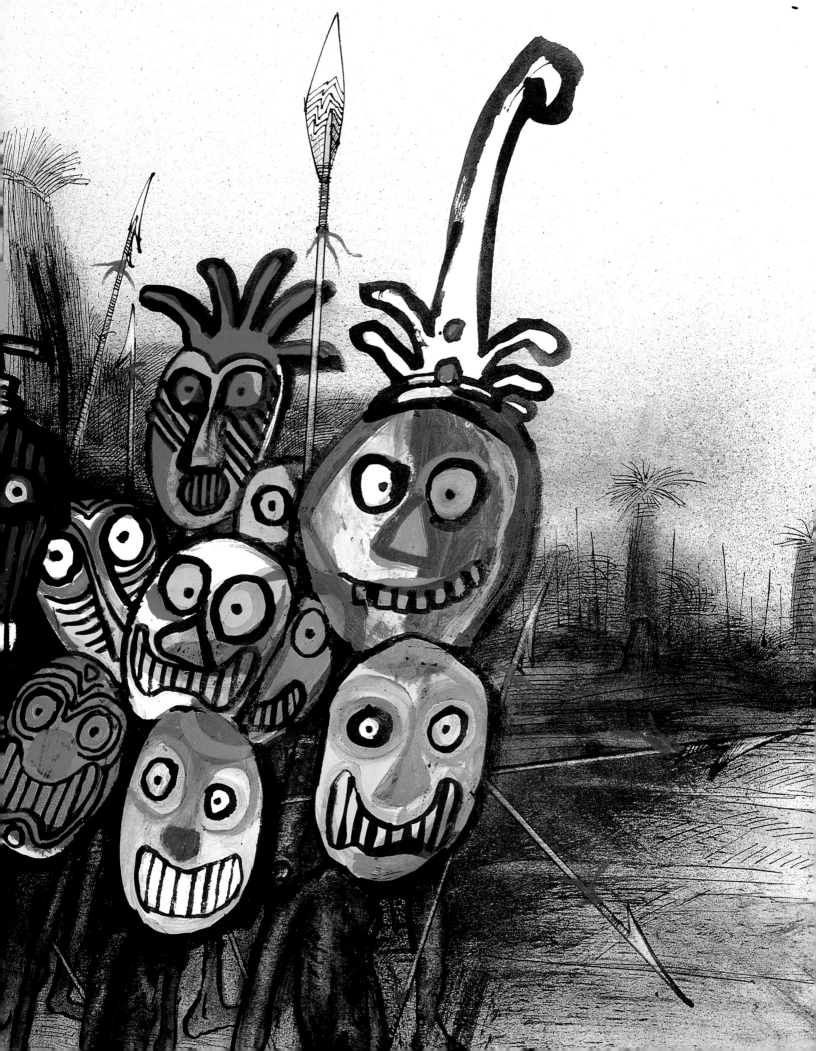

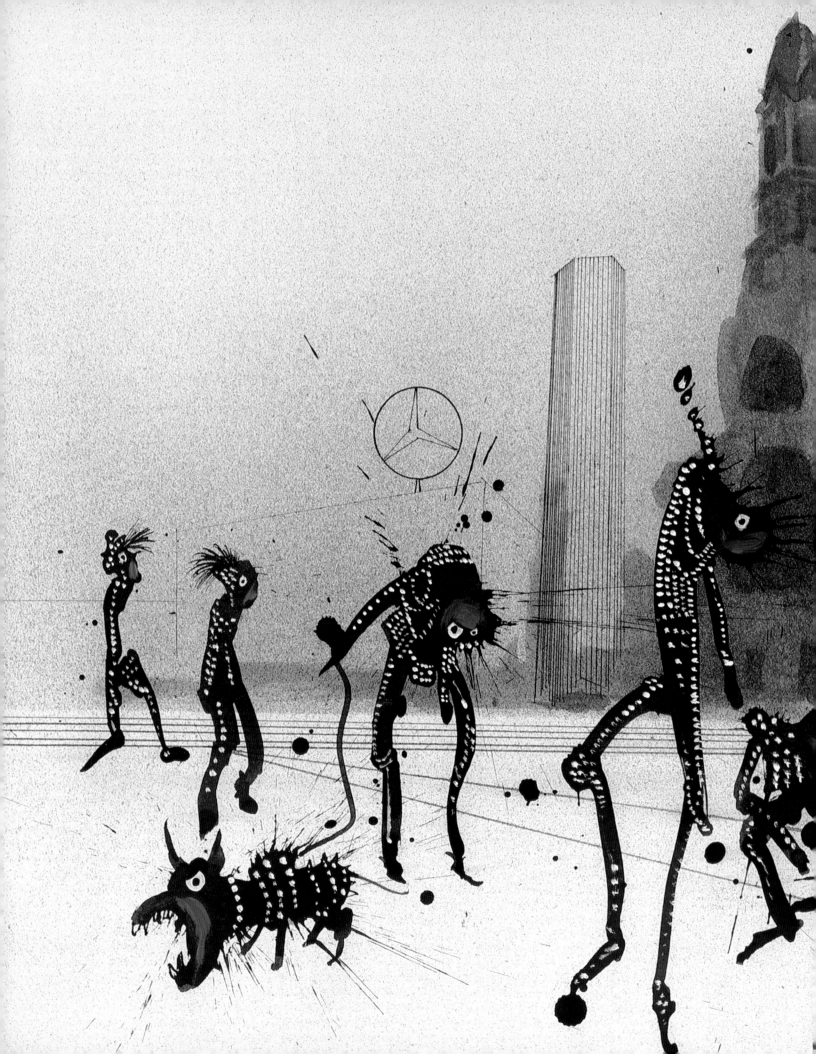

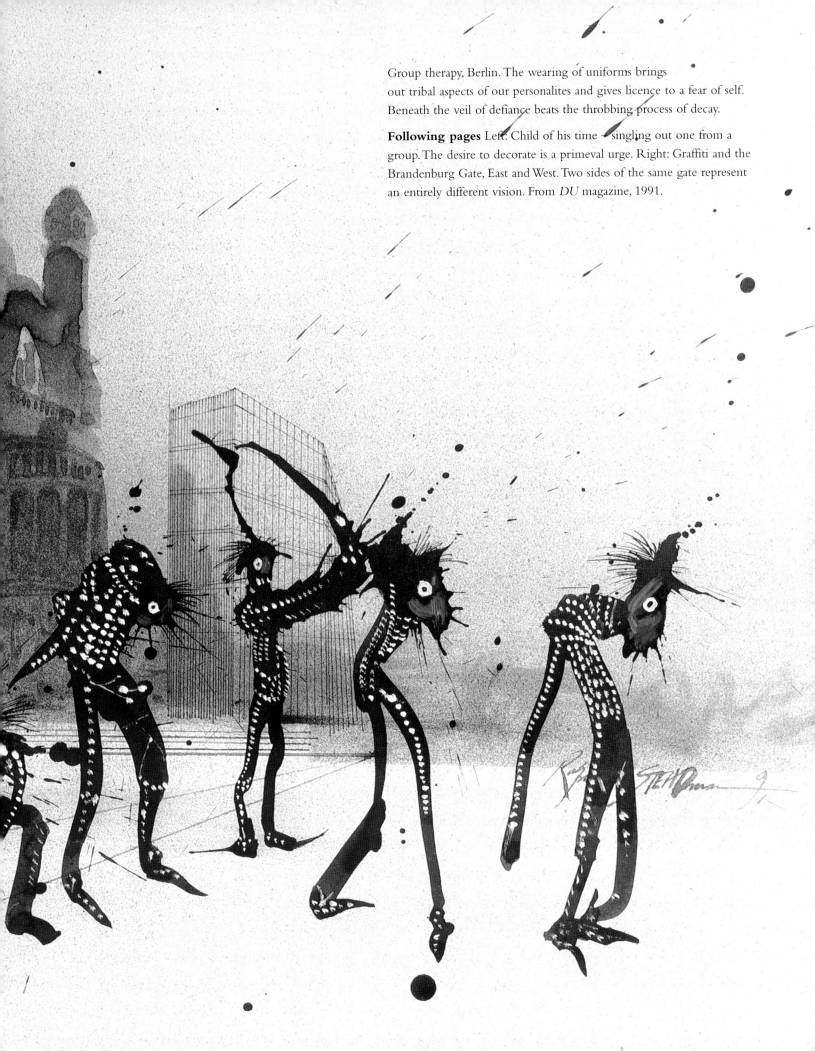

Group therapy, Berlin. The wearing of uniforms brings
out tribal aspects of our personalites and gives licence to a fear of self.
Beneath the veil of defiance beats the throbbing process of decay.

Following pages Left: Child of his time – singling out one from a
group. The desire to decorate is a primeval urge. Right: Graffiti and the
Brandenburg Gate, East and West. Two sides of the same gate represent
an entirely different vision. From *DU* magazine, 1991.

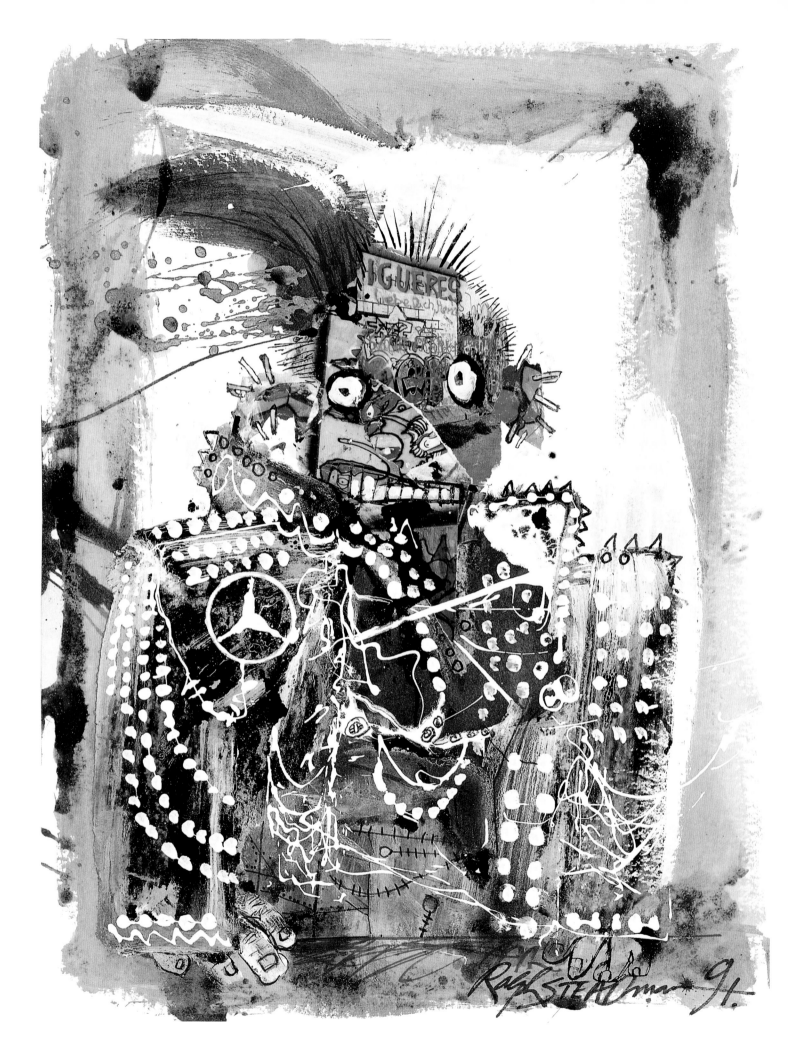

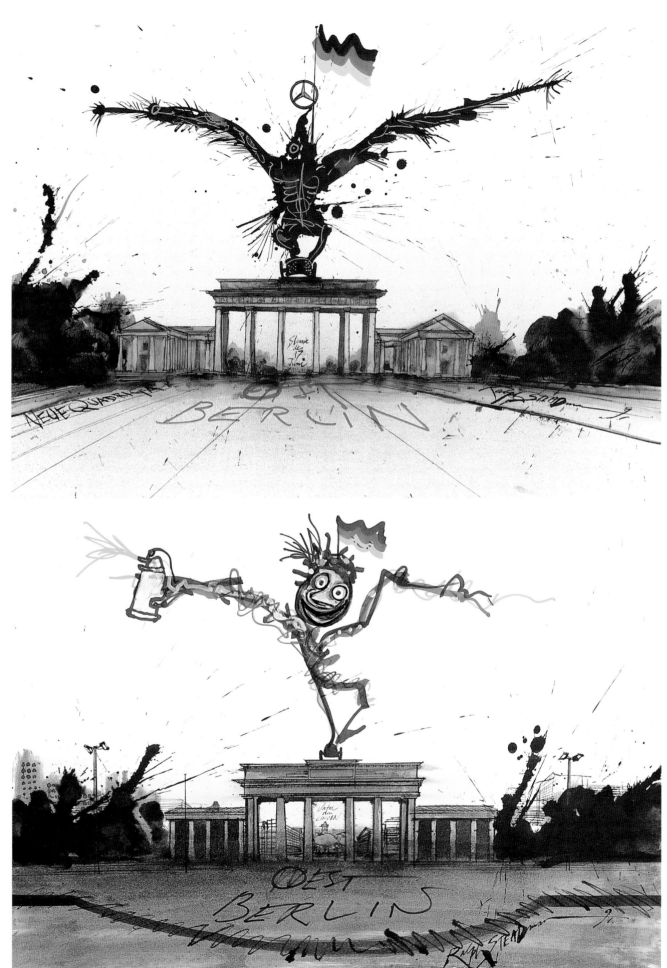

Overleaf
When the
Berlin Wall
came down
it exposed
a barren
landscape.

151

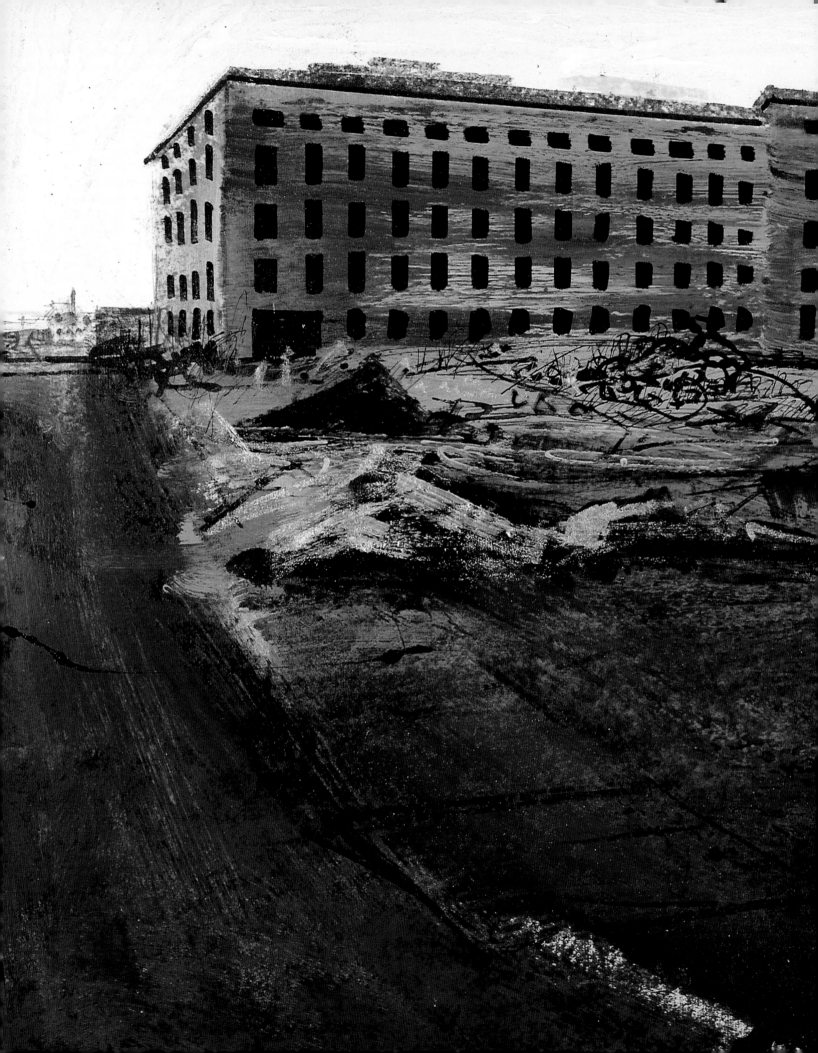

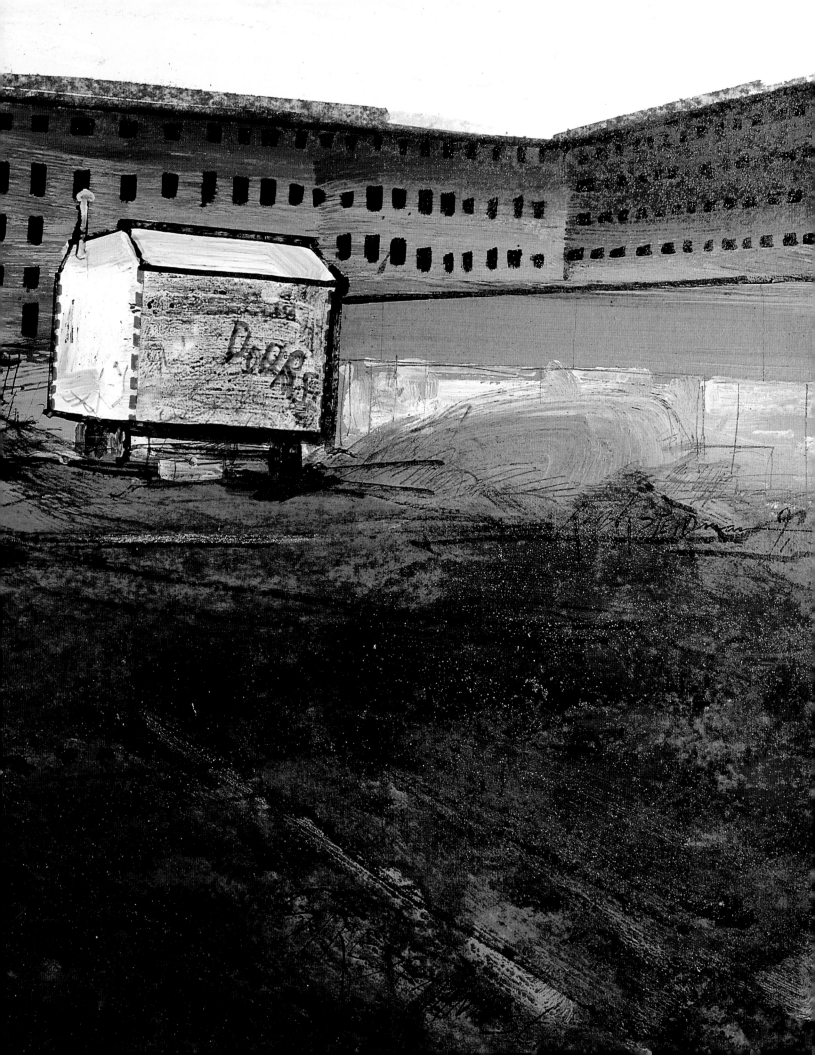

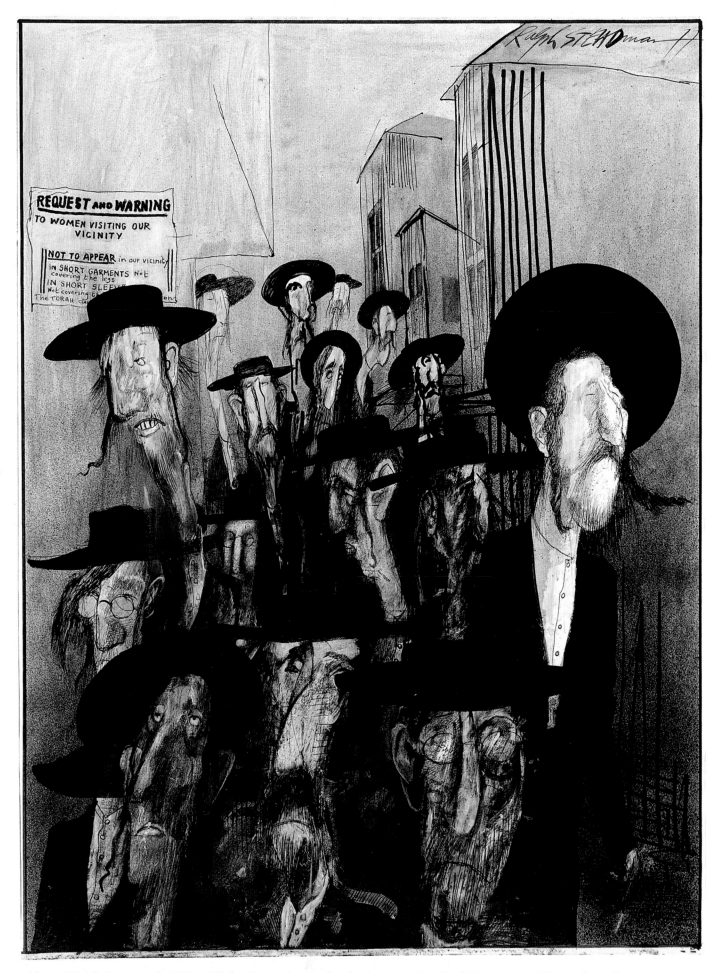

Above Hasidic Jews, Israel, 1977. **Right** Figures in an urban landscape. **Overleaf** Two views of The Berlin Wall.

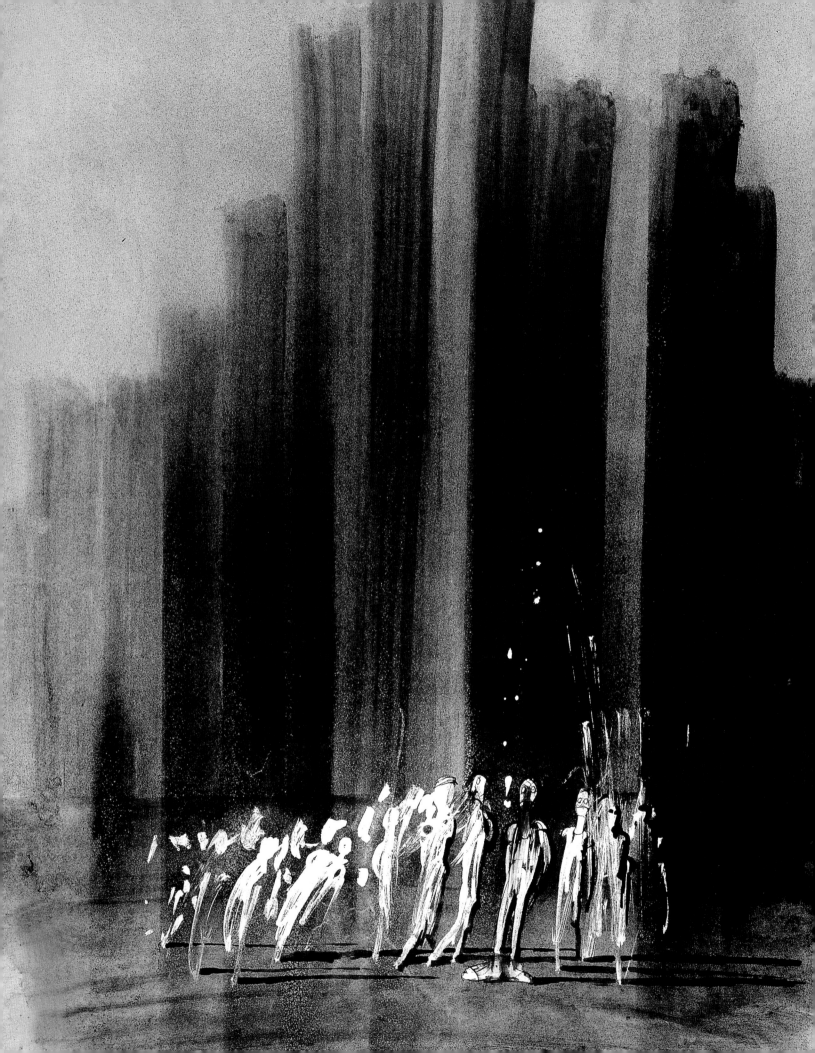

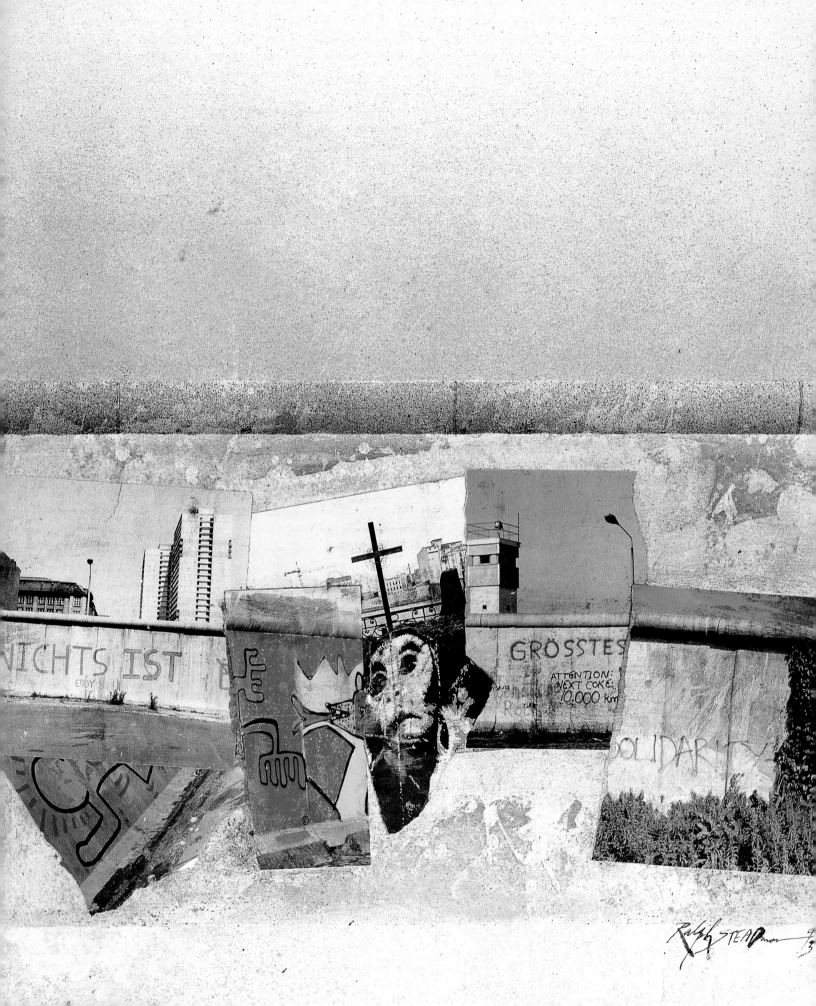

NICHTS IST

EDDY'S

GRÖSSTES

ATTENTION:
NEXT COKE:
10.000 km

OLIDARITY

Ralph STEADman

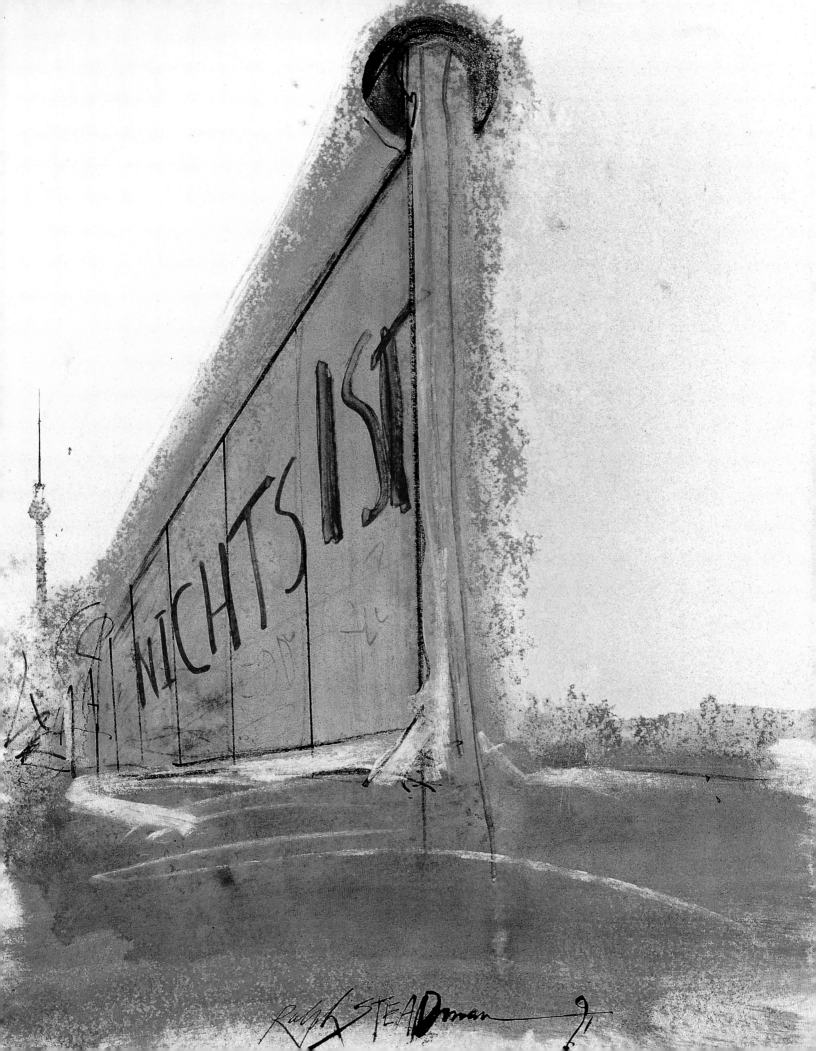

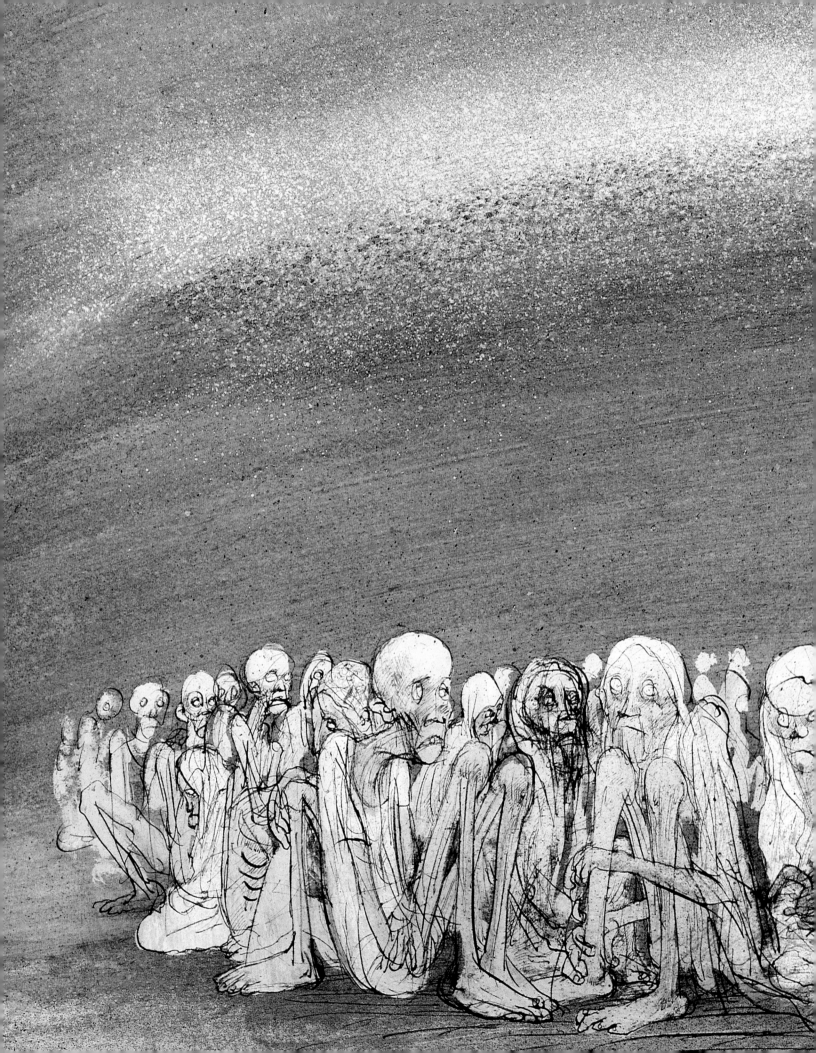

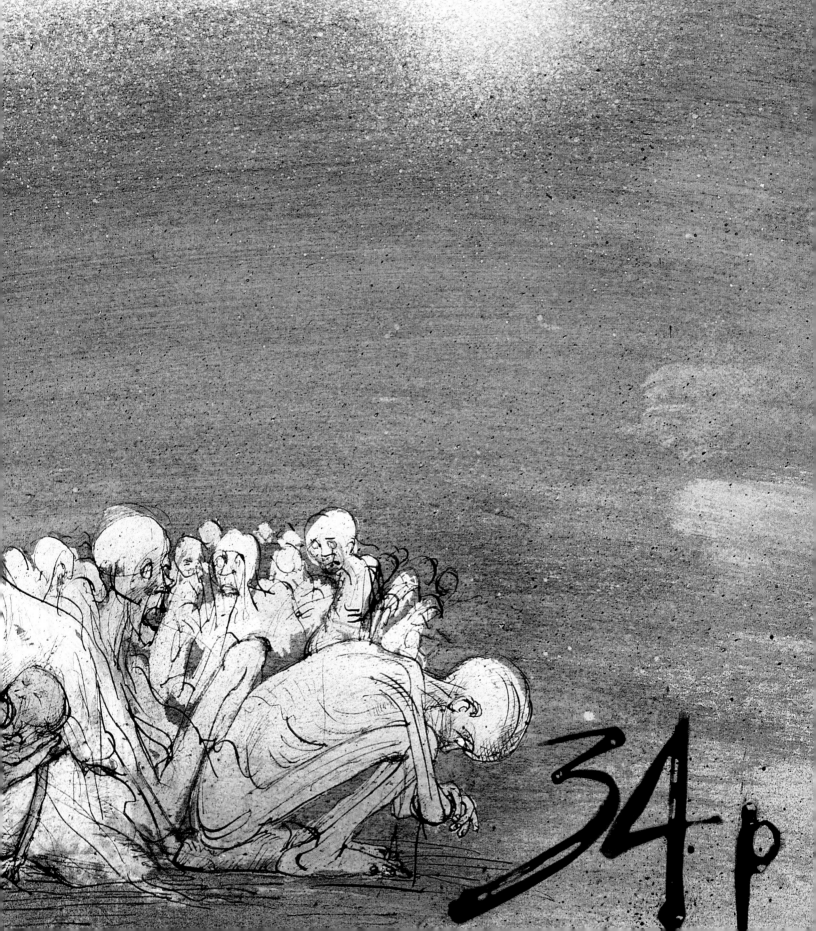

Previous pages Heavenly bodies, earthly bodies. Rejected stamp design celebrating Halley's Comet. Humanitarian, not political.

Right Falklands War. Collage with varnish, red ink and newsprint, 1982.

Below The Sentence. Sculpture from *Red Alert*, an exhibition whose theme was the colour red, October Gallery, London, 1990.

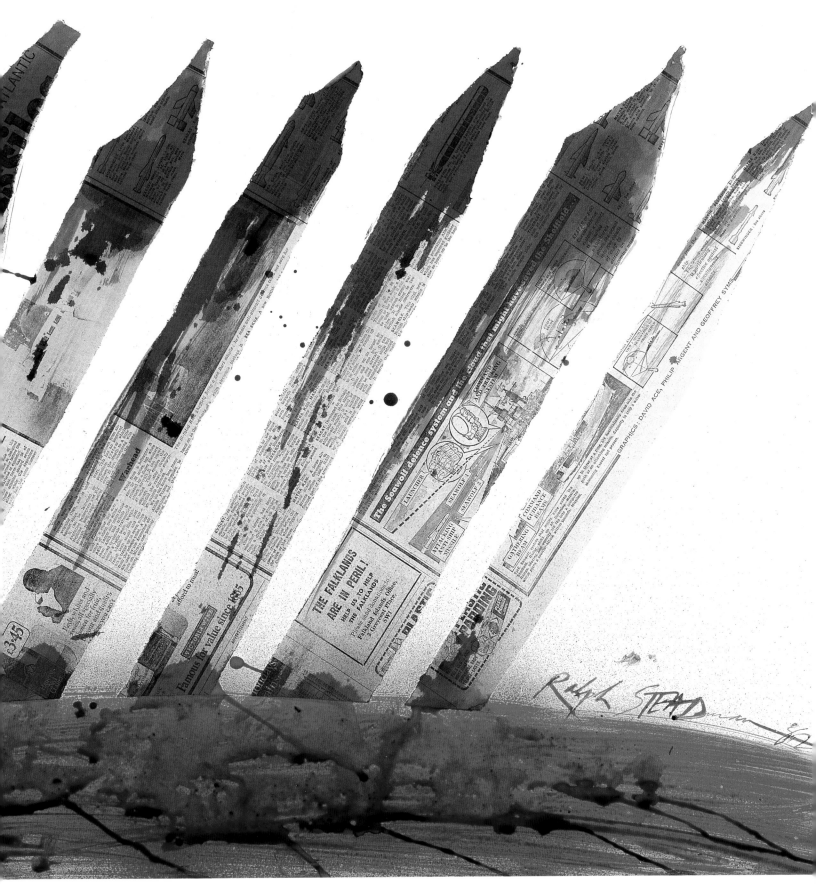

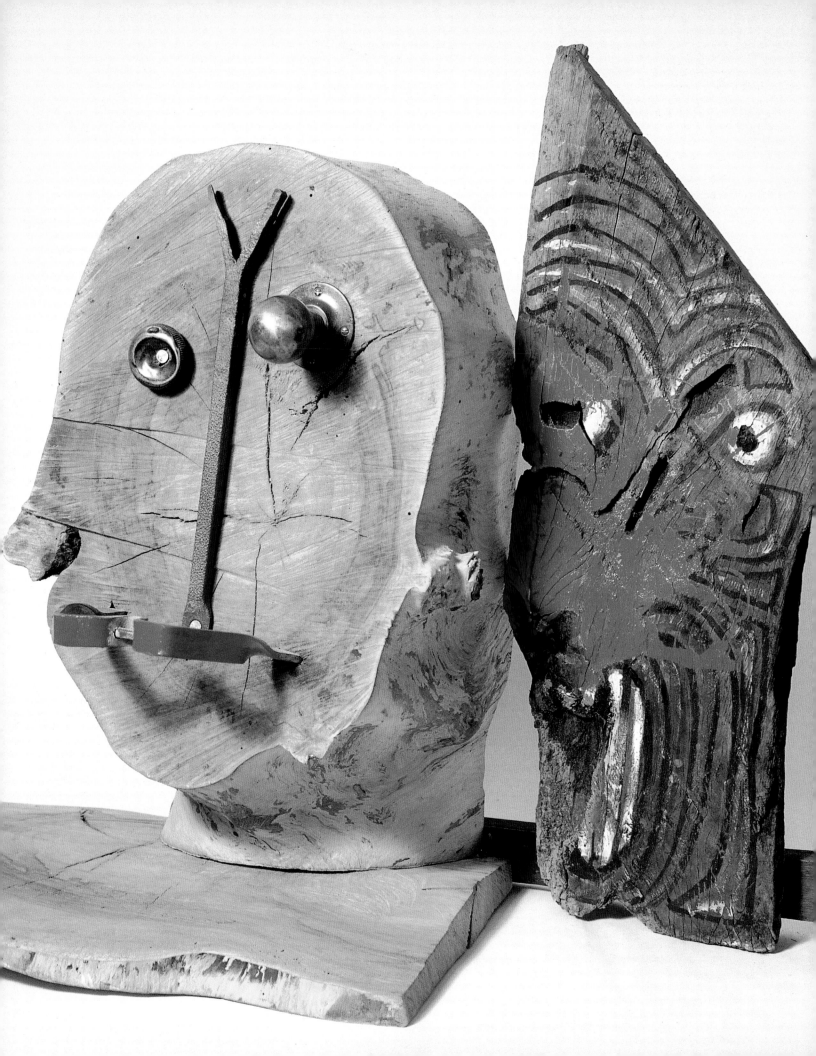

Left Loving Couple. A sculpture from the
Red Alert exhibition, 1990.

Below Face of war. The Falklands, collage, 1982.

Overleaf Left: Atomic face in gloss enamel.
Red Alert exhibition, 1990. Right: The Rolling
Stones. Collage, 1969.

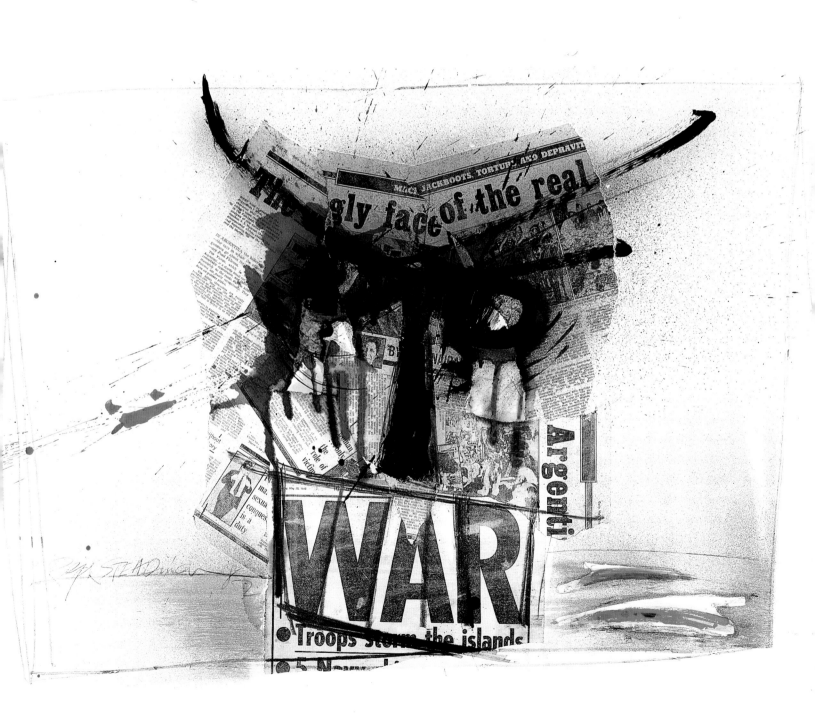

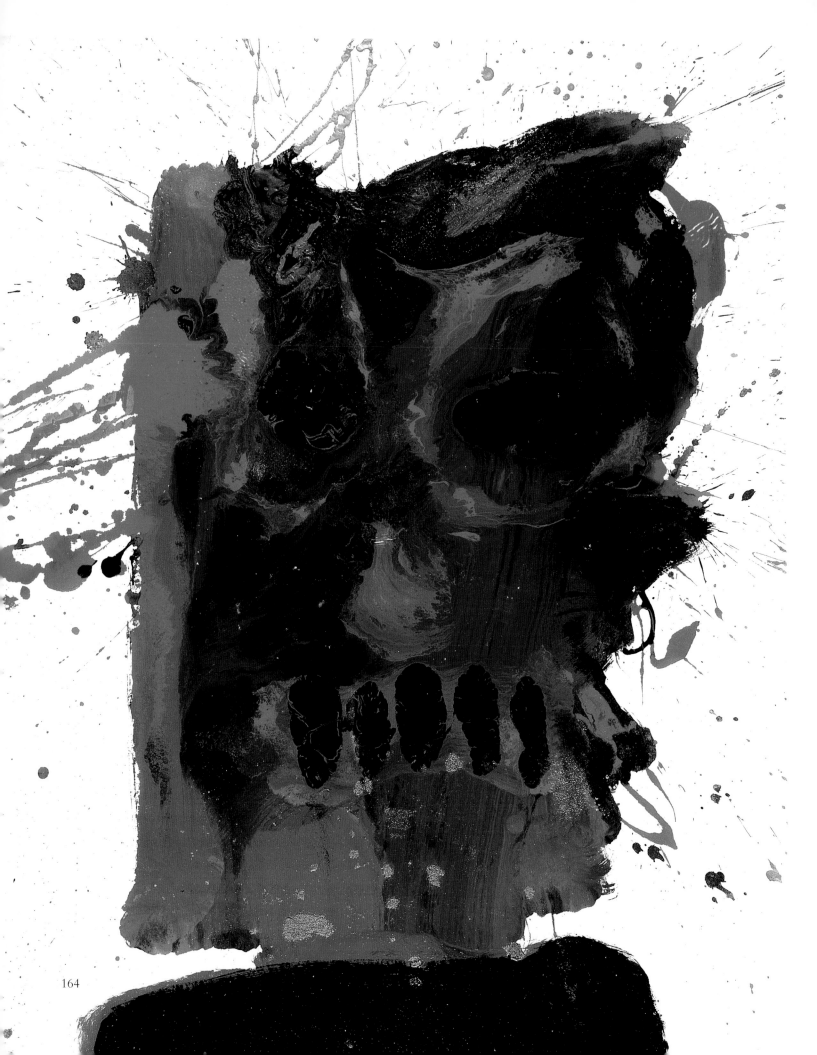

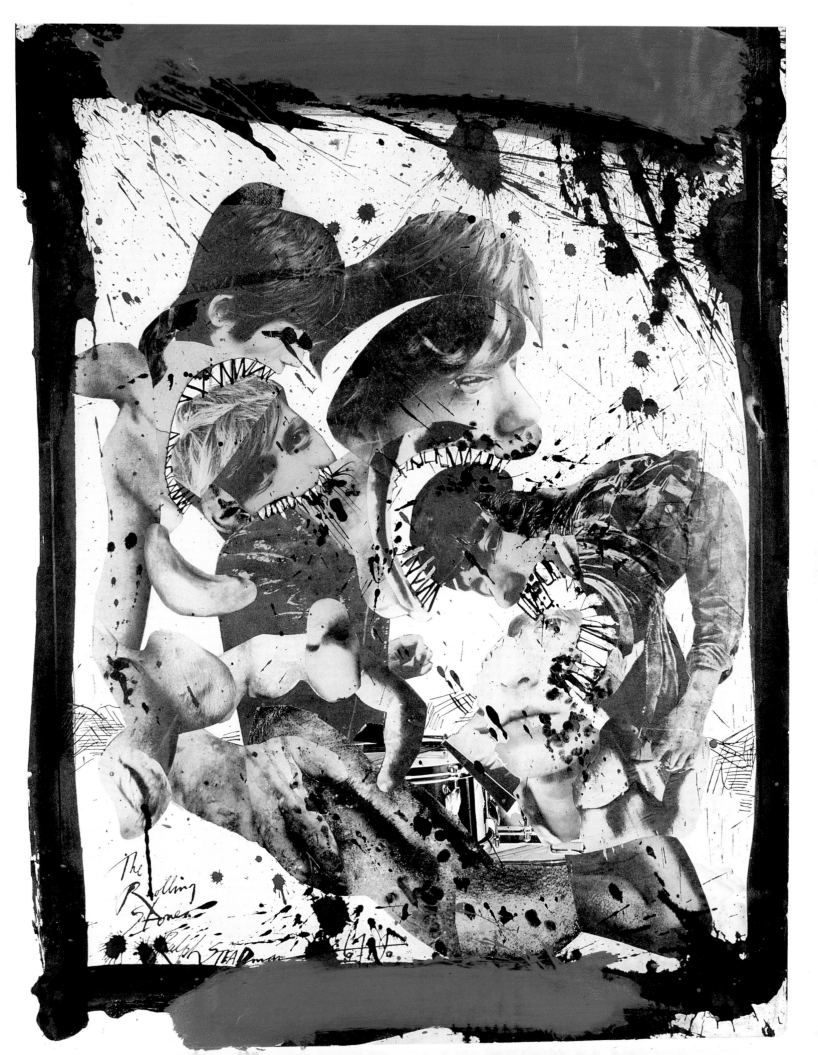

The Rolling Stones
Ralph STEADman

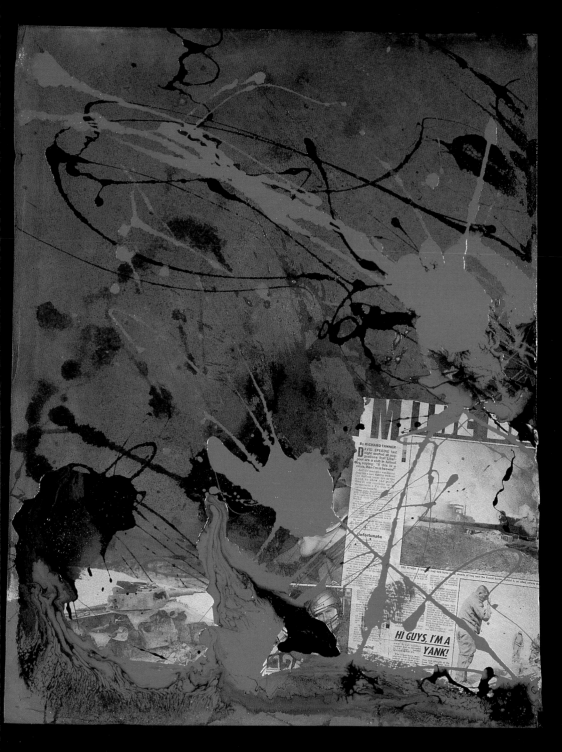

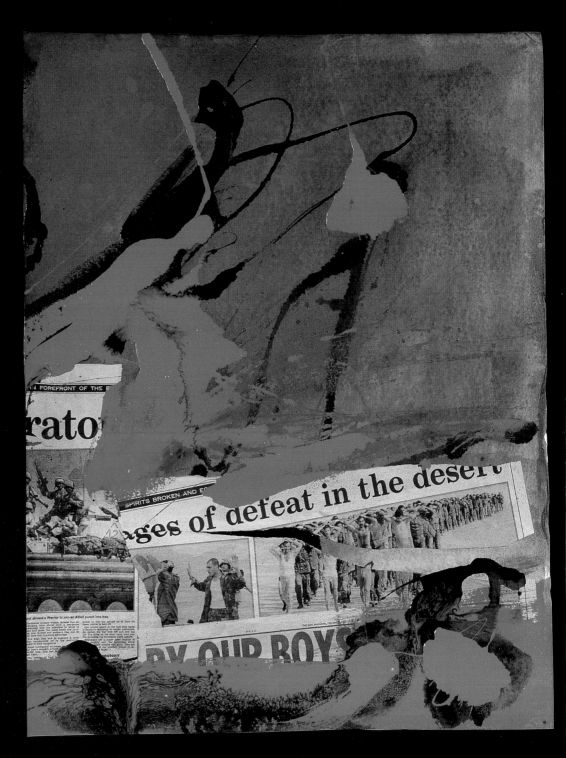

Gulf War triptych.
Painted on raw linen pulp, 1991.

Overleaf The Eternal War.
From *The Big I Am,* 1988.

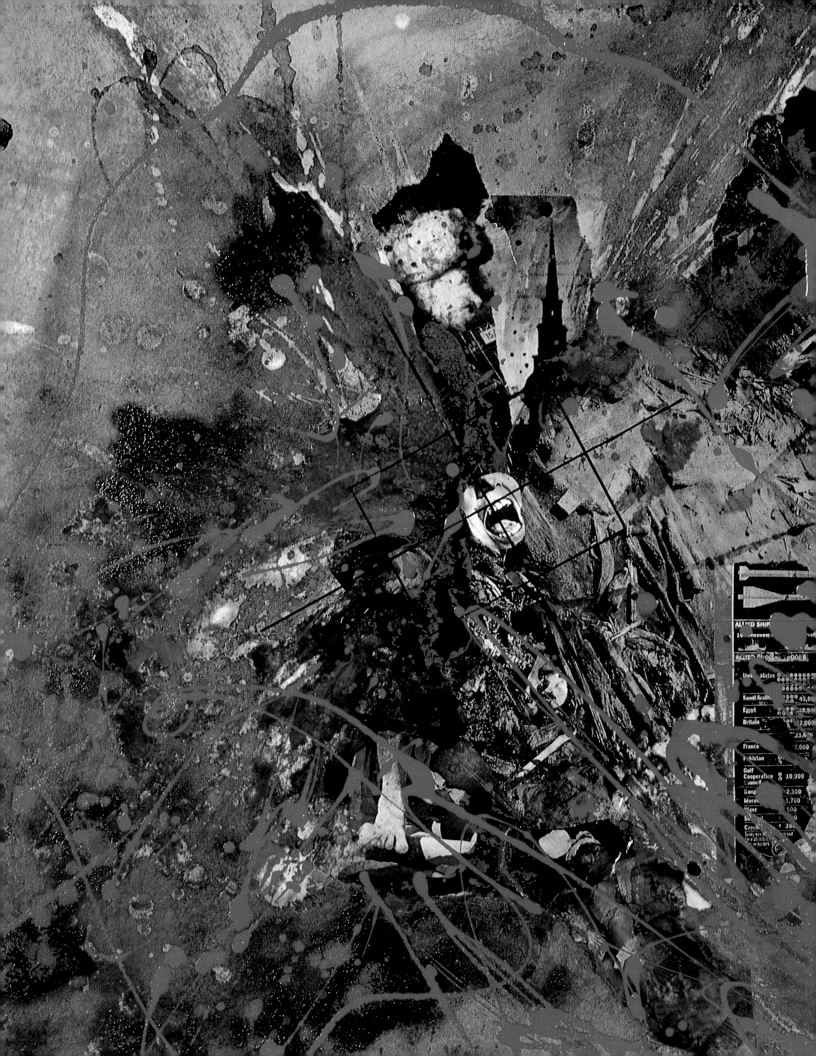

Left Smart Bomb. Gulf War, 1991.

Overleaf Left: Balancing Act. Gulf War, 1991. Right: Children at War. The image of the child was taken from a Second World War issue of *Picture Post* magazine.

171

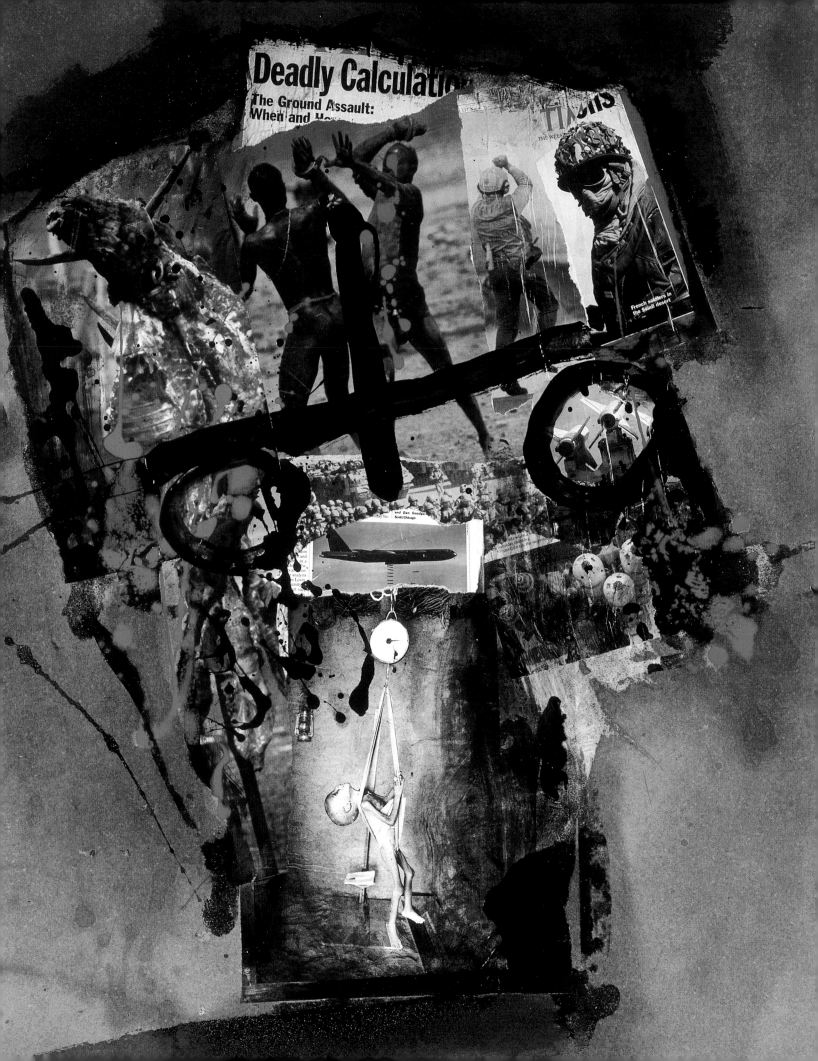

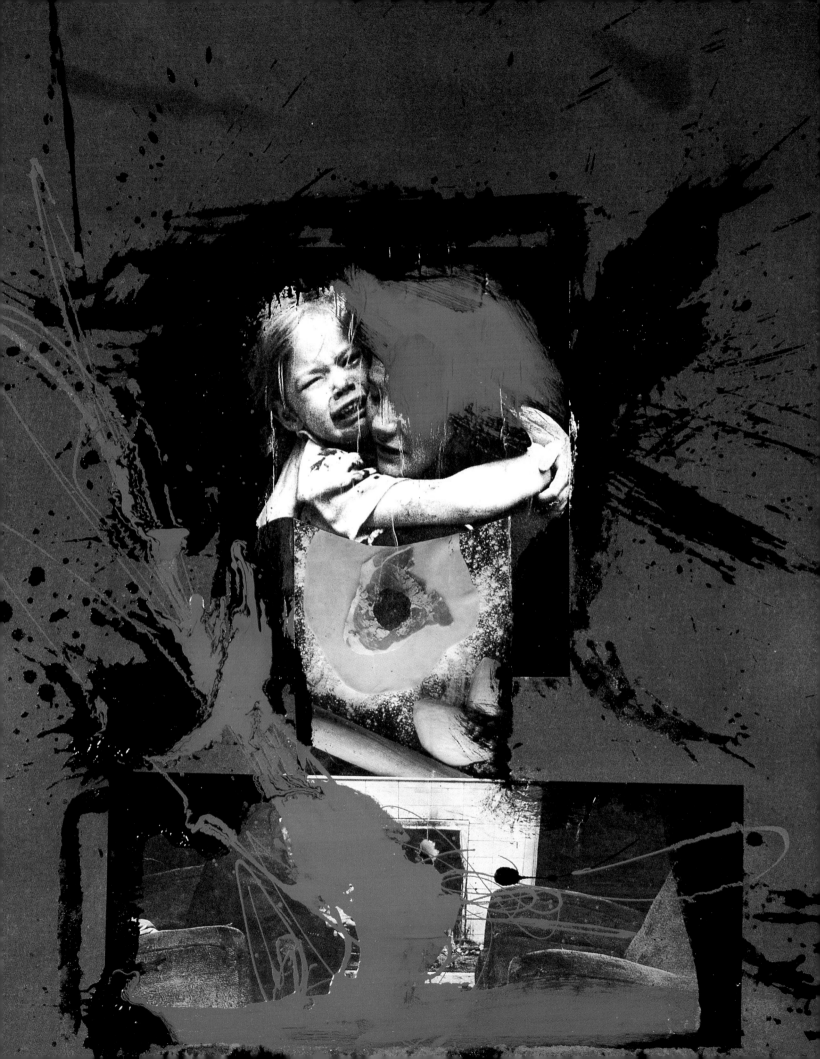

MULTIPLE FRACTURES

I reread the following diary notes in a sketchbook:

Akumal 23.1.91. At a Caribbean resort along the east coast of the Quintana Roo on the Yucatan peninsula in Mexico. The Gulf War, barely a week old, is being fought out in the LOL HA pizza bar, on the holiday complex known as Las Casitas. Desperate American refugees from Minnesota and Wisconsin, dressed in vivid Calcun t-shirts, bermudas and woven leather sandals, watch the Larry King chat show and the CNN newscasts every half hour for an update live from Riyadh. They are hoping to hear that everyone's bête noir, Saddam Hussein, has either been captured or collaterally damaged for good, and that peace has been pulled out of a hat like some conjuror's finale trick in a TV vaudeville show.

There is no small talk. In every face you can see the fear that perhaps this is another Vietnam, and worse, this time it is global and everything that they hold dear will be swallowed up in a conflict that escalates and gets stickier before their very eyes. Apocalypse at last. It has to be the television that draws them in. It certainly isn't the menu, though I can recommend the American breakfast any style, and the Plata de Frutas. This is the only cable TV in the area, broadcasting from Miami, and these people aren't deserting the ship. They are just out on a limb temporarily feeling uneasy. When they get back home they will be kicking butt with the rest of them.

We had found the English-speaking television. I started writing down the new euphemisms snapped out by flak-jacketed spokesmen intended to soften and sanitize the reality of killing and human suffering inside those silent-scream video replays. Back in England, I recalled the events.

For us – Anna, my wife; Yoshida, a gently failed kamikaze pilot (engine trouble, returned to base)-turned-painter; and our Mexican gallery friend, José Ferez – flying out here on the deadline day, things were strange. We had come to suck up as much Mayan culture as anyone can take in on a single visit and the scraps of news we had been getting so far had filtered through a combination of broken English and Japanese–French translations of Mexican TV broadcasts and footage of military activity which left us guessing who was shooting at whom. We knew instinctively what the hideous black thing floating in the sea was, but whenever General Schwarzkopf or Lieutenant Colonel Greg Pepin began to speak a Mexican interpreter overdubbed the statement and I can't lip read.

Images of war merged with the richness of monumental achievements from the ancient world. Where had the Mayans come from? And where did they go? What was a Scud? Something made the Mayans leave. Was it war, famine, pestilence? Were they aliens? Or did they really believe that their fate was guided by the stars and the stars had told them that their time was up? Had the Israelis retaliated? What the hell was 'benevolent destruction' and 'friendly fire'?

Questions asked while going through airport security on our homebound journey became sinister. What had I been doing in Egypt two years earlier? I see you've been in Israel. Any particular reason? Being a tourist was becoming a subversive activity. I include these notes because they were written just over a month ago and in that time the world has witnessed apocalyptic visions in black and white video replay, an unexpected ceasefire which turned surrender flags into a signal for revenge, premature celebrations and bestiality, complete with hell fires and a total eclipse of the sun to feed the sickly, lingering fear that we ain't seen nothin' yet.

We arrived back at the beginning of February to an England in the icy grip of winter, recession, growing concern for the homeless and the elderly and shocking reminders that, quite apart from the Palestinian issue, we, if not the rest of the world, have a problem in Ireland that demands a resolution.

I couldn't get the morning story on Radio 4 FM, or Woman's Hour, or even the afternoon play, and though news from the Gulf was sparse it was being regurgitated, dissected, replayed and analysed out of existence by retired major generals, before being interrupted by another update and then resumed to analyse the newest lack of information. It became hypnotic and I was hooked. I listened constantly, catching a change of mood here, a nuance there, an anxious resumé by John Humphrys or a taxi-driver's plans for the future from Brian Redhead, even a British Rail guard's no-nonsense comment told to Brian on the train from Macclesfield to London. Then, along with the weather came a blizzard of 'bovine scatology' (Norman Schwarzkopf's phrase) from some professor of desert warfare at Warwick University, followed by a breakdown on how many ancient biblical sites are likely to be razed to the ground in the 'precision' bombing raids if the area under attack were to be 'softened up' sufficiently for a ground attack.

By the time I heard the Tigris and the Euphrates and the Hanging Gardens of Babylon being mentioned I was fully convinced that this was indeed a holy war and that the end of our civilization was somehow to reflect the way the Mayan one had ended – but this time we would have it all on video, buried in heat- and radiation-proof boxes for future generations and possible demonstration showings at international mind control fairs. 'Look how archaic it all was in the late twentieth century. All that mess when they needed to neutralize the brain and render emotions digital like sound for ultimate control and perfect harmony.'

In frustration I asked myself what was Art for in all of this? Particularly the interior decoration variety. It paled to a mere frippery, much as I love it as an integral and important part of life. I was being swept along in the media deluge and for fear of drowning I swam in it, drank it and poured it onto heavy sheets of porous pulped linen paper. In what I can only describe as an heroic frenzy, though some might say helpless confusion, I produced over 30 images of war, my war I suppose, over a three-week period. It felt as necessary and natural as breathing, and is in effect a distilled diary of the war's progression – an artist's point of view.

WAR!!!

Excerpt from GOD'S DRAWING BOARD

Somewhere amongst the monoliths
Somewhere in the castellations
Somewhere carved in stone
Somewhere hewn
Brave signs shaped a prophecy
In foul jungle abattoir
Vultures gather on the bony landscape
Of a tangled past
Winged appetites
Magnetized by greed
Knowing where to feed
Gorging on our yesterdays
Huddled branches sharpen silhouettes
Into blades of fortune
Stark claims
Stark claims
The future's riding in
On dark hopes.

VOICE OF A DAMNED EXCITED:
I KNOW! LET'S HAVE ANOTHER WAR!!

ALL:
G-O-O-O-D IDE-E-E-A! HELLUVAGOOD-ONE!!
HALLELUJAH!!!! HALLELUJAH!!!!

Ga-a-a-stronomic co-on-flicts! HALLELUJAH!!!!
The taste of wars
Unthinkable
Deli-i-i-i-ights
Right to the br-i-i-ink
No time to think
Or hold back
No time to pause
Just time to strike
And open up a fle-e-sh wound
The smell o-o-f blo-o-od
Glistens thi-ckly
On the se-e-n-ses like oil

Turning reluctant sol-ol-di-er-ers
Into sha-arks – into sha-arks – into sha-ar-ar-ar-arks
In blood waters.

Good old God! Millennium!! (*sung like Hallelujah!!!*)
Good old God! Millennium!!
Good old Go-o-od! Millennium!!
Good old God! We'll make war in his name!

VOICE:
Hang on! We'll need a politician to justify our actions
To feel elation on our behalf
To find an enemy we can all warm to!
A spokesman to officially approve a new design for death
The lethal sculptures of our government departments.

Roll them out on shimmering heat
Fighting cocks
With spurs that glint
The shoulders rounded into a black curse
A smouldering refuge
A grounded insect
Just for a moment –

With the warmth of the sun on its wings
It leaps forward
Snarling into the air
Screaming fear in flight
With the sting of death
Hanging in its belly
MILLENNIUM!!!
Visiting
Visiting
Just visiting
Dropping in on target rich environments
Delivering babies
HALLELUJAH!!
MILLENNIUM!
MILLENNIUM!!
MILLENNIUM!!!
MILLENNIUM!

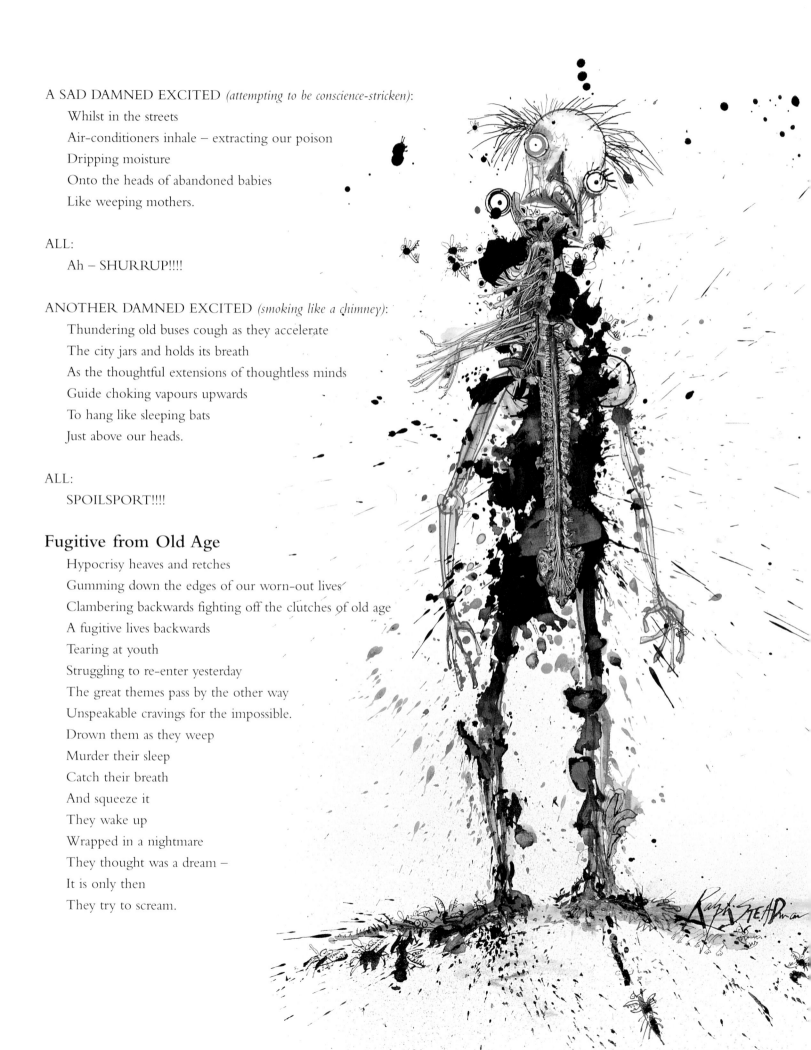

A SAD DAMNED EXCITED *(attempting to be conscience-stricken)*:

> Whilst in the streets
> Air-conditioners inhale – extracting our poison
> Dripping moisture
> Onto the heads of abandoned babies
> Like weeping mothers.

ALL:

> Ah – SHURRUP!!!!

ANOTHER DAMNED EXCITED *(smoking like a chimney)*:

> Thundering old buses cough as they accelerate
> The city jars and holds its breath
> As the thoughtful extensions of thoughtless minds
> Guide choking vapours upwards
> To hang like sleeping bats
> Just above our heads.

ALL:

> SPOILSPORT!!!!

Fugitive from Old Age

> Hypocrisy heaves and retches
> Gumming down the edges of our worn-out lives
> Clambering backwards fighting off the clutches of old age
> A fugitive lives backwards
> Tearing at youth
> Struggling to re-enter yesterday
> The great themes pass by the other way
> Unspeakable cravings for the impossible.
> Drown them as they weep
> Murder their sleep
> Catch their breath
> And squeeze it
> They wake up
> Wrapped in a nightmare
> They thought was a dream –
> It is only then
> They try to scream.

Judas Iscariot
Guilty in Shadow

If Judas is guilty of treachery then so is everyone else, but none more so than Jesus himself. It was he who compromised the Apostles by his teaching, their knowledge of it and his insistence that they believe what he told them. Then, more dangerously, his insistence that they follow him, go public and declare all.

The chosen Apostles were simple men, fishermen and farmers and no match for the charismatic intellect that Christ possessed, being as he was a prodigy among wise men and philosophers. He commanded his disciples' love, and expected total obedience in exchange for his startling new theories and claims of everlasting life which he attempted to consolidate in their minds with a few well-chosen miracles.

It was pretty heady stuff, and they fell for it. I wonder if any of them realized just what seditious doctrine they were embracing within the climate of Rome's sense of might and right which prevailed at the time? He was virtually saying to them, Well, it would be better if you do love me because I am going to ask you to go out there and get stoned or end up as cat food, the source of some heroic entertainment for bored Romans.

Being only human, every chosen Apostle had their weak moments. Peter denied Jesus thrice; Thomas doubted; Simon, the father of Judas, was wanted by Satan, according to Jesus, to do his bidding and Jesus prayed for him that 'thy faith fail not', as Jesus put it, according to Luke. The Apostles must all have discussed the finer points of their predicament over wine when he wasn't around. Every one of them had misgivings – and second thoughts. Jesus Christ may well have been a very persuasive nutter – so persuasive, in fact, that we still have doubts today.

Each of them could have been a contender to betray Christ given the right circumstances and the right pressures brought to bear at the right time on their weakest characteristics.

Judas was no better or worse than any of the other disciples, no more or less likely a candidate to put the finger on Christ in exchange for personal gain. He must have loved Christ just as much as the others in order to have made his commitment and sacrifice in the first place. It could not have been the money which provided the real motive for Judas' action since 30 pieces of silver would have bought no more than a few loaves and maybe a pitcher of wine. The money was a token of the covert transaction and a cunning device of the priests to implicate Judas in the betrayal, and incriminate him should their plan backfire. Even one silver piece in his possession would be proof of his calumny since all their worldly possessions had by this time been dispersed.

Judas Iscariot was the chosen fall guy, which fits into Jesus Christ's scheme of things. Somebody had to betray him from among his own kind just to prove how wicked the world really is and make the whole story compelling enough to survive the test of time.

Absolutely nothing is known of Judas' early life and any attempt to defend him must be based on conjecture, if only to provide food for thought in order that he be

given a fair hearing. It is certainly unfair that his name now is synonymous with treachery. People would no more dream of calling their son Judas than they would Adolf or Attila.

Several possibilities occurred to me as I stumbled over the biblical versions of the event. Firstly, Judas was the victim of blackmail. What could have compelled him to betray the most extraordinary figure ever to walk the face of this earth? Every disciple must have had at least one skeleton in the cupboard but the priests needed to choose one whose indiscretion was practically unforgivable. Judas may have committed the cardinal sin. Perhaps he was seen committing an act of bestiality upon the sacrificial lamb, prior to the feast of the Passover for which it was intended. Such a lever would break any man. Some may be above the law but none is above such a damning secret.

Secondly, Judas Iscariot may have been a schizophrenic. Judas loved Jesus more than any other of the Apostles but he was not Christ's favourite. Judas suffered from a deep psychosis which demanded his complete control of any situation. The object of his love was also the pinnacle of his ambition. Judas' pride would not allow him to love Jesus so utterly. This would mean a complete inability to achieve that ambition, namely to be the Messiah himself. This caused a personality disintegration, as commonly happens with schizophrenics who make wild and desperate attempts to destroy the vital bond that ties them to their world of reality, such as it exists. That world in itself would have seemed unreal.

Thirdly, Christ's remarkable declarations about his true status amongst them and indeed amongst the whole of humanity would have unhinged Judas. Follow that with the ultimate statement after the sacrament that Christ himself was to pay the price and be the ultimate sacrifice, then Judas would NEVER be the Messiah now. Whether or not he had the courage to take Christ's place became irrelevant. Confused by this realization, and his paradoxical love, he would be plunged into his other destructive role and become a cruel caricature of his former self, another common trait of schizophrenics. In other words he became a victim of his own psychological disorders and not the wholly evil and treacherous archetype which defines his role. He is the rest of us – the most human and the most fallible.

Finally, if Judas were the wholly evil and treacherous villain for which he is damned, then he would have been incapable of remorse or a sense of guilt and he most certainly would not have committed suicide.

I believe that the true perpetrators of treachery in world history are those who would use Christ's doctrine as a means of persecuting others who disagree with their version of the 'sacred truth', those who believe that compassion was a word used by their particular Messiah only as a means to an end, a way of annihilating the infidel, the unbeliever, all in the name of God. Theirs is a profane judgement on all of mankind which bears no relation to the fundamental teachings of their religious heroes and their demons.

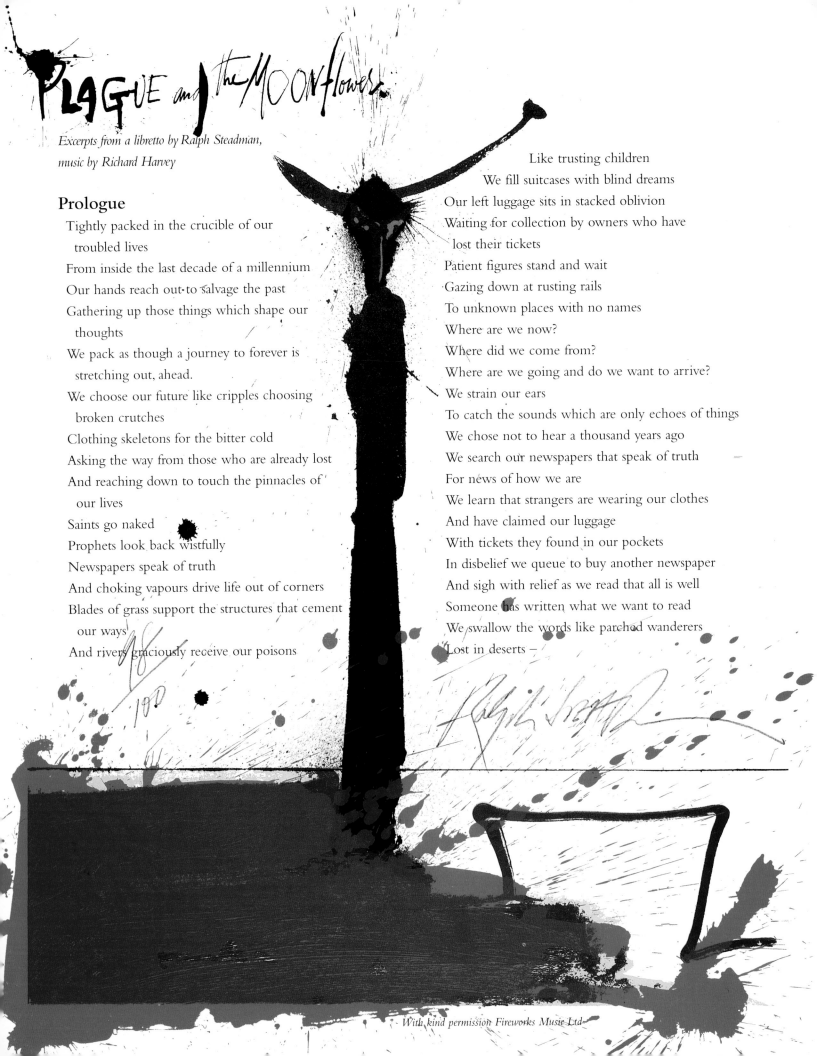

PLAGUE and the MOONflower

Excerpts from a libretto by Ralph Steadman,
music by Richard Harvey

Prologue

Tightly packed in the crucible of our
 troubled lives
From inside the last decade of a millennium
Our hands reach out to salvage the past
Gathering up those things which shape our
 thoughts
We pack as though a journey to forever is
 stretching out, ahead.
We choose our future like cripples choosing
 broken crutches
Clothing skeletons for the bitter cold
Asking the way from those who are already lost
And reaching down to touch the pinnacles of
 our lives
Saints go naked
Prophets look back wistfully
Newspapers speak of truth
And choking vapours drive life out of corners
Blades of grass support the structures that cement
 our ways
And rivers graciously receive our poisons

Like trusting children
We fill suitcases with blind dreams
Our left luggage sits in stacked oblivion
Waiting for collection by owners who have
 lost their tickets
Patient figures stand and wait
Gazing down at rusting rails
To unknown places with no names
Where are we now?
Where did we come from?
Where are we going and do we want to arrive?
We strain our ears
To catch the sounds which are only echoes of things
We chose not to hear a thousand years ago
We search our newspapers that speak of truth
For news of how we are
We learn that strangers are wearing our clothes
And have claimed our luggage
With tickets they found in our pockets
In disbelief we queue to buy another newspaper
And sigh with relief as we read that all is well
Someone has written what we want to read
We swallow the words like parched wanderers
Lost in deserts —

With kind permission Fireworks Music Ltd

Safe inside the mirage we gather coats around our bones
And ignore the icy wind that blows sweet papers
And yesterday's news
Down along the rusty nails.

What say you now great Pharaohs?
What say you from your ancient lands?
What can you say to stir our hearts?
Your children hunt in gangs.
The walls festooned in symbols
Once carved and glorified
Are now hacked out in mindless rage
And sprayed in poison
Frustrated outlets broadcasting to a numb world
The spirit lives in chains
Crying from its hollow cage
Fermenting strength to burst its bonds
And crash through walls that bear the names
Of those it hates
And in its time
Obliterates.
Destruction has its own tune
A clarion call to those
That think only of revenge
A mob awakes
And with the tools that once shaped Karnak's temple
Hack down the dreams and selfish hopes
Of our frail time
This is no crime
This is the cry
Of hearts betrayed
That would have stayed
To hear the song
That no one played.
I have danced with many yet I call out to you from the
 blackness of my ribald night
I have danced with an angel's face and yet I see you enjoy
 the joke that was only meant for you
I see you crash through walls and take over before the
 music dies
Yet I am strange

Do I need to die before I really know YOU?
If I were an ocean and you alone on my shore
My waters would reach out and touch you – draw back and
wait for you to swim in to me.

Come back to rebuild my heart
That woke in darkness just as it had died
In darker ages when the world was young
And I was living proof of life denied
I was proud
I gathered strength from mortal turmoil
My dreams were nightmares
And death my foil, come back to me.
Come back to me and all will live
Let Amazons of moonlight flood the land
And swallows can bring summer's sun ten million times
And wear away a resting place on which they stand.
Come back to me rekindle ancient dreams
Before the dawn when fireflies lit the soul
And nature's task was simply to increase its fold and smile
Come back to me and redefine my role.

With the coming dead millennium
Held fast inside a last decade
What have we done to make our pride run?
What have we made?
The weary must run to catch their souls
As though the time they have is past
Wearing masks to hide their fate
They nail their all to a phantom mast.
A thousand years tipped on its edge
Trembles naked, frail and old
Customs of ancient tribes prevail
Time catches breath on its own threshold.
Lives wild and plagued with fear
Awake! Rejoice! and scorn oppression
Burn incense and blow smoke rings to the gods
Declaring each and every odd obsession.
Now let Amazons of sunlight flood the land
And swallows can bring summer's sun ten million times
To wear away a resting place on which they stand.

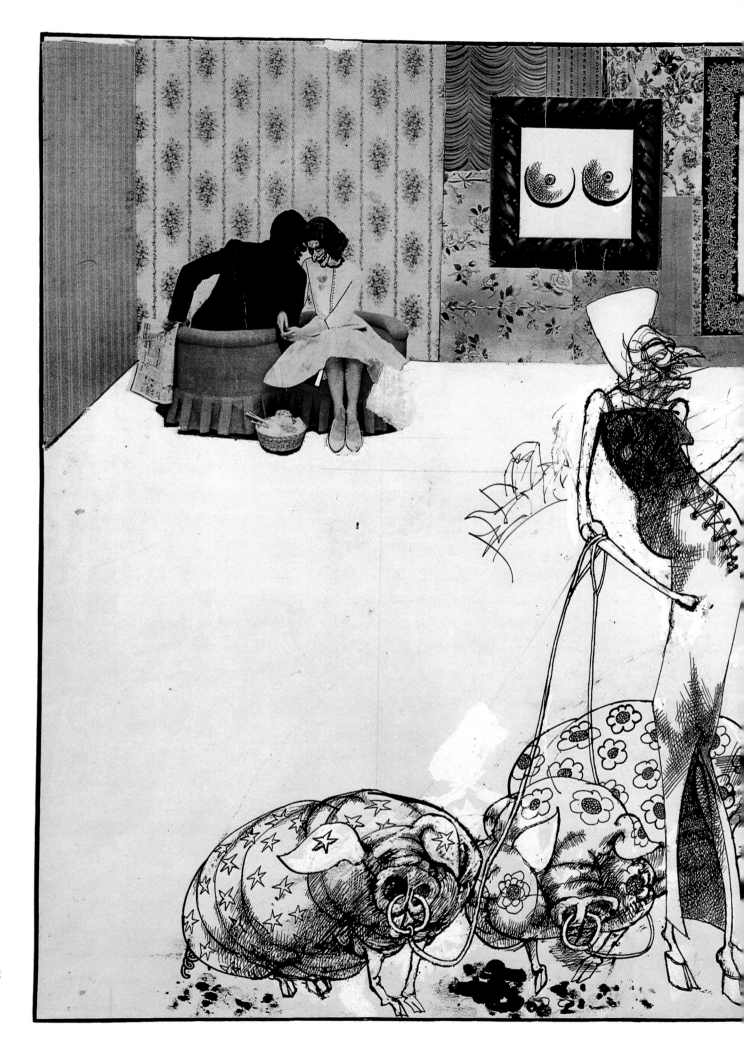

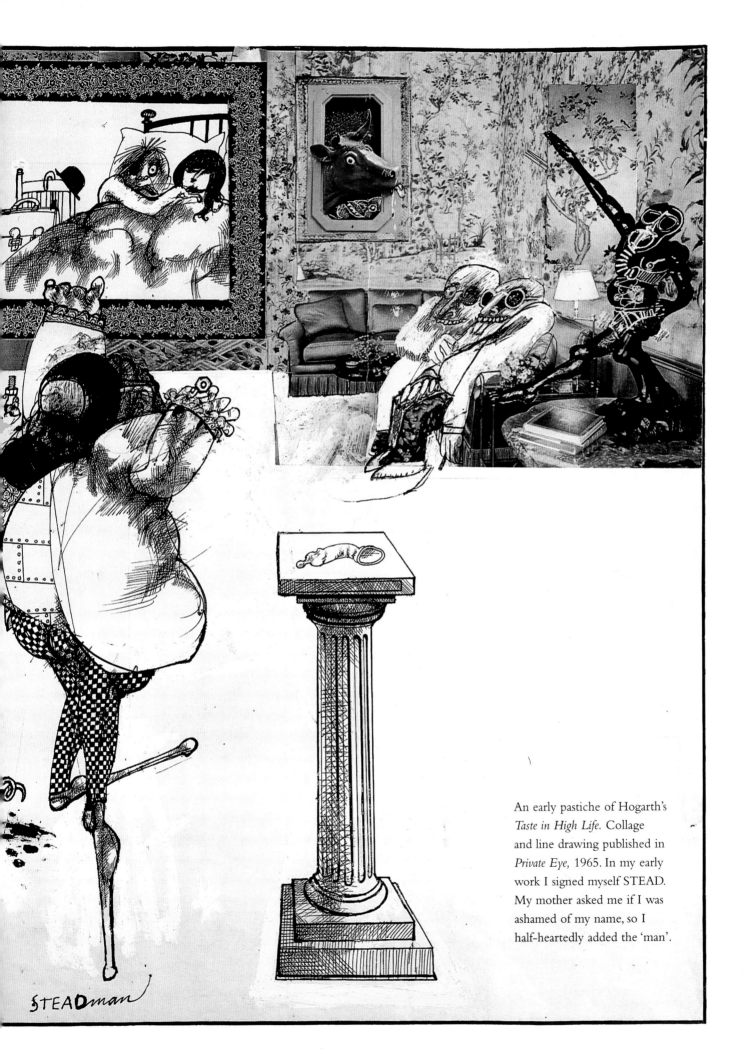

STEADman

An early pastiche of Hogarth's *Taste in High Life.* Collage and line drawing published in *Private Eye,* 1965. In my early work I signed myself STEAD. My mother asked me if I was ashamed of my name, so I half-heartedly added the 'man'.

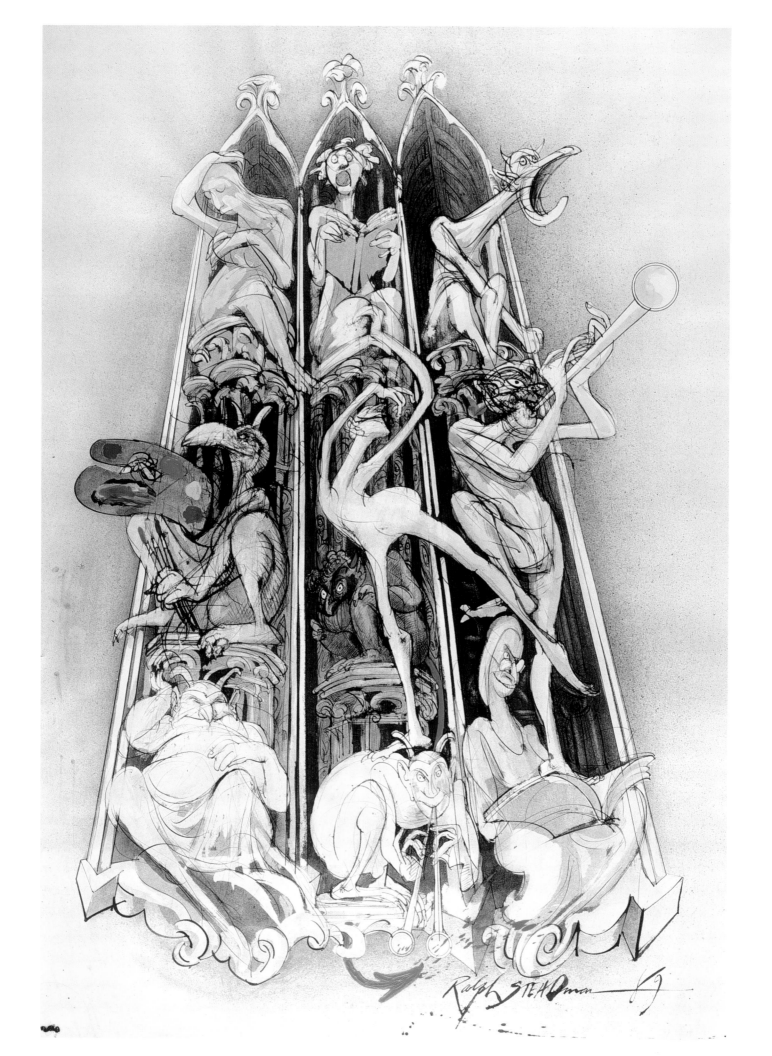

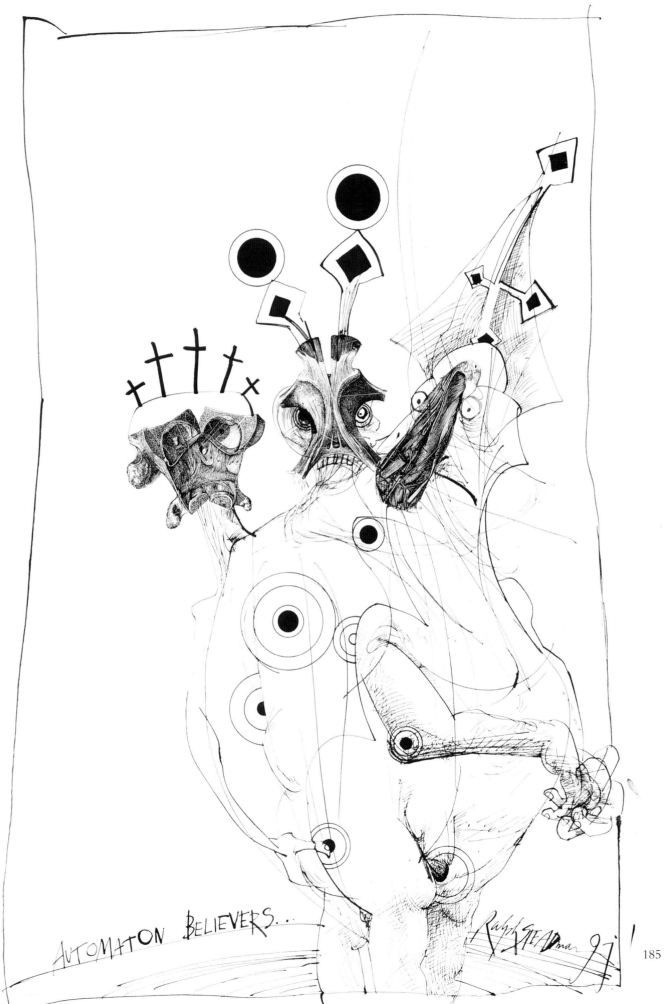

AUTOMATON BELIEVERS...

Ralph STEADman 97

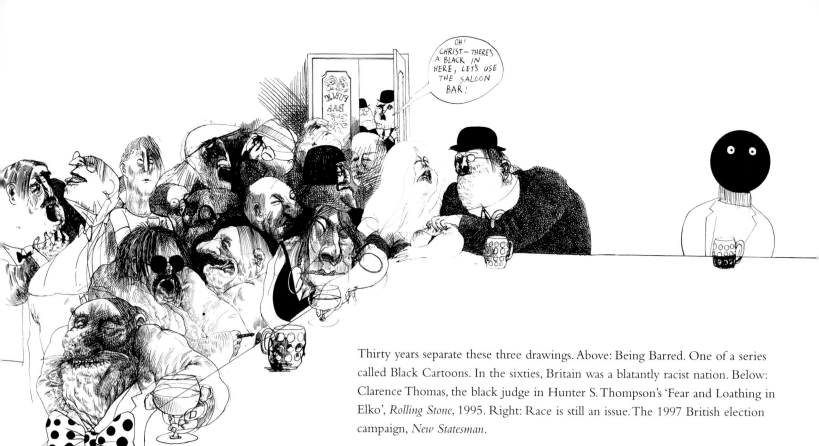

Thirty years separate these three drawings. Above: Being Barred. One of a series called Black Cartoons. In the sixties, Britain was a blatantly racist nation. Below: Clarence Thomas, the black judge in Hunter S. Thompson's 'Fear and Loathing in Elko', *Rolling Stone*, 1995. Right: Race is still an issue. The 1997 British election campaign, *New Statesman*.

Previous pages Left: Exeter Arts Festival, 1989. The Gothic figures on the front of the city cathedral are engaged in artistic activities. Right: Automaton Believer, 1997. One of my 'knee jobs'. In the evenings I rest a board with paper on my knee and draw whatever comes to mind.

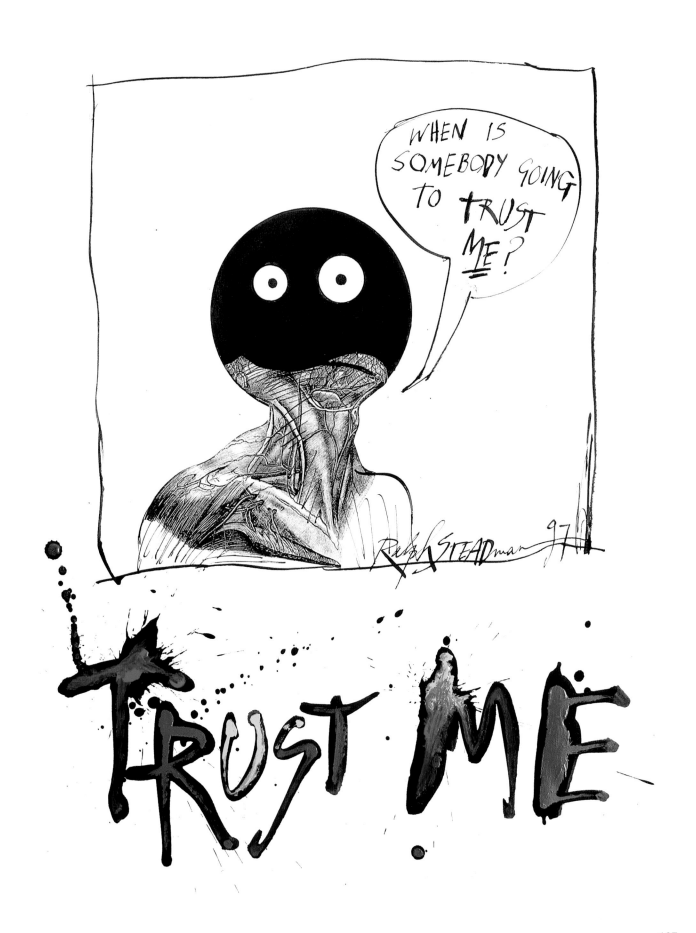

187

The NEW ELECTORATE

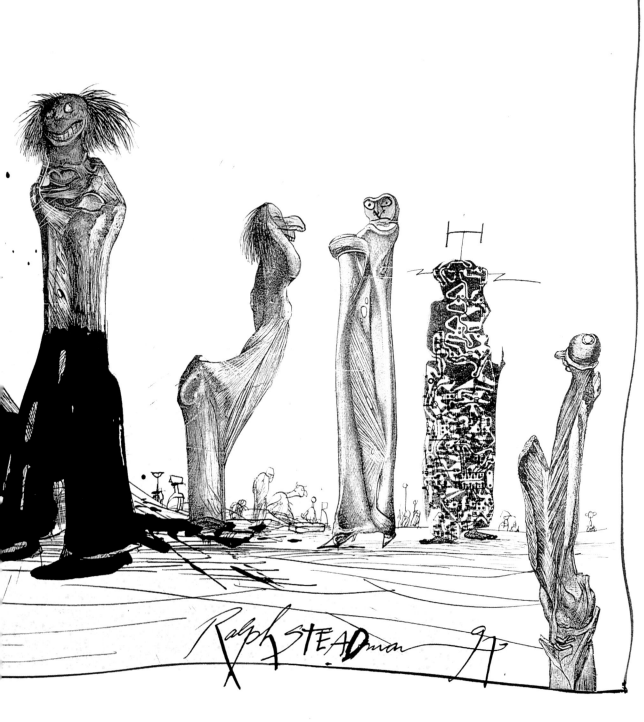

Left The 1997 British election campaign, *New Statesman*. How far removed, I thought, are the politicians from the citizens to whom they are trying to appeal.

Previous pages Stand up and be counted. The maverick beast will always stand out in the crowd.

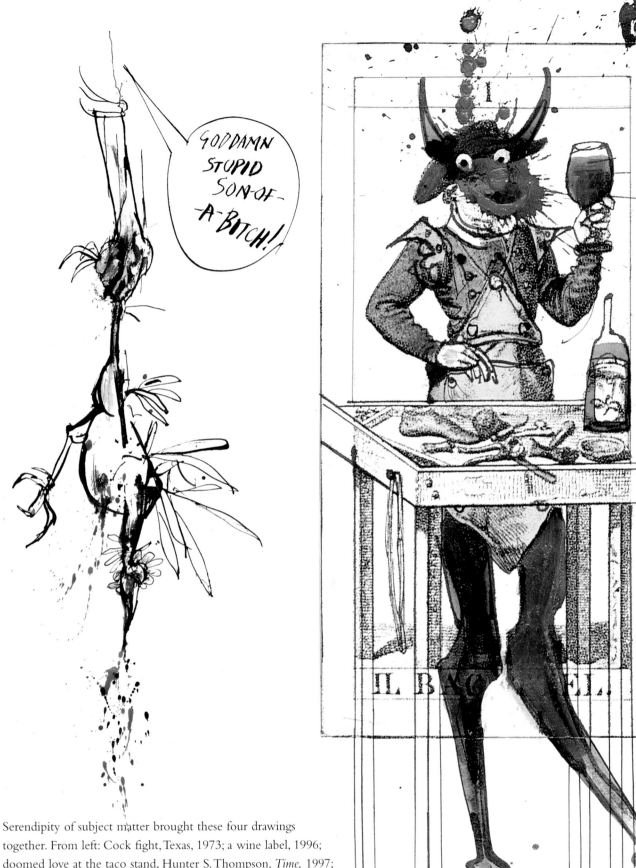

Serendipity of subject matter brought these four drawings together. From left: Cock fight, Texas, 1973; a wine label, 1996; doomed love at the taco stand, Hunter S. Thompson, *Time,* 1997; a study for a love object, vintage sixties Gonzo.

Overleaf Left: Portraits of a flawed man. Right: The beast, the man and God on high. Mt Olympus, 1997.

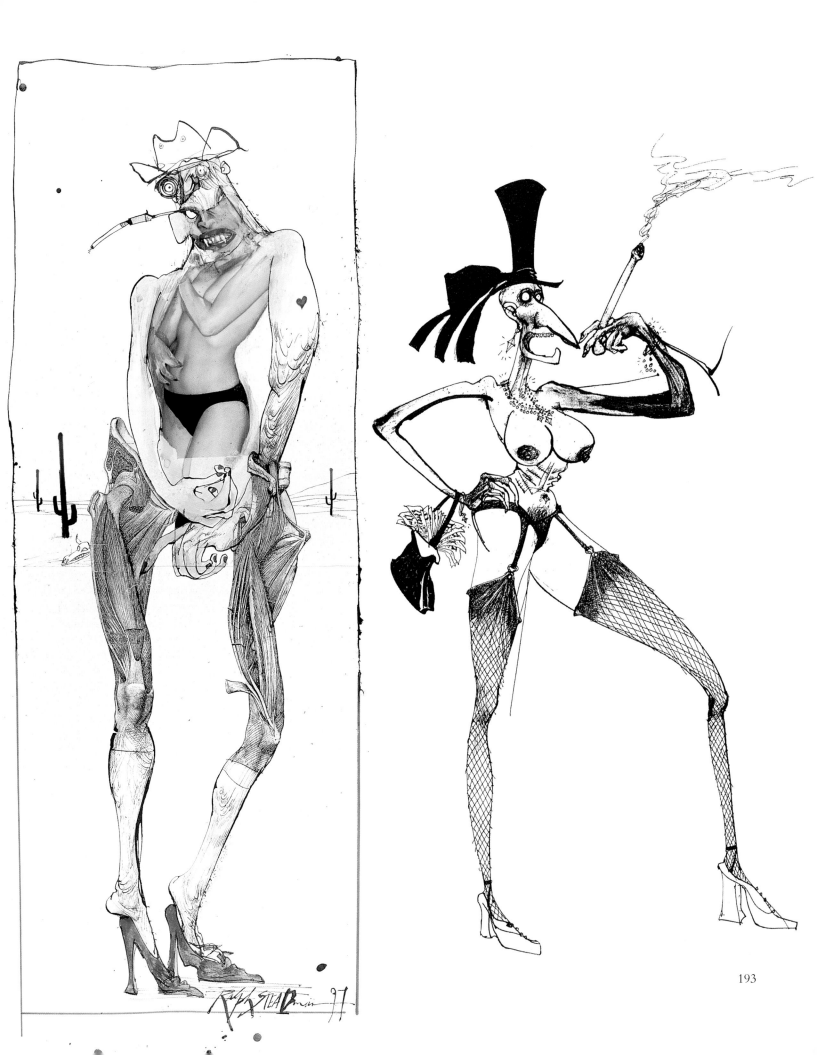

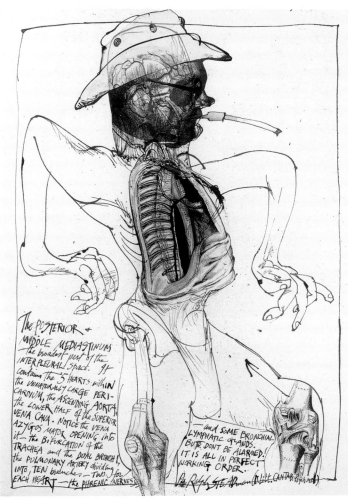

The POSTERIOR & MIDDLE MEDIASTINUM the broadest part of the INTER PLEURAL SPACE. It contains the 5 HEARTS within the UNNATURALLY LARGE PERICARDIUM, the ASCENDING AORTA the LOWER HALF of the SUPERIOR VENA CAVA. NOTICE the VENA AZYGOS MAJOR OPENING into it — the BIFURCATION of the TRACHEA and the DUAL BRANCH of the PULMONARY ARTERY dividing INTO, TEN branches — TWO for EACH HEART — the PHRENIC NERVES

and SOME BRONCHIAL LYMPHATIC GLANDS BUT: DON'T BE ALARMED! IT IS ALL IN PERFECT WORKING ORDER.

Dr. Ralph STEADman (D.Litt. CANTAB MD(ATH) MD)

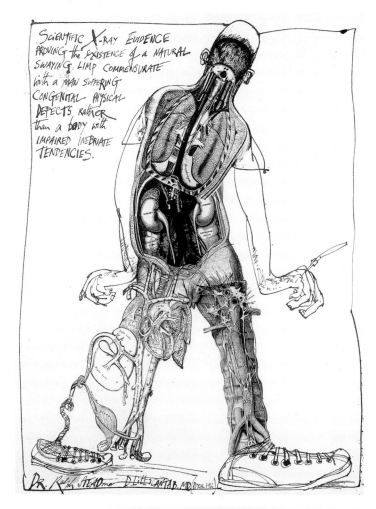

SCIENTIFIC X-RAY EVIDENCE PROVING the EXISTENCE of a NATURAL SWAYING LIMP COMMENSURATE with a MAN SUFFERING CONGENITAL PHYSICAL DEFECTS, rather than a BODY with IMPAIRED INEBRIATE TENDENCIES.

Dr. Ralph STEADman D.Litt. CANTAB. MD (ATH) MD

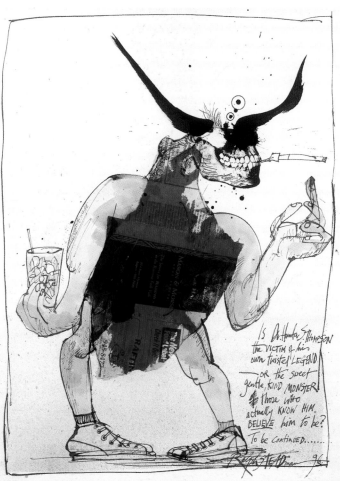

IS Dr. Hunter S. Thompson the VICTIM of his own twisted LEGEND or the sweet gentle, KIND MONSTER those who actually KNOW HIM, BELIEVE him to be?

To be Continued......

Ralph STEADman 96

IT DIDN'T MAKE SENSE UNTIL THE OLD HERB LADY of BASALT told me that HUNTER S. THOMPSON WAS BORN with FIVE HEARTS

Ralph STEADman 96

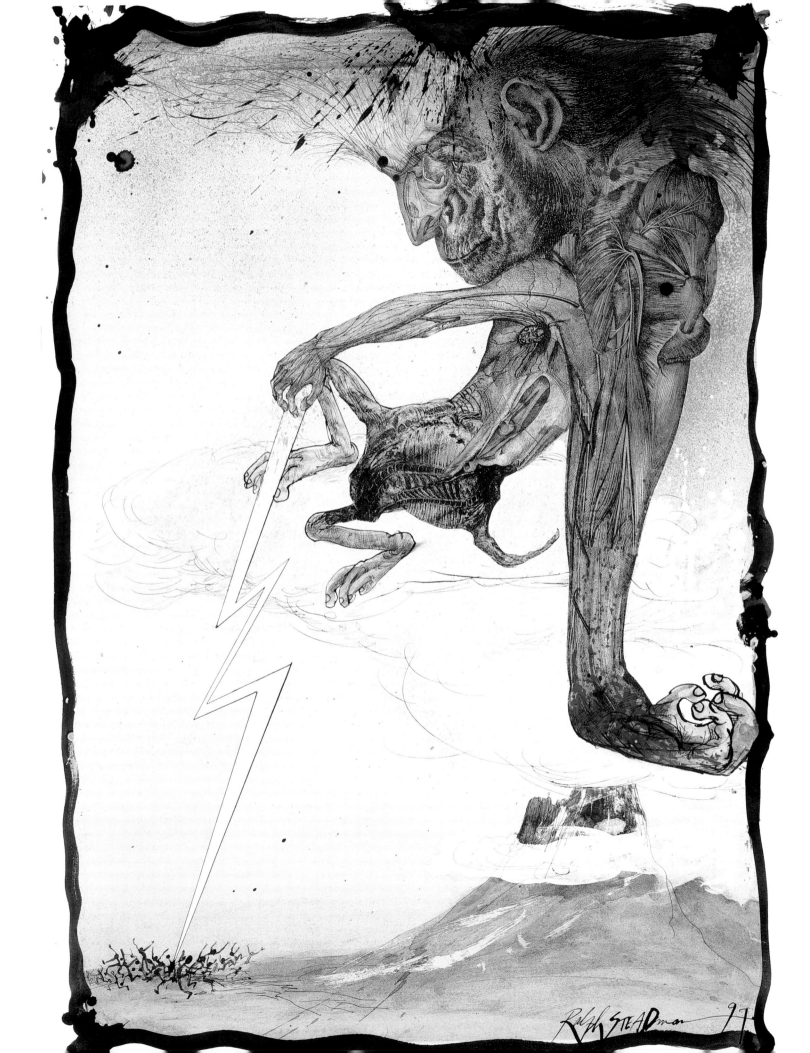

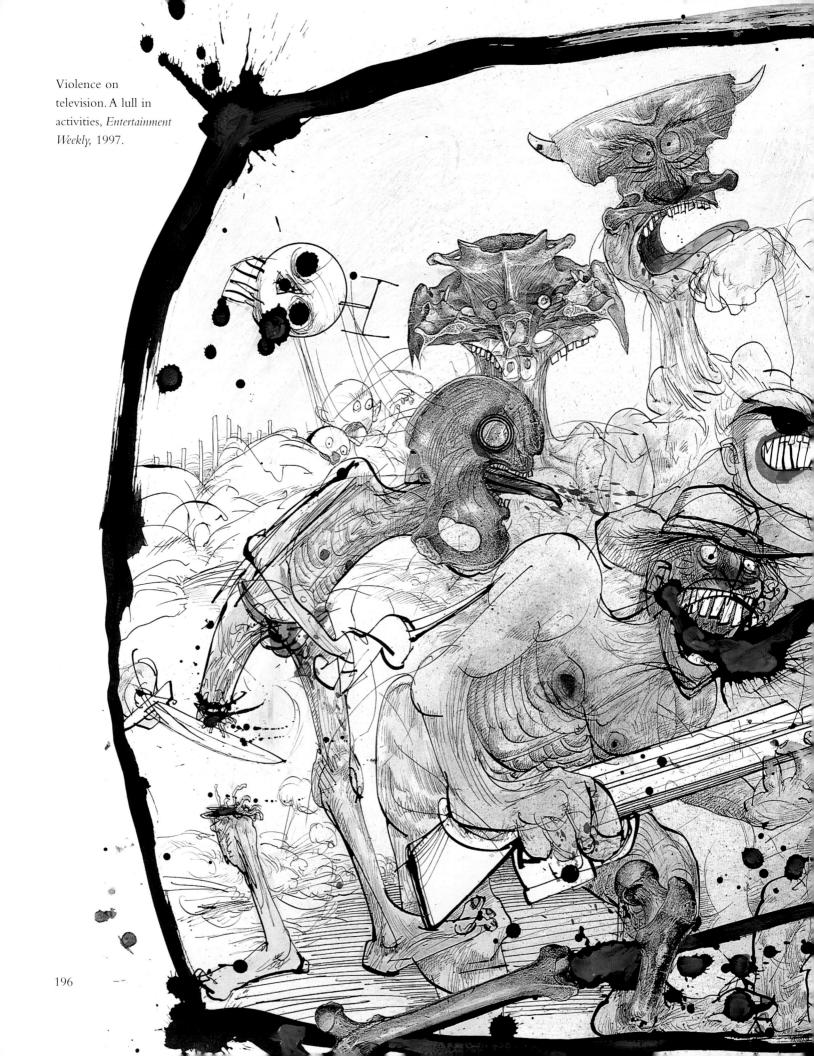

Violence on television. A lull in activities, *Entertainment Weekly,* 1997.

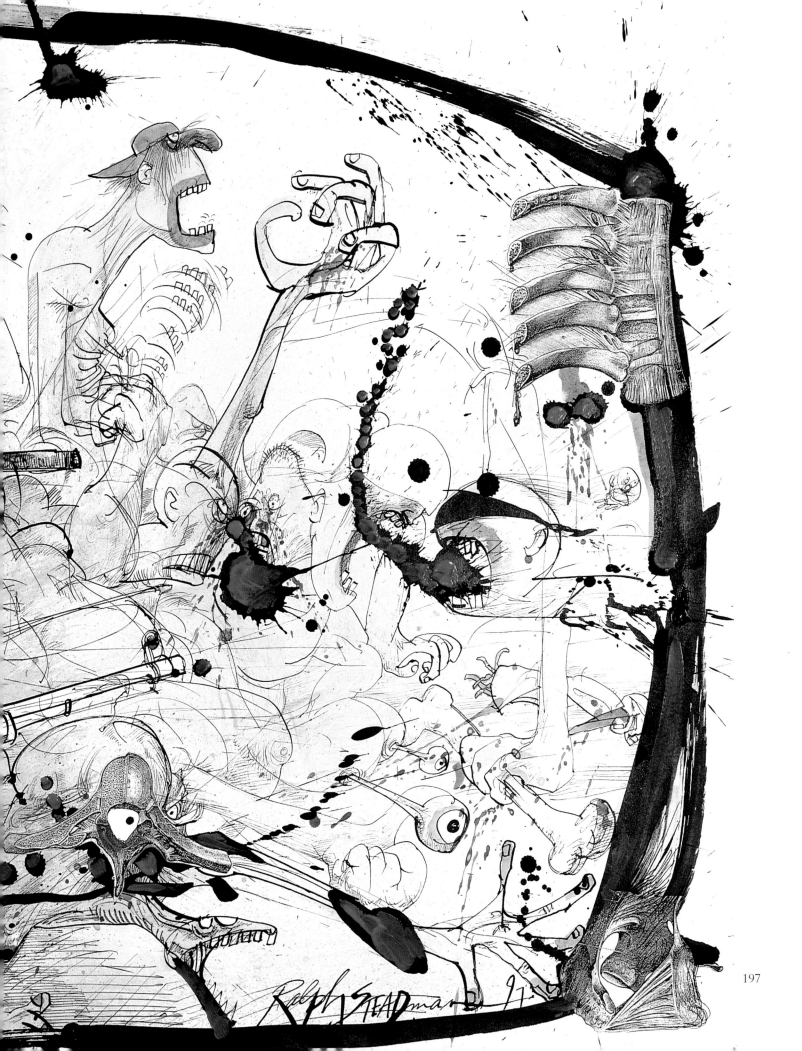

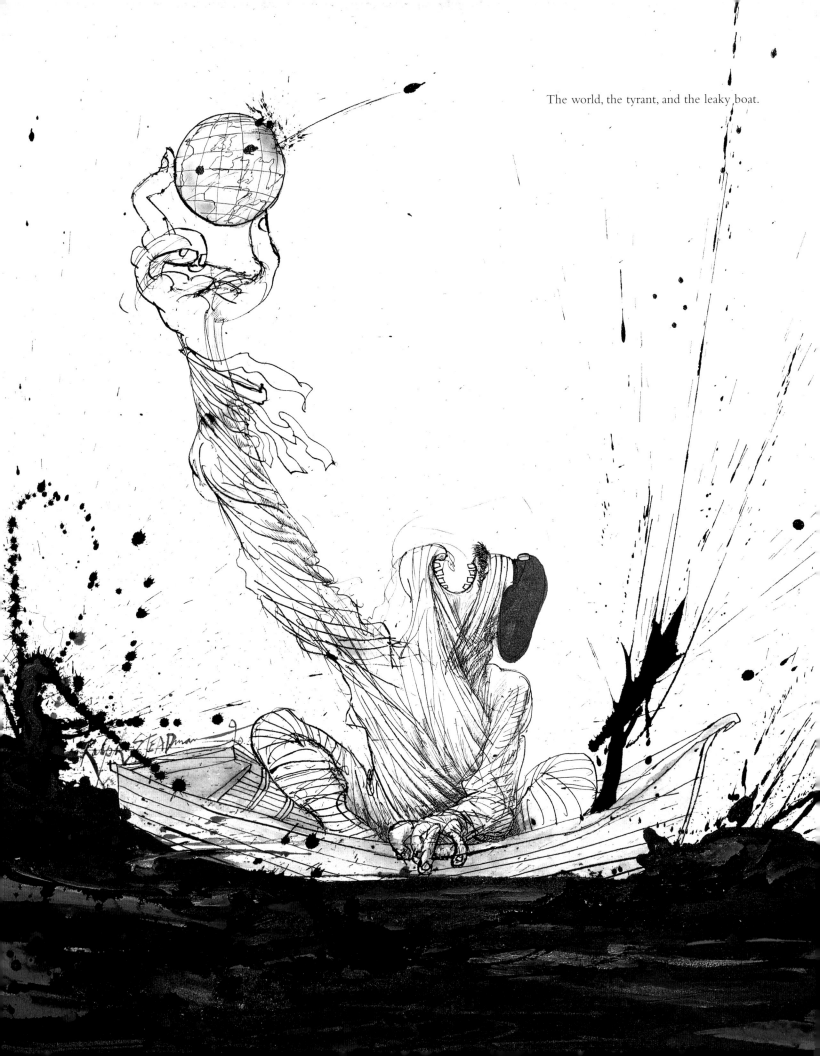

The world, the tyrant, and the leaky boat.

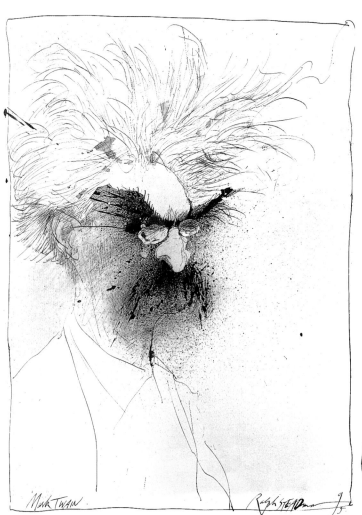

Mark Twain

Ralph STEADman

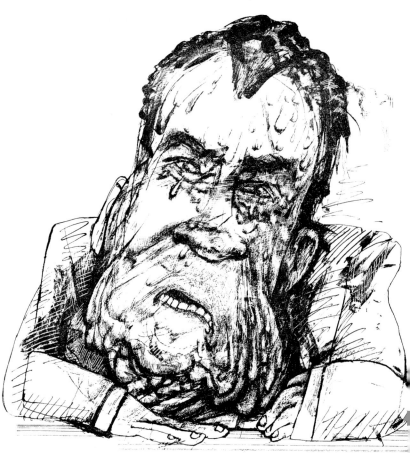

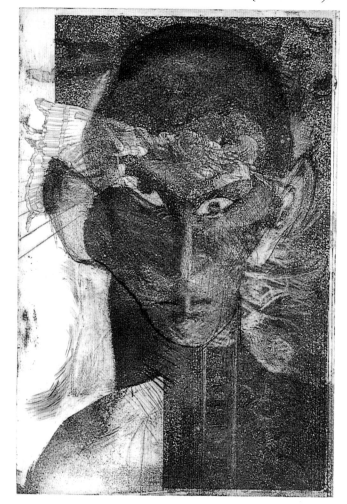

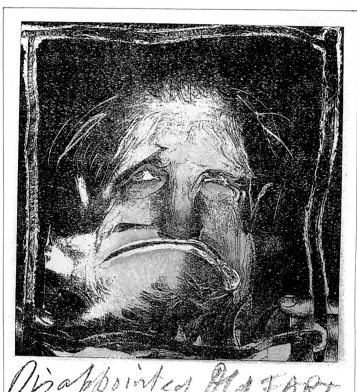

Disappointed Old FARt.
South AFRICA .24.1.96
Ralph STEADman

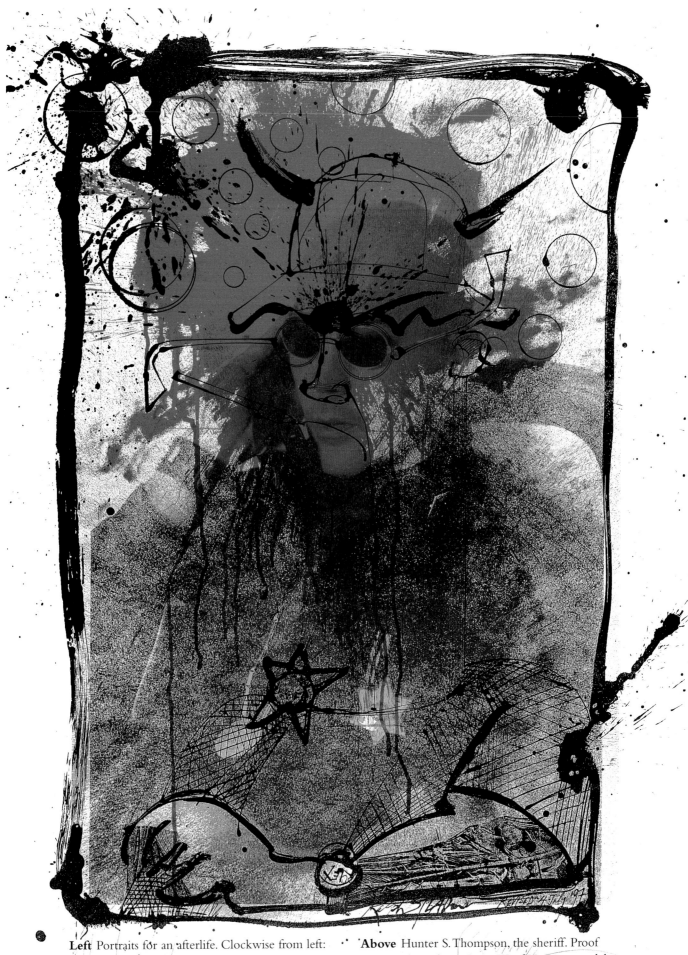

Left Portraits for an afterlife. Clockwise from left: Mark Twain, Richard Nixon, an apartheid supporter, Franz Kafka.

Above Hunter S. Thompson, the sheriff. Proof print made with Joe Petro III of Hunter, to celebrate the 25th anniversary of our first meeting.

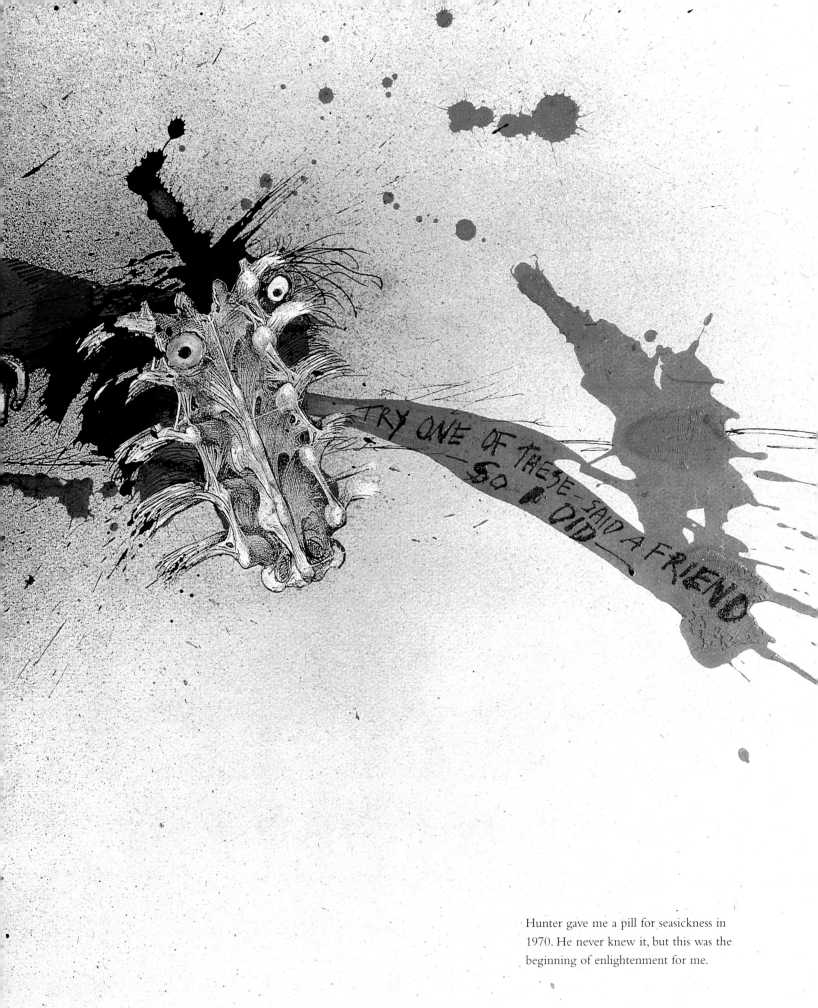

Hunter gave me a pill for seasickness in
1970. He never knew it, but this was the
beginning of enlightenment for me.

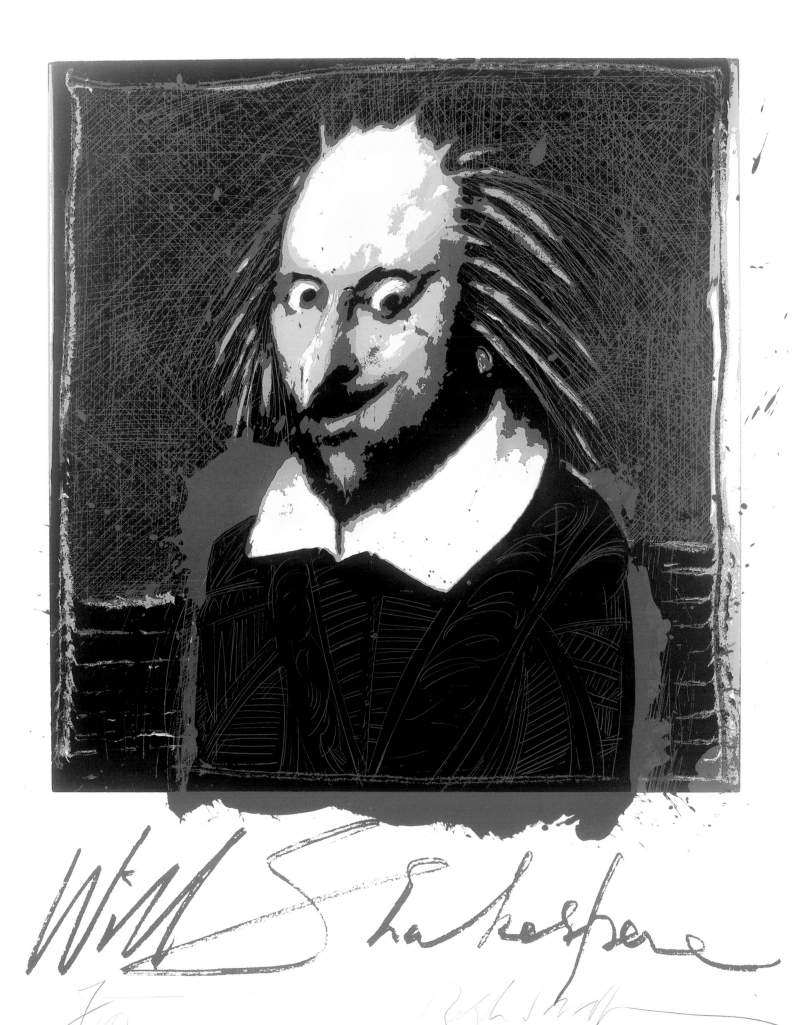

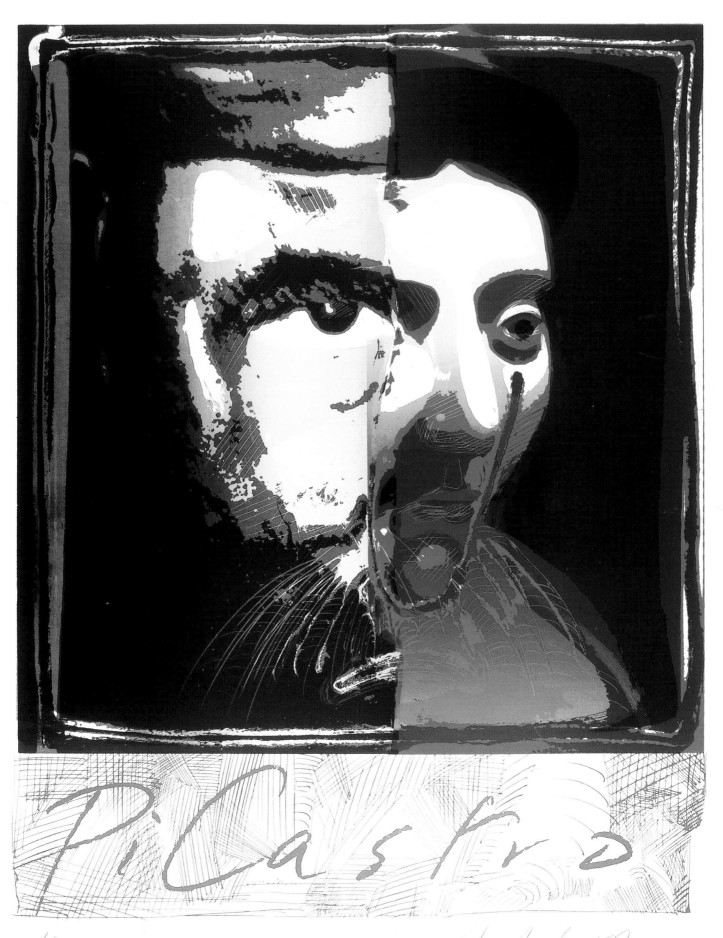

Paranoid silk-screen prints. Left: Every schoolboy's bête noir.
Above: Archetypal twentieth-century revolutionaries, Picasso and Castro.

THE
DEATH
OF
ART